P9-CBJ-000

Pelican Books

Style in the Arts of China

William Watson is Professor of Chinese Art and Archae-
ology in the University of London, and Head of the Percival
David Foundation of Chinese Art. He was a scholar of
Gonville and Caius College, and saw six and a half years
of commissioned service in the army during the Second
World War. From 1947 to 1966 he was Assistant Keeper
in the Department of Oriental Antiquities at the British
Museum. He has travelled in China, Japan, India and South-
East Asia, and conducted excavations in Thailand. His
books include *Ancient Chinese Bronzes*, *China before the
Han Dynasty* and *Cultural Frontiers in Ancient East Asia*.

William
Watson

Style
in
the Arts
of
China

Penguin Books

Penguin Books Ltd, Harmondsworth,
Middlesex, England
Penguin Books Inc., 7110 Ambassador Road,
Baltimore, Maryland 21207, U.S.A.
Penguin Books Australia Ltd, Ringwood,
Victoria, Australia
Penguin Books Canada Ltd,
41 Steelcase Road West, Markham, Ontario, Canada
Penguin Books (N.Z.) Ltd,
182–190 Wairau Road, Auckland 10, New Zealand

First published 1974
Copyright © William Watson, 1974

Set in Monotype Garamond
Text printed by
Hazell, Watson & Viney Ltd, Aylesbury, Bucks
Inset printed by
The Hillingdon Press (The Westminster Press Ltd), Uxbridge

Designed by Gerald Cinamon

For Katherine

Style
in
the Arts
of
China

Preface

An approach to Chinese art not wholly bound to the
necessities of historical order may, as an introduction,
offer readier insights into its general character than
the more customary sequential treatment. The present
book does not divide the subject by dynasties or by
the categories of the fine arts as they are understood
in the West. Instead it traces three major aspects of
the Chinese style separately from early to recent times,
looking for corresponding manifestations in both
major and minor arts.

For the historian of art the word style has many
meanings, all so implicit in his methods that he
seldom feels the need to define them. Some variety,
not to say inconsistency, of usage will be clear from
the rubrics under which the themes of the following
chapters are examined.

A chronological account of Chinese art presup-
poses, even if it does not define, standards of *period*
style. When such style is further distinguished among
the various categories of artistic work the connois-
seur and collector are best pleased. This analysis may
however not satisfy the curiosity of those who meet
Chinese art on neither the historical nor the acquisitive
level, but first and foremost demand to know where
Chinese art stands in relation to other arts of the
world, and how in general it relates to what is said
of the function of art in other societies.

Too often one hears comment from the viewer of
Chinese art to the effect that while it interests him, he
feels so ignorant of it that his opinion is valueless. He

is almost certainly mistaken in what he regards as the obstacles in the way of understanding. (If there is a mystique which estranges him it should be dispelled. No Chinese artist ever sought to mystify.)

It is hoped that this book will be accepted as a plain attempt to use the common language of art writing on a subject which sometimes appears unnecessarily isolated by its peculiarities. In the effort to appreciate the special and humane quality of the Chinese aesthetic there is no reason to apply criteria differing from those observed in judging the arts of other traditions.

Not that historical sequence is neglected here. The first chapter describes a stylistic cycle which, as primary expression (i.e. apart from archaistic revival), extends from the fifteenth to the first century B.C. The realism of the second chapter is present in significant degree only in much later periods. What is discussed in the section on decorative style touches upon early art but is largely concerned with the product of the last thousand years. That the theme in this case falls chiefly in the latest phase of the immensely long tradition of Chinese art is partly to be explained by the greater number of decorated objects which survive from recent times, but another reason is that a conscious separation of the decorative from the expressive is more characteristic of the T'ang and later dynasties.

I offer my thanks to Miss Margaret Medley and Miss Pamela Gray for reading the text and supplying some essential corrections; to Mr Oliver Watson for much help with photography, and constant encouragement; and to Mr Gerald Cinamon for most sensible advice on the placing of the illustrations. Figures A and C were drawn by Mr Paul McAlinden after the *Pan-p'o Report* and a plate in the Kōdansha's recent *Chinese Art*.

Chronology

The Neolithic Period
c. 7000–c. 1600 B.C.

The neolithic cultures, with their settled farming communities and pottery making, extend through some five thousand years, ending with the advent of bronze metallurgy under the first historical dynasty of Shang, in the seventeenth century B.C. Three chronological divisions are significant for the diverse ceramic styles associated with them. In central China, Honan and south Shensi, a tradition of painted pottery is the earliest. It is followed in east China from about 3000 B.C. (in a zone extending to the east coast) by a black-pottery tradition, whose burnished, plain, wheel-thrown pots are in striking contrast with the painted designs of the central tradition. Two trends of Chinese design are prefigured: geometric figures without detectable reference to natural forms, executed on vessels of no great significance as to their shapes; and the careful manipulation of shape, unaided by any decoration of the surface beside its polish.

The third division of the neolithic, centred in the north-west province of Kansu, is the best known outside China, thanks to the splendid painted burial urns plundered from graves in the between-war years and distributed to many European and American museums. Their painted patterns are individual, only remotely related to the central tradition, but equally without explicit meaning.

In an artistic context of which these pots are the only witnesses was formed the vision which comes to fruition in the succeeding bronze age, from c. 1600

B.C., when the long-lived hieratic tradition was founded in central and north-west China.

The three neolithic cultures are named respectively Yangshao, Lungshan and Kansu Yangshao.

*The Shang
Dynasty
c. 1600–1027
B.C.*

In 1400 B.C. the Shang king moved his capital from Cheng-chou in Honan, south of the Yellow River, to a site near Anyang in the same province and north of the river. This move gives a chronological point for the account of the style of sacrificial bronze vessels which were produced at each place. The Shang state, with its chariots, walled cities, ideographic writing and oracle taking, and monstrous royal funerals follows a familiar pattern of bronze-age civilization. An artistic problem lies in the origin of the fully formed *hieratic* style which dates from the earliest levels at Cheng-chou, just as a technological mastery appears to be implied by the launching of bronze casting from an advanced degree of skill and sophistication, without hint of the preliminary stages which would normally be expected.

*The
Western Chou
Dynasty
1027–771 B.C.*

Moving in from the north-west a federation of peoples defeated the Shang state and divided its territories among its leaders. So were formed the principalities of a feudal organization. The head of it, the Chou king, remained at his capital near the modern town of Sian in Shensi. The princes' courts as well as the king of Chou produced bronze vessels in the old tradition for use in sacrifice and as awards to notables. The wider distribution of bronze manufacture, and of the tombs in which bronzes were buried, now allows us to form an idea of the development of regional styles, and of the distinction between an official style patronized by Chou and its imitators, and other styles less augustly connected. But all of this remains within the definition of hieratic

style. Surviving examples of realistic art are as rare as they are under the Shang in earlier times.

Meanwhile we perceive the first signs of a simplification and transformation of Chinese motifs undertaken in the northern territories, the Northern Zone, which are ancestral to the later art of nomads in Central Asia.

In 771 B.C. the Chou capital moved to the vicinity of Cheng-chou,· which has always been the principal seat of power in central China.

The Period of the Spring and Autumn Annals
770–475 B.C.

This was a time of increasing disunity in the feudal empire. The influence of the official art of Chou declined, with changes in hieratic design which herald the transformation due in the following period. Now for the first time it is possible to speculate on the artistic influence exercised on the Chinese tradition from beyond the political pale, elements resembling the steppe 'animal art' being added to the hieratic repertoire.

The Period of the Warring States
475–221 B.C.

The internecine warfare of the states was destined to continue until the unification of 221 B.C. This was a period of intellectual ferment and technical advance. Wax-casting introduced at the very end of the preceding period now increasingly changed the character of bronze; iron was the utilitarian metal. The artistic scene is far from reflecting the troublous fragmentation of the country. A fresh formulation of hieratic style spread to all the main bronze-casting centres. The purpose of the designs is merely decorative to a greater extent, but allusion to the main themes of the old hieratic tradition is never lost. Lacquer painting and jade carving enjoy a revival as artistic media. In the former the first signs of unorthodox religious themes make their appearance in sophisticated art.

*The Ch'in
Dynasty*
221–207 B.C.
*The Western
Han Dynasty*
206 B.C.–A.D. 8
*The Hsin
Dynasty*
9–23
*The Eastern
Han Dynasty*
24–220

Together these reigns constitute the period of political and cultural unity which intervened between the disruption of the Warring States and the break-up of the Han empire. With respect to centralized government and vast military organization with its accompaniment of road building, Han China bears comparison with the early Roman empire. Archaism in official factories prolonged the life of the hieratic style until the end of the Eastern Han (the like had no doubt occurred in earlier times, though we are less well informed on that), but from the time of Ch'in new standards of realism imposed themselves gradually in figural art. For long this development is allowed little scope, the fondness for geometric stylization lingering into the first century B.C.

Two political developments make a lasting impression on national life. In the late second and early first centuries B.C. came the first expansion of the empire into neighbouring territories – west to the Persian border, north-east into Korea and south-west into Yünnan, the stronghold of the Kingdom of Tien. Secondly, of greater significance for the future, a new official class, linked with the interests of the smaller land-owners, and professing Confucianism as a unifying ideology, gradually penetrated all the organs of government, and by the beginning of the Eastern Han was dominant in affairs civil and military, at the centre and in provincial and frontier posts.

These phenomena have their counterpart in art. The far-western contacts, which introduced various Persian products and plants into China, encouraged the trend towards artistic realism, particularly in the statuettes which attempted to represent the points of the horses imported from Ferghana/Sogdiana at the beginning of the first century B.C. By the second century A.D. a realistic pictorial art was well established, serving the social needs of the official class.

*Period of the
Six Dynasties
220–580*

The name of this period is a long-standing convention. The division of China upon the fall of the Eastern Han dynasty was first into three, and eventually into many more small principalities, these being often grouped as a Period of Northern and Southern Dynasties. The chief artistic events were the cessation of the realistic art of Han and reversion to a more traditional style of mannered design. More important however was the introduction of Buddhist artistic themes. Knowledge of the Buddhist religion had reached China as early as the first century A.D., having travelled from north-west India through Central Asia. The earliest surviving representation of an icon of the Buddha belongs to the third century, and in the first half of the fifth century a variety of western-derived versions of the Buddhist images was being made in China. In the first place the demand for images, often of monumental proportions, launched a tradition of sculpture unlike anything known earlier in east Asia, but marked strongly by Chinese character. The minor adjuncts of the Buddhist sculpture and paintings reaching China from the west implanted new themes and decorative styles. The architectural elements which often framed the sculpture remained within the orbit of religious art, but some ornamental motifs, chiefly the lotus in all its transformations, and in general a habit of fluent vegetable ornament had their effect on Chinese art as a whole.

*The
Sui Dynasty
581–618
The
T'ang Dynasty
618–906*

Reunification under the Sui emperors and continued prosperity under the T'ang produced a brilliant period of Chinese civilization which recent historians regard as classical. Imperialism was revived. The penetration into central Asia was more effective than that of the Han. By the mid seventh century Chinese power was paramount from the Jade Gates at Tun-huang in Kansu to the foothills of the Pamirs.

The expansive spirit of the age fostered vivid realism in painting and sculpture. The linear style

attributed in its perfection to the painter Wu Tao-tzŭ spread through Central Asia along the Silk Route, establishing T'ang style in local schools of painting. In reflex the painting of Khotan in west Central Asia was launched at the T'ang capital by Wei-ch'ih Yi-seng, its illusionistic relief and chiaroscuro astonishing Chinese viewers. Western influences flooded into the capital, determining the ornamental designs of textiles and metal work. Elements of the art of Sasanian Persia were adopted in the first half of the eighth century. Their transmission was aided by the arrival of noble refugees from Persia, conquered by the Arabs in A.D. 638, during the later seventh century. The modeller of clay statuettes excelled in portraying real types, Chinese and foreign, availing himself of the brilliant colours of the newly revived lead glazes. The greatest achievements in monumental sculpture belong also to the T'ang age. The models upon which it was based correspond broadly to forms of the post-Guptan sculpture of India, but the performance is essentially Chinese. Unfortunately the wooden and bronze sculpture which was the greater part of this work has largely perished, and the style must be judged from stone images. In these the representation of realistic detail was less complete.

Among the minor arts the absence of jade carving and archaistic bronze are a negative reflection of the new enthusiasms. In ceramics also traditional methods are revolutionized, not only in the three-colour lead-glazed wares but in high-fired white and green wares which mark the advance towards true porcelain. The achievements of the architect survive from the T'ang period in not more than two or three buildings in China, but temples built at the Japanese capital of Nara at the beginning of the eighth century, like the sculpture these contain, show the establishment of structural and ornamental methods which laid the foundation of later building history.

The Five
Dynasties
907–960
The Sung
Dynasty
960–1279

(*Northern Sung:*
960–1127
Southern Sung:
1127–1279)

The period of the Five Dynasties is famous for its great painters, among them Ching Hao and Chü Jan, who founded the stylistic tradition of the Northern School, a category not constituting a school of artists in the ordinary sense. The landscape, always imaginary, is composed of comparatively realistic elements. The political reunification of 960 introduced a period of intense nationalism, and, in contrast to the receptiveness of T'ang times, initiated a cultural exclusiveness which has lasted to the present day. In the face of economic and military collapse the last emperor of the Northern Sung dynasty, Hui Tsung, organized a painting academy and encouraged scholarly antiquarianism. Paintings from his own brush survive.

From the fall of the T'ang dynasty until 1125 the territory north of the Great Wall had been ruled by the Liao dynasty of Khitan Turks. Their successors, the Chin, in 1127 overran north China and established their own dynasty. Hui Tsung was captured and disappeared, but the kind of palace patronage which he had undertaken continued in the south. Here his successor, retreating from the northern capital at K'ai-feng, founded a new capital at Hangchow south of the Yangtze mouth. The painting academy was re-established, and the influence of the court extended to porcelain and other fine goods required for palace furnishings. The positive exuberance of the Northern Sung gave way to a mood more contemplative and sentimental, as exemplified in the misty landscapes of Ma Yüan. A corresponding change is detectable in ceramics, in which purity of colour and archaistic shape were best liked by the connoisseur.

Yüan
Dynasty
1271–1368

During a short rule of only eighty-eight years, Kubilai, the Mongol conqueror of China, and his successors presided over revolutionary changes in several branches of Chinese art. The most dramatic

was the rejection of the sentimental and thoroughly
conventionalized painting of the Southern Sung
painting academy. The styles which now received
universal favour outside the academy (which con-
tinued under the Mongols) above all displayed the
personal touch of the artist's brush, and the beauty
of texture, exalting the surface of the painting in
contrast to the earlier emphatic structure and perspec-
tive devices. This trend of taste and the apotheosis of
the amateur scholar-painter which went with it, were
later claimed to be distinctive of a stylistic tradition
attributed to a notional Southern School, for which
ancestors were sought among early painters. All of
this was joined to an earnest desire to recapture the
innocence of ancient painting, especially the supposed
simplicity of the T'ang. The blend of imitation and
invention which came to be regarded as the indis-
pensable condition of artistic creation reaffirmed a
traditional attitude, but the appraisal of cultivated
amateurishness was new.

The archaism of painting is echoed in the archaism
of bronzework, which the Yüan age inherited from
the Sung and enthusiastically pursued. The Sung
aesthetic as it is seen in porcelain gave way to
crowded floral and other figural ornament, painted
in the new underglaze technique in blue and red. This
reflects an influence originating from the Yüan court,
whence came also the metal vessels of Islamic design
which were frequently copied. Court taste seems to
gain more general acceptance in the minor arts than
ever before, and henceforth the palace patronage
more clearly determines the character of much
decorative art.

*The Ming
Dynasty
1368–1644
The Ch'ing
Dynasty
1644–1912*

The Ming emperors issued from native stock. National enthusiasm was at its height when the Yüan government was overthrown. In painting as in the minor arts (notably porcelain and lacquer) the innovations of the preceding period were developed and varied. The rebuilding of the Peking palace on the site of Kubilai's gave continued impetus to arts receiving the official patronage. Chinese society had never before looked to the court for standards of every kind. In the arts, palace taste and demand of excellence were spread abroad through the emperor's conscription of artisan labour and distinguished craftsmen from all over China. The provinces of Chekiang and Kiangsu inevitably supplied the greatest number.

Intellectual activity with aesthetic implication is concentrated in the seventeenth century, bridging the change of dynasties. Evidence of it is seen most clearly in the work of individualist (and often most eccentric) painters. The ultimate in graphic freedom was made acceptable by Chu Ta, who never spoke and was reckoned mad, while Wu Li even became a Christian.

The Ch'ing, last of the Chinese dynasties, launched their power from the steppe camp, like their Mongol predecessors, but they had already absorbed much of Chinese culture even before their conquest. In 1644 their capture of Peking and pacification of the rest of the country caused less cultural disturbance than even the Yüan had occasioned. Palace influence was now heavily on the side of conservatism in art as in all else, and pious archaism reigned in everything. The Wang school of painters revived something of Sung style (reacting against the liberties assumed by the scholar painters) and the academy flourished in routine production. Under Ch'ien Lung (1736–95) through the eighteenth century members of the Jesuit order professed the arts and sciences at the court. A Europeanizing style gained acceptance, though it hardly went beyond the palace walls.

In jade, porcelain, metalwork, textiles, etc., the palace imposed uncompromising conservatism, but the overloading of ornament and some tasteless exaggeration were not avoided. When regular contacts with Europeans began in the early eighteenth century the ornate palace style was naturally taken to be the essential Chinese style. This view, abetted by the chinoiserie of Europe, still colours the popular conception of Chinese art in the West.

Chapter 1

The Hieratic Styles

The term hieratic denotes a long and singularly logical development of artistic style which can be followed from the beginning of the bronze age to the eve of the unification of China in 221 B.C. This period of some fourteen centuries saw many variations in the motifs represented and the manner of representing them, but the basic assumptions of the art altered little. The society which the art served began as a small community of city dwellers who ruled from walled towns over a large territory which in parts remained quite primitive. The Shang city state is comparable to the city states of Mesopotamia in some fundamental aspects. The monopoly of bronze under the control of a small ruling class meant that the population at large had little access to it, especially for uses connected with art. Therefore the ornament cast on bronze vessels, which is our chief source of knowledge, must reflect the taste, and the social and religious preoccupations, of a very narrow section of the bronze-age society. Yet in the fourth and third centuries B.C. when power was in the hands of many rulers, and wealth was more widely distributed, extraordinarily uniform styles, clearly related to the ancient tradition, are still followed in decorating bronze vessels, weapons, and ornamental bronze objects of many kinds.

It is clear by this time, if not earlier, that priestly regulation is not the reason for the persistence of motifs and styles, and the term hieratic may seem to

be misapplied. In the Shang dynasty and the earlier
part of the Chou dynasty however the association of
certain schemes of ornament with the ritual of sacri-
fice is so regular that one must suppose feeling for
the special ceremonial character of the ornament to
be very real. The fact that all the surviving examples
of Shang and Chou art come from tombs does not
necessarily give us a partial view of it. We note that
the hieratic style was used from early times to
decorate objects that can have had no immediate
religious import, such as chariots and parade weapons.
But it is obvious nevertheless that it was in producing
their most ambitious work, the ritual vessels, that
the artists and bronze casters were at their most
original. In other words, the design of the ritual
vessels influenced the course of style more than other
considerations.

We may therefore define the hieratic art as one
shaped at its origin by the requirements of a ritual of
sacrifice. Over its birth presided the wish to admonish
participants in the sacrifice by portraying fierce mon-
sters which somehow symbolize spiritual forces. But
soon after these origins were left behind the designs
evolved as if with a life of their own, being first
abstracted from the shapes of mythical animals into
geometric figures, which then in turn were revita-
lized by reintroducing the animal content, only again
to evolve towards abstract pattern.

The question arises whether the monster masks and
dragons of the Shang hieratic repertory were simply
inherited from neolithic ancestors. The most interest-
ing part of neolithic style appears however to be
more simply decorative, without specific symbolism.
Even if symbolic meaning is attached to the ornaments
of neolithic pottery, it is hardly likely that they are
ancestral to the Shang motifs. The immediate pre-
decessors of Shang, in the region of Honan where the
bronze art was launched, belonged to the Lungshan
branch of the neolithic, which is singularly destitute
of figurative art. Some of the shapes of the bronze
vessels of Shang recall those of Lungshan pottery,

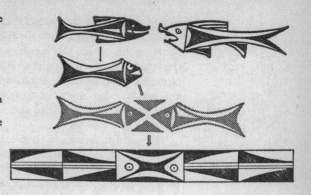

Fig. A. The decorative treatment of the ubiquitous fish motif painted on Yangshao neolithic pottery. The sequence from top to bottom suggests the stages of reduction from the real to the wholly schematic. The third line is an imaginary reconstruction; the other three all occur on the pottery. Such schematization, while akin to the methods of hieratic style, is absent from the Lungshan neolithic which immediately preceded the bronze age in central China.

but the resemblance is not close enough to suggest that a pre-Shang ritual tradition survived into the bronze age. On the other hand, some decorative principles of the earlier neolithic, the Yangshao culture, foreshadow the bronze-age style. 1, 6

We are thus left to conclude that the hieratic style is a Shang invention, the adoption of a few carefully devised motifs to represent spiritual entities which were believed to inhabit animal forms. By far the most prominent designs are the *t'ao-t'ieh* monster mask and the *k'uei* dragon.

Hieratic Art under the Shang Dynasty

Hieratic art is generally predisposed to jolt the viewer out of his easy acceptance of the surrounding world by distorting natural forms, or by placing them in astonishing combinations. In this respect Shang art is no exception. The *t'ao-t'ieh* mask hovers between 2 the tiger, the greatest plague of men and animals, 3, 9 and the ox, its natural prey. Various guesses have been made on its origin as a design, on the assumption that it was a motif imported from abroad (for example, the Persian lion-griffin) or that it represents a conventionalized version of a real animal. As for its symbolism, it has been suggested that it represents a storm god or wind god, such as is believed to be

named on oracle inscriptions dating from the Shang dynasty; and that it stands for fecundity, the success of the crops, which was a constant preoccupation of the oracle takers who worked for the Shang kings. None of these interpretations remains convincing, and it is possibly mistaken to assume that it had any such precise significance to the makers of the ritual vessels.

The earliest reference to the *t'ao-t'ieh* in Chinese literature occurs almost a thousand years after the fall of the Shang dynasty, in the third century B.C. It is then described as a monster possessing only a head (not quite an accurate description, as we shall see presently) which 'tried to devour men but was unable to swallow them, and so damaged its own body'. Therefore it is taken to be a reminder that all excess brings retribution. We have no means of verifying this interpretation from Shang sources. The word *t'ao-t'ieh*, the glutton, is itself a late appellation which finds no place in the Shang inscriptions. To call it an averter of evil is no doubt to recognize one function claimed for it in Shang times – but then we are still left wondering why so outlandish and strictly regulated a creature should have been chosen for this purpose. It is likely that all the paraphernalia of the ritual was believed to discourage undesirable influences.

The fact that on rare occasions the place of the *t'ao-t'ieh* mask on a bronze vessel – particularly the four-legged variety of the food-vessel *ting* – is taken by another animal is not without an artistic interest, because in these cases the replacement is drawn in comparatively realistic fashion. An ox-head, deer-head, and even a human face has been found

7 performing this function, and each falls outside the hieratic convention of design. It is argued in the following chapter that a more natural art subsisted in Shang times alongside the hieratic style, whose special status is thereby corroborated. The few lapses of the ritual style into the realistic idiom show that no agreed convention existed for representing subjects

extra to the repertory, and that no real need was felt
even to adapt their delineation to the prevailing style.
It was reasonable to represent on some vessels the
creature who provided the flesh for an offering to the
gods and ancestral spirits.

3 Besides lacking a lower jaw, the *t'ao-t'ieh* frequently
9 has the peculiarity of dividing easily into two animals.
On either side of the mask, with its eyes, fangs, horns
and ears, a summary body is added with a single
clawed foot. Since symmetry was essential to the
designs, this would seem to be the only method of
suggesting a body behind the mask. Each body and
its half of the mask can then be seen as an indepen-
dent design, a kind of one-legged tiger with a large
eye and ear, and a curling nose. This is the dragon
which later interpreters identified with the *k'uei*, an
unidentified mythical creature which is named in
Shang inscriptions and was evidently believed to
belong to the royal ancestors. In the Han period its
name was given to an official in charge of music under
the legendary emperor Shun. It is difficult not to
conclude that the design of the *t'ao-t'ieh* came first,
and that the *k'uei* arose from it. Sometimes a mask is
flanked by two of the dragons drawn independently, so
that the contrary argument is possible, though
improbable: that the mask arose by the junction of
two pre-existent dragons.

Whichever of these two explanations is correct, no
symbolic meaning can be read into the process. On
the other hand two important principles of design are
involved. It is impossible to see the *t'ao-t'ieh* simul-
taneously as single mask *and* as two dragons standing
nose to nose. An awareness of the two possible
readings of the shapes disturbs a viewer as soon as
they are pointed out to him. *T'ao-t'ieh* of large size,
such as are known to have been made of wood with
inlay of bone, would surely spread their disquiet
rapidly through any place where they were displayed.

To the principle of graphic ambiguity thus intro-
duced into the design of the mask is added a practical
expedient of great promise: that of elaborating a given

8

theme in line so as to produce eventually separable units, which can then take their place independently in schemes of ornament. In Shang times these processes were applied almost exclusively to the mask and the dragon, the other motifs which accompany them generally retaining an individual and comparatively unchanging character. The method of graphic development became basic however to succeeding phases of hieratic style, whose periodic shifts it often seems to explain. But the problem then still remains of determining what other factors, if any, precipitated change within so tight a circle of graphic ideas.

Other frequent animal motifs of the Shang style are birds (an unreal crested species and a more natural owl), snakes, cicadas, and silkworms. The life cycles of the last two include stages which might be likened to rebirth in this or another world, but there is nothing in Shang texts or Shang traditions as later set down to confirm that this was the meaning in

2, 10

early times. It is more relevant to style that the animal motifs were nearly always combined with small geometric or tendril-like figures. Of the former, spirals tightly wound in small squares or parallelograms are ubiquitous, and long ago earned the name *lei-wen*, 'thunder pattern' from the resemblance of the figure to the corresponding Shang ideograph. Their size and shape are varied to suit the areas they fill. When the need arose to cover the whole available space of the vessel sides with ornament, as happened in the later stage of Shang art, it was this *lei-wen* that was multiplied, though it does not seem to have been invented for this purpose in the first place. The tendril-

9

like lines came to be used to break up the surface of the raised parts of designs worked in relief. More rarely the thunder pattern also invaded the main elements of the design, when a quite particular effect seems to be intended.

The use of these quasi-geometric minor elements is a prominent feature of the later phase of Shang art in the twelfth and eleventh centuries B.C., when the

contrast of the pseudo-organic forms of the monsters with the strictly meaningless linear ornament appears to be deliberately sought. This expressive resource was available when the custom arose of covering the whole ritual vessel with appropriate ornament, and, in turn, when the whole vessel was the field for the design, its shape might have a lasting influence on the development of the graphic style. Change in this respect is to be seen between the bronzes of the earlier Shang period, belonging to the occupation of the earlier capital at Cheng-chou in central Honan, and those of the later and last location of Shang kings, near Anyang in the north of the same province.

The Early Shang Style

In the Anyang period the nature of the Shang rite is revealed by the inscriptions carved on animal shoulder-blades which were used in oracle-taking. The great majority of the questions put to the oracle demanded confirmation from an unspecified supernatural source whether a particular sacrifice suited a named royal ancestor, more rarely some other spirit seeming to be a natural force deified. The chief god, Shang Ti, appears rather rarely. After cracking the bone in fire, the answer was read from the cracks by a means no longer intelligible. Meat, grain and wine were offered in the propitiation of spirits, and these were held in bronze ritual vessels during the ceremony. Like other ancient deities, the Chinese gods were attracted to the sweet savour of the oblation.

In the Han, and again in the Sung, Chinese antiquarians were at pains to determine just which vessel shape was used for each purpose of the variously named ceremonies described in ritual texts. The latter were compiled in their extant form just before the Han period, but their contents are of much earlier date, and must essentially descend from the Western Chou period, if not in part from the Shang dynasty itself. The ritualist tradition naturally attaches great importance to the proper naming of the vessels; but our

present archaeologically increased knowledge of their
varieties and grouping tends to disprove strict alloca-
tions of names and functions. The term occurring in
the inscriptions of excavated vessels sometimes con-
tradicts the traditional one, and some names are
conventions of the Sung dynasty antiquarians. The

7, 9, 11 tripod vessels and bowls (*ting* and *kuei*) held meat and
18 grain. The basin and water pourer (*p'an* and *yi*) were
for ritual ablution, while the wine vessels comprised
6 the more surprising forms. The tripod goblets, *chüeh*
and *chia*, and the slender *ku* served for libation and
drinking. While ceramic shapes may have lain behind
the bronze in the case of the simpler containers, the
goblets must have another origin – and one whose
peculiarities seem to have influenced the ideal which
the bronze artist set himself regarding profiles and
proportion of parts, as distinct from surface orna-
ment. The *chüeh* and *chia* have been explained as
rationalizations of a drinking horn supported by two
sticks, and no explanation has been advanced to
replace this unconvincing suggestion. The tapering
legs, sharp-edged and of triangular section, give at
once the impression of delicate balance, while the
indispensable columns on the lip of the cups (pos-
sibly to lift them by) relieve the shape of ponderou
effect. We feel at once that we are faced with par-
ticularly deliberate artifice.

The taut lines of the ritual vessels were not
achieved at once. During the earlier half of the Shang
dynasty – the Cheng Chou period – the shapes are less
2 inspired and varied, nor as a rule does the ornament
exceed a band under the lip. As to the nature of the
hieratic style, it is most interesting to find that the
14 draughtsmanship is hardly less complex on these
early pieces than on those representing more evolved
stages of the art. The *t'ao-t'ieh* figures almost alone,
occasionally combined with a more realistic animal,
such as a tortoise, which does not enter into the dance
of the linear design. Extending either side of the mask
are strange tentacles in which the hint of a bodily
shape is even more remote than in later versions, so

curlie-wurlie and behooked they appear. Already there is a tendency to arrange these additions in three parallel bands, thus founding the tradition of the mask with animated frieze, a device which persisted through the whole of the Shang period alongside the more ambitious developments about to be described.

The Late Shang Style

These developments can be put in a logical sequence, which partly succeed each other in time. First the masks and dragons are multiplied to cover a larger surface, by the simple expedient of repeating subordinate parts, like the classical architect multiplying pediments over the façade of a building. The lateral elements of the mask may be maintained and then repeated as distinct dragons, perhaps stood on their heads. Another method was to explode the mask, widely separating its constituent parts (nose, eyes, ears, horns, fangs, etc.) and to scatter these over a larger field, filling the interstices with *lei-wen* or allied spiral scrolling. After being beguiled into too easy acceptance of outlandish themes which seemed to be moving ever nearer to decorative anonymity, we are thus taken unawares by a brilliant invention. Like the Cheshire cat, the *t'ao-t'ieh* fades into a menacing grimace, but only to return presently more fierce and coherent than ever.

The next stage saw the main items of the designs raised into relief, stepping up the animation of the vessel surface a key higher, setting off the detail with shadow. The monsters and their retinue were probably executed on a monumental scale with the same finesse and variation that is to be seen on the bronzes, and then the effect of the exploded monster must at first sight have been overwhelming. Possibly it was large-scale work that inspired the bronze artist in his more extravagant essays in the plastic style. Not only are the figures of animals raised from the ground of the design – with protuberance of eyes and horns which add a third step to the relief – but this trend is

accompanied by increasingly freer use of projecting elements as part of the design of the ritual vessels. The horns of the bovine type of *t'ao-t'ieh* stand free, monsters distinct from the masks are set as escutcheons over the swivels of handles, and vessels are

13 cast in the shapes of whole animals. The latter are modelled fantastically or, as an occasional quotation from a non-hieratic tradition, are given surprisingly realistic shape. One class of vessels, consisting mostly of the wine-bucket *yu* and the food-holder *kuei*, perform extravaganzas of relief ornament that are unpleasing in themselves and appear to contradict the artistic aims apparent in other vessels, reducing the power of the images to the merely grotesque. This 'baroque' style falls at the very end of the Shang period, and may be the first sign of a north-western, Chou, influence on Shang art which was to transform the hieratic style after 1027 B.C.

Connections outside China

It is appropriate to ask at this point to what extent the Shang hieratic style reflects tendencies present in early East Asian art as a whole. The lack of any bridge from Shang art to that of local neolithic predecessors was mentioned above. Still earlier in the neolithic period however designs painted on pottery bowls of the Yangshao culture show the trace of an affinity to the visual bias of Shang. A stylized fish, frequent on the pottery, is seen in increasingly geometricized versions, ending as a simple oblong with diagonals. Like the *t'ao-t'ieh*, the fish may have had an original magic meaning. But one notes that the move from rationalized realism to complete abstraction is hardly the trend which produced dynamic variety in Shang designs. The Yangshao line of development came to a dead end – the oblong could inspire nothing further; whereas the Shang artist appears consciously to avoid any such artistic impasse, and every version of the few themes he juggled with seems in retrospect to be pregnant with the next.

Just as the graphic method of Shang art is peculiar to itself, the type of motifs it operates with are not known in the same period outside the pale of Chinese civilization. An interesting demonstration is seen in the connection of Shang culture with the bronze age of South Siberia, in the Yenisei region. It is the contention of Soviet archaeologists that Chinese influence transformed the technology of the Siberian bronze tradition, thereby founding the Karasuk culture, whose influence in turn flowed strongly westwards through the northern steppe zone. Some shapes of weapons found in the Yenisei are said to derive from Shang, and one tool, the bag-shaped 'socketed axe', has been found along the line of the probable route which joined China to the distant north, by way of Lake Baikal. There is a good case to be made for the axe being a Chinese invention. In versions excavated at Anyang decoration on the axe often takes the form of plain *t'ao-t'ieh* masks near the lip of the socket. The most prominent feature of the mask is its eyes, while on the axes found in the Zabaikalye, believed to be Chinese-inspired but of local manufacture, the frequent ornament of a T with small circles beneath the arms is only explicable as a reminiscence of the original Chinese feature. The latter, in full form, had no meaning outside China, and could not be exported with the axe.

A serious parallel with a foreign art can however be made outside of Asia. There are some striking resemblances to Shang in the overall character of the themes of Mexican art in pre-Aztec and Aztec times. Similar monster masks, similar use of subordinate animal parts, similar variegation with fascinating linear figures – all this seems at first to ally the two traditions, and with astonishing implications. Even historical connection, by way of migration, has been claimed between the two civilizations, but unfortunately not demonstrated by convincing evidence along the way. More than a thousand years separate the Shang from the rise of urban civilization in central America. It seems hardly credible that the

Shang style should be preserved for so long, over such distances, when it left no trace along the way, and since even in early times it barely seems to have made itself felt to the north of the Yellow River valley. Similar analogies can be made of Shang art with the ornamental styles practised among Pacific islanders in recent times. It is more to the point to note that neither these arts nor that of Central America show the interest in logical graphic development of the kind fundamental to the Shang vision.

The Influence of Technique

In discussing the varieties of the hieratic style which flourished in central China between the fifteenth and the eleventh centuries no mention has been made of the effect of the method of casting on the development of a style. Some of the artistic consequences of technique are quite obvious, but they should not be exaggerated. It would be mistaken to seek reasons for stylistic *change* in the varying devices adopted to render the designs in metal. Contrary to what was first believed, the bronzes were not made by the so-called lost wax method.* This was the regular method followed in the bronze age of the West and the Near East, and it was natural for it to be expected in China. But after excavations had begun at Anyang it soon became clear that *piece moulds* were employed by the Shang casters, at least when they were preparing the ritual vessels.

A piece mould, consisting of as many separate parts as conveniently encase the object to be made, implies usually that a preliminary model was produced, from which impressions were taken to form the mould. But it is also possible to make the mould directly, by carving out the necessary shapes in negative, engraving the ornament in reverse. Both

* This procedure requires a model to be made in wax, which is encased in clay and heated, or even baked. When the wax has been consumed a hollow answering to the desired shape is left within the mould.

procedures apparently had adherents in the ateliers of the Shang capital, for fragments of positive models have been recovered as well as the parts of moulds. The special character of the ornament implies, however, in most cases that it was engraved by the casters in reverse on the inner sides of mould parts. By no other means would it have been possible to achieve the accuracy of the *lei-wen*. These are rendered by minute walls, as close together as a millimetre and even less than a millimetre in thickness, whose sides are perfectly vertical and edges sharp. In the Cheng-chou style, although no *lei-wen* is used, the crispness of the cast design indicates mould carving no less.

In these methods there was thus a presumption that the Shang caster was required to produce work animated by the touch of the chisel, for which clear vision and assurance were the first requisites. Like the paper later used in painting, the clay mould, already hard, would suffer no retouch. At the joints of the mould parts, inevitably seams were formed, which had to be removed in finishing the casting after it was taken out. In bronze vessels with smooth sides no sign of the seams appear, for here it was easy to file them away. But where a mould joint ran across a band of ornament the seam could not be wholly removed, and therefore must be made a virtue of by inclusion in the design of the ornament itself.

This must be the origin of the vertical ridge which runs down the middle of the nose of most *t'ao-t'ieh*. Except as a tangible axis of symmetry, which the artist apparently did not object to, this ridge was not at first further exploited. It was at the late stage of the Shang evolution, in the 'baroque' and grotesque manners especially, that the potentialities of joint seams were seized on for positive effect. Even here the device was not adopted suddenly. At the stage when the designs were worked in relief, the main vertical lines of the bodies of vessels frequently carried flanges raised to a height approximately equal to that of the highest part of the relief. The flanges followed the lines of the mould joints, and the

grooving of the mould which they necessitated no doubt facilitated the correct assembly of the parts. Artistic sensibility would not permit the flanges to remain as mere bars adhering to the surface of the vessel, and so they were decorated, but in a manner that has defied explanation. Usually the flanges have on each side a series of Ts, head inwards, formed of shallow channels in the bronze which fail to penetrate its thickness. As a piece of nicely congruous ornament this could hardly be bettered, but an unprovable suspicion lingers that the Ts arose in the first place through some keying device employed in adjusting and locking the mould parts exactly together.

The flanges associated with vessels in flamboyant styles, with many projecting parts, abandon the Ts and vary their profile, pointing it at places with great hooks and spikes. Here the flanges have lost any practical function they may have had, and no longer even allude to it by their ornament. The process is one characteristic of the whole hieratic style, which might be expressed as: necessary technicality → decorated and disguised technicality → independent motif.

Styles in the Western Chou Dynasty

In 1027 B.C. the Shang state was overthrown by the advance of a coalition of peoples from the north-west, under the leadership of the house of Chou. Speculation on the import of this event has long been one of the chief themes of historians and epigraphers. To the art-historian the stylistic change which accompanied it is particularly intriguing. One may read in some recent accounts that the Shang hieratic style continued for a time only slightly altered under the new rulers; and again that a striking break in style is to be seen immediately. The reason for such divergence of views lies in the difference of the art-historian's approach to the problem. If the motifs of Shang art are listed as unit components – dragons and masks of various types, birds, cicadas, *lei-wen*,

whirligig roundels, animal-head handles, various geo-
metric figures – and the occurrence of these is looked
for on bronze vessels that may be safely dated post-
1027 B.C. on the evidence of inscriptions, then the
conclusion is easily reached that the Shang 'style'
survived the Chou victory. Such an analysis, termed
a 'grammar of style', does not necessarily bring out
a change of feeling in representing the motifs, apart
from their formal identity. When one looks at the
early Chou manner, the *stylistic* change as compared
with the Shang practice is really very striking.

This topic has also been obscured by the assump-
tion traditionally made by Chinese historians that the
people of north-west China whose leaders suddenly
found themselves ruling in Honan were inferior in
culture to the Shang, and only rose to the civilized
level of their defeated enemies by imitating all their
institutions, including their art. It was a tenet of
traditional history that the reigning dynasty had a
monopoly of civilization. One fact which throws
doubt on this theory is the superior literacy of the
conquerors, as shown by the long circumstantial
inscriptions which were cast on bronze ritual vessels
from the time of the first Chou reign onwards. These
reveal also a social function of the vessels which has
been suspected to exist also under the Shang, but
not conclusively proven: in promoting meritorious
officers the king read out a laudatory statement, made
gifts, and permitted the recipient to make a ritual
vessel to commemorate the occasion. Later the phrase
'to be treasured in use by sons and grandsons' was
frequently placed at the end of the inscription record-
ing the distinction. The same custom was adopted at
the courts of the subordinate princes among whom
the newly conquered territory was parcelled out by
the Chou king. Thus in speaking of the bronze
vessels of the earlier Chou period (Western Chou)
the pieces made at the Chou court may be distin-
guished from those made at the courts of the feudal
princes, according to information supplied in the
inscriptions. But in the decoration of the bronzes no

differences between the various courts can be affirmed.

There are a number of vessels in which Shang schemes of ornament are only subtly affected, the original designs acquiring a new movement from the multiplication of hooks and frills along the edges of the chief components. On other pieces a simplified scheme of dragons is placed against a plain ground, and much of the vessel sides is left undecorated. This 'severe' style has been described as a reaction from the grotesque, but the difference is perhaps better explained as one of local tradition, the grotesque being a Chou contribution from the north-west. Tangible indications of the arrival of a new tradition of design in central China are many *kuei* with ornate animal handles, often with vertical ribs on the sides, and birds substituted for the dragons usual under Shang. The great *kuei* of the Marquis of Hsing in the British Museum is a class of its own: the elephants vaguely simulating a *t'ao-t'ieh* are unusual, and for the 'austere' style (much of the smooth relief is on a plain ground) the ornament is exceptionally elaborate. The sagging S-profile of its sides is a feature increasingly noticeable in vessels of the early Chou reigns, contrasting sharply with the vertical spring of typical Shang shapes.

16

All these innovations leave the basis of hieratic style unaffected, but the manner in which they are treated, with softer relief and more unified treatment of masks and dragons, is nevertheless alien to Shang work in any of its forms. The suggestion that the change is owed to the arrival of an independent Chou tradition is plausible. No bronzes from the north-western home of the Chou have been dated on secure ground to the pre-conquest period (a time equivalent to the reign of the Shang in central China), but it is quite probable that bronze technique was already advanced in that area before 1027 B.C. We should not expect the iconography of the Chou to differ radically from that of the Shang, for both were included in a Chinese culture of common ancestry. The *t'ao-t'ieh*

and dragon were probably the stock in trade of north-western bronze-casters no less than of the Shang, but the former were more attached to designs of fantastic birds as the basis of extended schemes. Some finds made in Shensi of pieces in an extreme version of the grotesque style raise the possibility that this was a creation of the Chou. Moreover, the Chou style, wherever it is met, moves from the repose of Shang motifs towards more dynamic design.

The Hieratic Style Geometricized

One gains the impression that the art of the ritual bronzes as it was practised from the Western Chou period onwards became in a stricter sense a court style, governed by official conservatism rather than religious prescription. An increasingly geometric treatment of the ornament is to be observed, not so much to diversify the fantastic shapes of the mythical animals, as for its own sake. The dragon frieze so well established in late Shang existed in a number of clearly separated versions. The next step, taken

11 before 900 B.C., was to reduce the dragons – or the birds which had to some extent replaced them in early Chou – to completely non-figurative shapes whose relation to the dragons is only apparent in retrospect. The eye of the animal usually persists, but the limbs and body disappear into a linear figure somewhat

12 resembling two interlocking Gs, with the eye like a bean in the middle. A series of flattened Cs, like over-lapping tiles, marks the latest stage in which distinct units are retained. After that the units blend into continuous undulating ornament, from which allusion to dragon or bird largely, but never completely, vanishes.

Such a process might be regarded as degeneration of a decorative repertory through endless repetition and eventual carelessness and misunderstanding, were it not part of a general change which cannot be denied conscious purpose and intelligible taste. The new abstractions, in comparison with the exuberant

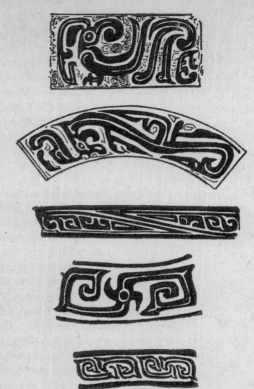

Fig. B. The bird and
dragon motifs of the late
Shang period reduced
to near-geometric forms.
The design third from
the top is sometimes
combined with the
explicit versions, but the
fourth and fifth, evolved
by about 900 B.C., appear
in wholly abstract
schemes.

ornament of the earlier period, indicate a return to
austerity unknown since the earliest Shang work.
Gone are the grotesque and frowning monsters,
replaced by vessels of solid, dignified appearance,
19 not without a touch of decadent elegance. Their sides
are variegated by horizontal grooves, or often left
plain. The urge to fill every available piece of surface,
which dominated in Shang art at the end, was tem-
porarily overcome, even if it was destined to reappear.

*Hieratic Style
and the
Animal Style
of
the Nomads*

During the Western C
of the art proper to
immediate Chinese do
Great Wall, and Inne
from China a bronze
some of the artistic
shops. In this outer 'r
nique had naturally to be su
were produced, the requiremen
calling almost exclusively for daggers,
helmets and other weapons, and for or
fittings for horse harness.

While ideas suitable for these purposes were being drawn from China, the foundations of a new artistic tradition were being laid in this North Chinese steppe, and in similar territories at the other end of the inner Asian zone of grassland. This was the so-called 'animal style' of the nomadic cattle-herders of Central Asia, which, as a form of realism, finds its proper place in the next chapter (see p. 58). Basic to the art is the distortion and stylization of the bodies of *real* animals in the interest of effective overall pattern. Evidently there is a kinship between this treatment of organic form and the habits of Shang design; but the two traditions are nevertheless distinct in principle. Nothing could be farther from the hieratic style than the blend of fantasy with closely observed realism found in the animal style. The contributions which China made to the latter were first filtered through the Northern Zone, which mediated between civilized culture and barbarian much as Panticapaeum in the Crimea was an artistic entrepôt from which the Scythians acquired some elements of Greek art.

In the later Chou period there are frequent coin-
25–7 cidences of motif and design of Chinese style with the animal art of the steppes, both in the eastern steppes and in the far western province of the nomad culture. Sometimes these resemblances are made grounds for arguing that Chinese art was strongly influenced from the steppe. If this was the case it was still not a direct influence that reached the bronze ateliers of central

China. More probably ideas were borrowed from designs favoured in the Northern Zone, where they had been rendered palatable to Chinese taste, and reduced to forms utilizable in ornament of the metropolitan type. To what extent the Chinese were responding to external influences in adopting particular motifs (e.g., the roll-nosed tiger, the ram mask) is rarely certain, all the more since innovations of design in the developing hieratic style itself often seem to meet the foreign motif half way. Such an instance is the adoption of interlacing design.

Interlacing Design

In the schemes of Shang and Western Chou, strands of elaborate ornament rarely intertwine, however near they may come to suggesting this possibility to the eye. The single exception to this rule appears to be in the tails of the large birds which decorate the sides of some wine-buckets of early Western Chou date, and these seem to have had no immediate sequel. Occasionally the abstracted double-G figures overlap, but they do not properly interlace, and the principle is not followed in the standard versions of the linear abstraction. It was not until the seventh century B.C. that interlaced design became established as a regular device. Possibly the casting methods practised in the Western Chou period played a part in discouraging this kind of ornament. If no attempt was made to link separate motifs by interlaced or other continuous elements, it was easier to avoid visible errors in making the mould sections correspond. But a technical factor cannot provide the whole explanation of the initial avoidance of interlacing figures. Other necessary correspondences of ornament over the joints of moulds had for long presented little difficulty. When interlaced design came into fashion, even in ambitious schemes cast on vessels and bells, casting by means of piece-moulds remained the rule. When the lost wax method of casting was eventually adopted – or its use generalized – in the fourth cen-

18

20

tury B.C., it was still not always used for work to which it would appear well suited, as is seen in the very demanding piece-moulding practised at Hou-ma in Shansi.

The change to interlaced rather than merely juxta-posed design of the Western Chou kind would thus seem to reflect an altered taste. From the sixth century B.C. new styles which exploit this principle were established in the majority of the bronze ateliers. Henceforth intriguing complexity in more organic shapes became acceptable for ritual vessels as for other finely wrought objects. In this context the earliest well-formulated style to be considered is that of the Li-yü bronzes.

The Li-yü Style

The majority of the vessels found at Li-yü are decorated with a series of short, ribbon-like units, flat or raised in low relief, which intertwine for short lengths, with here and there an animal mask facing or in profile. This may well be a deliberate revival of the Shang *t'ao-t'ieh* and *k'uei* dragons, which had disappeared from bronze art in the Western Chou period; though it is more likely to be a design adopted into the bronze repertory from ornament previously worked on perishable material. The facing mask lacks the lower jaw, and both it and the profile head have the rolled-up nose of the crouching tiger of the nomads, mentioned above. A limited number of new devices were admitted into the Li-yü style, such as cordons of plaited-rope pattern and realistic *ronde-bosse* animals set on vessel lids. But elements which are later the direct resource of the two Huai styles are less conspicuous. These are the small spiral with an attached hook-like wing which punctuates the bands, mainly at their turns; and the combination of spiral and triangle which is continuously repeated as filling of the bands.

While the typical Li-yü scheme is full of points and strong accents it meticulously avoids the angularity

produced by the junction of straight lines or by inclined surfaces meeting at a straight line. This smoothness of ornament matches the rounded and subdued profiles of the bronze vessels – chiefly the tripod bowls, *ting* – on which it appears. If any relief is allowed at all it is natural for a decorative scheme so infected with spirals to raise these into brief concave and curving surfaces. This is found in Li-yü designs much as it is in the late La Tène style of Celtic Britain. Such mannerism may be only the regularization of an effect produced originally in carving wood with a knife. The 'chip-carved' style of some gilt-bronze belt-hooks of the Han period certainly arose from the transfer to bronze of a wood-carving technique.

The location of the Li-yü style in Shansi raises the question of the rôle of provincial foundries in the progress of hieratic style, in contrast to the official manner of the Chou court and the princes' courts, which at first adhered to the orthodox ornament of bronze. Recent discoveries have corrected an old view of the virtual universality of each official version of the style. In the provinces of Kiangsu, Anhui and Hopei have been found ritual vessels with ornament closely related to that of the ateliers of the Shang capital, but still sufficiently individual to be easily distinguished from the strict metropolitan manner. In these cases we must assume the existence of provincial foundries where the repertory of ornament was treated with some independence.*

In the ninth and eighth centuries local varieties of vessels and ornaments were multiplied, some of the products being transported a considerable distance from the place of manufacture. The Li-yü bronzes demonstrate one such local style which rose to a dominant position. In it were incorporated realistic elements – the ram masks and modelled animals –

* On the other hand vessels found as far south as Hunan follow the Anyang designs so closely that they may be taken to be exports from the capital.

which existed in local animal art allied to that of the
steppe nomads farther north. The interest in inter-
lacing design must come from the same local source,
although this device is rare in animal art as a whole.

The First Huai Style

The Li-yü designs were comparatively short-lived,
being replaced soon after 500 B.C. by the Huai style,
which was brought to standardized and enduring
form in Honan. The beginnings of Huai style are
related to Li-yü, but it cannot be asserted that they
derive directly from it. The name it has been given is
misleading, for the style was not confined to the
basin of the Huai river. This comprises the province
of Anhui, lying south-east of Honan, in the direction
which it was natural for cultural influences from the
inventive Honan centre to take. Until its conquest
by Ch'u in 741 B.C. the Huai valley was in the terri-
tory of the state of Wu. Near the important Wu city
of Shou-hsien two large mounds, one plundered in
1936, and the other excavated in 1955, have yielded
numerous bronzes. But these are for the most part of
inferior workmanship. Far from suggesting that
Shou-hsien was the place where the new style
originated, they rather show up the Shou-hsien work
as provincial versions of pieces that were better made
elsewhere. Again the source of the innovation lay
farther north, in Honan and Shansi.

The earliest phase of Huai style is exemplified in
perfection by a large bronze bell in the British
Museum. Its close connection with the centre of
Li-yü workmanship is seen in the fact that the double
dragon handle is matched almost exactly by a clay
mould excavated at Hou-ma. Many Li-yü details
recur: the scaly and granulated bodies of animals, the
wing-and-spiral element of the Li-yü dragon band,
here and there the spiral-and-triangle. But as a whole
the dragons are much more ambitious in relief and
elaboration. Above all the wing-and-spiral, pictur-
esquely shaped as in the fully realized Li-yü

convention, or reduced to a mere hook-and-volute, is
multiplied till it dominates the design. It imparts a
restless movement which tends to obscure the out-
lines of explicit figures.

This motif, the hallmark of the Huai style from the
fifth to the third centuries B.C., is at first applied to
animals' bodies, usually at the joints of limbs, the
roots of wings, and the head. Its origin may be sought
in a mannerism which arose in the later devolutions
of Western Chou ornament, but in Huai work it
assumes a particular role as symbol of the vivid
21 movement and supple articulations of animals —
qualities which the Chinese attributed above all to
dragons, inhabitants of water and cloudy air.

The bell was excavated from one of a group of
tombs located at Chi-hsien in Honan. It is probably
the work of a bronze foundry in North Honan, or
possibly in South Shensi, at Hou-ma. The ornament
is more varied than the average of work executed in
the style, which suggests that Honan or South Shensi
rather than some other more southerly region was
the place where the Huai motifs were first designed.
How far the manufacture of the bronzes continued
to be concentrated there is not certain, for the pro-
ducts were fairly widely dispersed, but the numerous
bells and vessels found at Shou-hsien indicate that
here at least was a subsidiary foundry active soon
after 500 B.C. Its products are inferior in finish to the
Honan bronzes, the ornament less imaginative. The
inelegance of the heavily contoured tripods placed in
the Shou-hsien tombs has been attributed to the
semi-barbarian taste of the rulers of the Ch'u state.
More properly it may be said to reflect a local design
followed since the early decades of Chou, when *ting*
tripods of the same ponderous type were made,
devoid of the Shang finesse.

The Second Huai Style

In the fourth century B.C. Huai-style bronzes must have been manufactured at many places in central and east China. The style can now be seen to have entered a second phase, in which its application is expanded while its content is reduced. On the decorative parts of weapons, belt-hooks and chariot parts such as axle-caps, the hook-and-volute motif is used pervasively, and animals' bodies are adapted to it, though these are generally less ambitious than the dragons and tigers which heralded the style a century or more earlier.

24

The casting technique displayed in later Huai work is still so admirable, the skill of ornament wrapped around utilitarian form so beguiling, that the eye overlooks the impoverishment of the style. But it was not only the insouciance of bronze founders that finally reduced the basic motif to a mere wart with a vague attached line. The motif had finally lost its dynamic character and was reduced to the conventional variegation of a surface. This line of development came to a full stop, but not before another manner, by origin related to it, had been formulated, and directed artistic invention into another channel. The new style is justly termed geometric.

The Late Chou Geometric Style

The schemes which dominated the bronze and lacquer work of the late Chou period, in the later fourth and third centuries B.C., recapture the Huai vision in a new key. Basic to the new schemes is a tight spiral associated with a sharp-hooked figure approximating to a narrow-based isosceles triangle. This motif can be explained either as a linear reduction of the original wing-and-spiral, or the promotion to principal place of the detail filling the bands in typical Li-yü schemes. Both procedures are characteristic of the artistic methods of the Chou period. It would be hardly possible to determine which was followed

here, both being variants of a rhythm fundamental to the decorative vision.

But once the way was open to purely geometric elaboration, and the connection with animal form and pseudo-organic design forgotten, new motifs could be rapidly developed. The triangles were mostly reduced to angled lines darting from one 31 spiral complex to another, their large leaps articulating the areas of detailed interest. As we know these designs today they appear executed in silver inlaid in bronze, or painted in lacquer pigment on lacquered cups and receptacles for wine. The designs usually contrast broad lines with much narrower lines, producing a double register seldom interrupted by intermediate breadths. They fall broadly into two groups which appear to be successive phases. In the earlier, the repetitions of the design do not produce symmetric units, the sense of movement being very strong. The later phase of design, while not altogether losing the sense of asymmetric balance, tends nevertheless to arrange the parts symmetrically about frequent vertical axes. As a result the designs tend to a heraldic staidness, and once again the original inspiration fades.

Mirror Design Ornament applied to the back of bronze mirrors stands apart from what has been described, although it still falls into the category of geometricized ornament. Two pre-Han traditions of mirror designs have been distinguished as the Shou-hsien and the Loyang schools, because the earlier archaeological finds tended to associate one of the styles with each of these places. There is no doubt however that the mirrors (particularly the Shou-hsien type) were cast at a number of other places in central China. Both styles adopt the principle of placing large explicit motifs on a ground of Huai diaper. At Shou-hsien this is the hook-and-volute motif, caught at an early stage of its evolution, whereas at Loyang it is the

spiral-and-triangle of Li-yü detail, often elaborated
29 into a variety of key-fret and rhomboid patterns.
The Shou-hsien mirrors make use of small figures of
animals (rather naturally drawn), fleurets (including
the water-chestnut), and some peculiar devices such
as 'flails' (a rondel with a paddle-shaped appendage
bent at a right-angle) and the mountain symbol. The
latter is so-called from its resemblance to the Chinese
ideograph, being something like a 山, but perhaps it
is taken from the pattern of twilled cloth, as certain
diamond figures certainly are. The latter may have
zigzag sides.

At Loyang mirror makers favoured leaping animals
which have clawed feet and dragon-like heads,
although they bear little resemblance to earlier
dragons or the conventional shapes of animal art.
The body of the animal may be almost entirely
abstracted into a zigzag lozenge pattern with the
same affinity to woven design as the Shou-hsien
mountains. The ornament bequeathed to the early
Han dynasty by the Loyang tradition shows stylized
birds or dragons in a continuous band of scrolled
lines decorated by excrescences representing clouds,
the older zigzag lozenges still appearing here and
there.

The Han Animal Style

Many of the representations of animals belonging
to the period from the second century B.C. to the
second century A.D. show conscious effort towards
realism, being quite liberated from the conventions
of the animal style. But when effigies of unreal
animals had to be made, old models were re-
fashioned, still in the geometricizing style. Of these
the most frequent are the animals symbolizing the
three directions: a tiger denoting the west, a dragon
the east, and a fabulous bird the south. The pacing
tiger was cast in bronze towards the middle of the
Han period, when it already had begun to acquire
39 the wings and horns which suggest an influence

from Iran. The most impressive works are life-sized carvings in stone which were first executed in the last decades of the Eastern Han dynasty, and became the regular guardians of royal·tombs in the third and fourth centuries. Achaemenid griffins and Sasanian lions seem to have influenced the type, but the noble stance and tense lines of the Chinese chimaeras are a native heritage.

The evolution of the hieratic style may be seen also as a gradual secularization of designs which had initially a strong ritual association. At first the discarding and alteration of the forms of vessels are surer signs of the declining claims of the ancient ceremonial than the devolution of the ornamental motifs. The latter retained their status long after the archaic wine-holders and goblets, food-vessels and zoomorphic vessels of the Shang and early Chou periods had been replaced by plainer and more sedate forms, having less of sculptural surface and contour. By the mid fifth century B.C. the application of the Huai style was so general that hardly any conscious connection of ornament with ceremonial can have existed. Because there was no other, this style still however did duty on bells and vases used in the performance of ritual. Complete secularization seems to have been reached at the opening of the Period of the Warring States, when bronze became more widely available. At this time the support which the old feudal organization of the states had given to the maintenance of hieratic art was at last greatly relaxed, if not quite abolished, and everywhere the seeds of social change were being sown. It was not however until the Han period that a considerable change in the social order produced a demand for realism in art which at last ousted the hieratic tradition completely. This caused the most rapid and fundamental revolution which occurred in the history of Chinese art.

Chapter 2

Realism

Chinese representations of persons and animals are mostly very lifelike. If we press the question, exactly how much of realism, or verisimilitude, is to be found in Chinese art, judgements will differ, since impressions of this matter are apt to be subjective. If we mean by realism the utterly faithful reproduction of real things – like some Japanese work which almost frightens by the thought that for artistic ends anyone could observe with such utter objectivity – then the answer is simply that the Chinese have paid little heed to literalism of this kind. Chinese critics have always stressed the duty of the artist to penetrate to the reality of the subjects he portrays, whether these are living beings, or dead matter, though even in the inanimate world nothing was thought of as inert.

No Chinese artist would have disagreed with the view that things represented 'should appear to those who look at them to be extremely like real natural forms'*, but his opinion on what constitutes reality would differ considerably from what has been said on the subject in the West. Some Chinese comment on the European style, as it became known through the Jesuit artists at the court of Ch'ien Lung, is enlightening on this point. Tsou I-kui (1686–1772) was in his way a modernist who rejected much of the high-minded aesthetic doctrine of traditional criticism, but he had no sympathy with the Western manner: 'Their perspective and chiaroscuro are

* Alberti.

banalities of artisan realistic painting – in painting of worth there is no place for them.' At the Ch'ing court appreciation of the work of Giuseppe Castiglione was qualified, although it was recognized that no other occidental had succeeded so well in combining the Western and Eastern styles. His beasts and flowers were good, his horses excellent, but 'neither the line nor the colour are sufficiently powerful'. The Jesuit 'excels only in the resemblance of the form of things'.* Chinese painters on the other hand had been exhorted since time immemorial to identify themselves so completely with the essence of their subject that exact rendering of its outer form became not only unnecessary, but positively damaging, to the interpretation of their reality. 'Subjective realism' of this kind was and remains an unshaken tenet. It is particularly insisted upon as the basis of style in the language of the scholar painters who worked in the great anti-academic movement launched by Chao Meng-fu and his colleagues in the Yüan period.

What Chinese artists have always consciously aimed at is an *illusion* of life. To that end they have accepted any degree of distortion of real form which is not so great as to outrage the viewer's sense of the coherence of the external world, according to the latitude allowed in a given historical period and by an average individual. Illusion of this kind can usually be achieved without over-much attention to detail, and it certainly does not call for the literal copying of all the parts. Vital form is substituted for imitative form. By the Chinese these two approaches to artistic representation were never distinguished theoretically or practically. But in our sense of producing work extremely like real natural form, there are interesting changes to be seen in the course of time.

A great cycle of the unreal is offered by the pre-Han hieratic style. Some of its later dragons look lively

*C. and M. Beurdeley, *Giuseppe Castiglione*, Lund Humphries, 1972.

enough, but they draw a fictitious life from the dynamic of a uniform linear style developed in large schemes; the suggestion of unpredictable movement so essential to the vital illusion is absent from them. Apart from the hieratic style however we detect a tradition of realistic art which was forced off the stage by the dominant position of the hieratic bronzes in pre-Han work that has come down to us. Even pieces that may be singled out to support the argument for the existence of a realistic style are themselves subject in varying degree to the distortions practised in the prevalent hieratic style. Their makers nevertheless intended to capture an aspect of living matter, and that was enough to set the work apart artistically.

How far this realism is to be attributed to a sub-merged, primitive practice of art which Shang civilization deliberately excluded is an attractive speculation. Some realistic carvings of animals are found among the southern population, in the state of Ch'u, but it is uncertain how far the makers of these things served a public isolated from the mainstream of culture in that part of China. Moreover, many of their products are decorated in a manner as stylized and abstract in its way as the art of Shang.

Realism in Shang and Chou The Shang conventions governing ritual vessels were occasionally applied also to stone statues of animals, and in one case at least to the figure of a seated man. 34 Studiously ignoring natural proportion these works give no hint of life, the sculptor's main preoccupation being to ensure uniform surfaces on which the schematized motifs of the bronze art could be inscribed. Yet examples survive of a realistic formula for the human face. It varies so little from one occurrence to another that it might almost be classed with the hieratic repertory, but it is natural enough, with no addition of linear ornament. The face is singularly coarse, and perhaps for this reason alone it has been thought that it represents an inferior subject, a slave

or prisoner destined to be killed as an offering to the gods.

A four-legged *ting* adorned with this visage on all of its sides perhaps corroborates the theory of sacrifice, since the image of the creature to be slaughtered was sometimes cast on the side of a ritual vessel in the midst of the regulation ornament. When the victim is thus represented, in the case of ox and deer as well as the hapless prisoner, the style is realistic, and it looks out of place in its context. Life-like images were not beyond the powers of the Shang artist, although their application to his work was controlled strictly by ritual usage. In the case of the human faces, the smaller motifs disposed on either side derive from parts of the exploded *t'ao-t'ieh*, but they omit the branching grooved lines which normally break up their surfaces. Such was the feeling for the congruity of the whole scheme that the smooth expanses of the human masks had to be imitated in the remainder of the ornament. Were it required, this would be a further argument for the deliberation and sophistication of the hieratic style.

It is to be expected in a chariot-minded city state that the horse should attract the artist above all other animals. Its value may be judged from the lack of any suggestion that it was ever killed for the gods, except indirectly when chariots, complete with their pair of animals and pair of soldiers, were buried in consecrating a sacred precinct, temple or palace. The charioteers were usually furnished among other weapons with a short curving knife cast with a pommel which often takes the shape of a horse-head, interpreted with unusual realism and sensitivity. The horse is the low steppe breed which alone was available to the Chinese at this time, and its blunt head and stolid expression are well caught in miniature. At the close of the Shang period the horse-head was used also as an ornament to be fixed to some part of the chariot, and in this case it is covered with the tendril-like lines of the standard decoration, which does not however detract from its lively presence.

Another ornament of the knife pommel was the head of an ibex. Its treatment is more abstract than that of the horse, being sometimes turned into a combination of a number of circles for horns, eyes, nostrils. The chariot burials in which the knives are mainly found at the Shang capital belong to the last decades of the dynasty, and among the bronze ornaments mounted on the chariots were some decorated in a style differing from the typical Shang iconography. Possibly the chariot was developed in northwest China, the original home of the Chou (the modern Shensi province), where the terrain is more suitable for horse breeding. It is an interesting but admittedly still tenuous speculation that the realism of the knife pommels may reflect an art native to this region. The ibex head resembles others made subsequently in the sphere of the animal art of the Central Asian steppes, of which more is said below.

In Chou China the human figure fared badly even when no religious prejudice got in the way. Since the images are mostly of serving men, placed in tombs as substitutes for the unfortunates who formerly had to accompany their masters to the Yellow Springs, there is seldom reason for the sculptor to attempt to show them in movement. Two bronze acrobats of the fifth

Fig. c. Cart and chariots engraved freely with a sharp point on a fragment of thin bronze. The three-pointed headgear is like that worn by Taoist deities in later representations, and here suggests that the theme is a religious procession, or a scene in a Taoist paradise. The flying crane, a familiar of the immortals, points to the same. The horses disregard the stumpy proportions of the Chinese breed of the pre-Han period; the allusion of their zebra bands is lost.

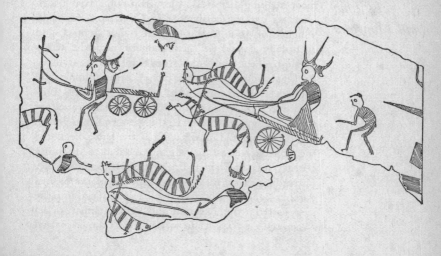

or fourth century B.C. are exceptions which prove
35 the rule. They are about to go into action, and are
depicted with a touch of humour, but their propor-
tions are no less lumpish. These figures are never-
theless not naïve designs. One may suppose behind
them a widely accepted and rather uninspired conven-
tion of the human form. On the other hand some
drawings scratched on bronze, of age about equal to
the wrestlers, introduce us to realism of the most
naïve kind. The carts and people are present in
profile, but the horses appear to be on their sides,
the backs of each pair turned towards the shaft.
Apart from a mythological interest (two of the
figures wear the triple crown of Taoist deities) it is
worth noting that horses harnessed to chariots are
represented in a similar fashion on many Shang
bronzes in the emblematic characters which are
believed to stand for clan names.

Realism in the Animal Style of China and Mongolia

After about 800 B.C., through the remainder of the
Chou period, may be traced the development of a
repertory of animal design endowed with con-
siderable realism, although the motive behind its
most striking features is far from objective truth.
Here we see the equivalent in China to a tradition
which took root in the Central Asian steppes, and
eventually spread at the hands of nomadic tribes
through all the grasslands from Kansu to the Crimea.
As was suggested above (p. 43), the animal style
appears to be compounded of many elements bor-
rowed from the high civilizations established at either
end of this vast territory. In the western Chou period
China contributed motifs such as the hawk-head and
the wolf-bent-in-a-ring, which are dated to the ninth
century B.C. in Shensi. From the sixth century B.C.
onwards, artistic ideas – the griffin and the animal
combat – and weapon forms were introduced into the
steppes from the Assyrian and Persian spheres. Be-
tween these two poles in east and west the borrowed

cultural items diffused so rapidly that their move-
ment from one region to another can hardly be ascer-
tained by archaeology. The extent to which China
was involved with the animal style as giver or re-
ceiver is still debatable. The movement has often
been explained as a wave of Iranian culture rolling
east to break on the north-western marches of the
Chinese empire, but this underrates the influence
which China exercised on Central Asia through the
mediation of nomadic peoples inhabiting the eastern
steppes.

The flat bronze ornaments of the nomads add
geometric ornament to the bodies of animals, pre-
ferably show them locked in combat with griffins or
tigers, incongruously add to one animal some parts
of another, represent the violence of the kill by
twisting the victim's body through a half circle. None
of these themes occurs in China, but a certain feline
with rolled snout and crescent claws is present there
from the eighth or seventh century B.C., and is later
ubiquitous on the steppes. A pair of tigers with the
crescent claws but not the curl of the snout, in the
collection of the Freer Gallery, look like ancestors of
all the later animals. The bodies are hollow, and there
are openings in the back, features which class these
bronzes with the sacrificial vessels. The ornament is
of abstract figures deriving from the geometricized
dragons of the hieratic style, the motifs on the
shoulder and haunch sketching the beginning of a
spiral. In the ancient Near East as well as in China
this device for suggesting the muscles of the limbs
is very persistent. It may still be seen on the lions of
the Persepolis frieze. What connection may exist
between east and west to explain the coincidence still
eludes us, but the paternal relation of the Chinese
tiger of the Western Chou period to those which
follow it both in China itself and in Inner Mongolia
appears to be certain.

This is an important conclusion regarding the
origin of the eastern component of the animal style.
At least one important motif is seen to issue from the

Chinese realm of hieratic style. But in general the development of animal art in Inner and Outer Mongolia is independent of the metropolitan tradition of China, though it runs parallel to it and from time to time fertilizes it with fresh ideas. It also stimulated realism in the portrayal of animals. Many of the designs seen in China from about 600 B.C. onwards (i.e. from the inception of the Li Yü style) have affinities with the steppe art. This is not a response to influences reaching the eastern steppes from the Near East – the Scythian art of south Russia and its Iranian counterpart – but the result of continuous exchange between Central China and the Northern Zone of the Chinese sphere. In China animal shapes were stylized in forms compatible with the conventions of the Huai style (which were discussed in the previous chapter) and naturally they cease to reflect the ideology of the nomad and the hunter to an equal degree.

23a, 24a, 25, 27

What impressed itself most upon the inhabitants of the grasslands of inner Asia was the skill and splendid ferocity of the attack by predatory animals on gentler or domesticated species. In a sense this combat symbolized the incursions of the nomads themselves into the territory of their civilized neighbours, and their contempt for the sedentary occupations of farmers. In depicting these subjects their vision is peculiar to themselves, inherited from the remote past of inner Asian culture. Design is conceived in two dimensions, and is subject to preconceptions of abstract shape: curves, spirals, triangles, sharp returns of line, into which the animal anatomy must be fitted to make it worthily expressive, and the whole design is distorted to compose a crisp outline intended to please as mere shape.

The animal style of Mongolia, the art of the Hsiung-nu people who so sorely harassed the Chinese on their north-east frontier from the third to the first century B.C., adds features of its own: grooved lines, pear-shaped dimples and many spirals. Its multiplication of bird-heads, as a kind of filler ornament, is in keeping with the practice throughout Central Asia,

while the mysterious addition of unnecessary snakes to a few designs is a local speciality. A pure version of animal style was introduced into the territory of China proper when Hsiung-nu tribes occupied the Ordos region within the great northward loop of the Yellow River, during the late third and the second centuries B.C. Examples of this art of tigers and horses, deer and griffin-headed quadrupeds, fighting and under attack, are to be seen in many western collections of Chinese art.

37, 38

Barbarian Realism in Yünnan

A very different branch of the animal style is found during the second and first centuries B.C., in a barbarian kingdom in the mountains of Yünnan (the south-eastern province of China) which is the subject of an improbable story recounted in a history written in the Han period. Chuang Ch'iao, a general of the southern Ch'u state and descended from one of its kings, is said to have been ordered to campaign against the Yünnan kingdom of Tien in the 330s B.C. When he and his army wished to return to Ch'u they found their way barred by an army of the north-western state of Ch'in, which had advanced across their route. So Chuang Ch'iao and his men returned to Tien, where the general reigned as king and the men by taking local wives founded a semi-Chinese population and culture. In this way the rulers of Tien and the Chinese emissaries who visited them in the early Han period explained the strange medley of Chinese and barbarian custom to be found in the kingdom. Wu Ti of Han threatened to attack, and Tien wisely made its submission. Its king was appointed for a time as a client ruler under Chinese protection.

The achievement of Tienians in casting animal figures in bronze ranks them with the best animal artists of any time or place. The compositions are mostly plaques in high relief which gives the impression of sculpture in the round. The finest of them

40 portray the animal attack: leopards seizing a boar,
hyena-like creatures bringing down a deer. It is not
by chance that this theme is so prominent in Tien art.
Some of their weapons show a connection with the
culture of the nomads living over a thousand miles
to the north in an entirely different environment, and
from them too must have come the custom of repre-
senting animals locked in combat.

Across inner Asia this motif can be traced at
intervals of space and time from the outskirts of
Assyria, where it first appears in the sixth century
B.C. The version which reached south Siberia, in the
fourth century B.C., as the motif travelled eastwards,
shows felines attacking an elk, whose body is twisted
through a half-circle at the middle, and the same
convention is sometimes seen in Ordos art. But for
the Tienian no such departure from reality was
acceptable, and his energies were bent on accuracy of
shape, taut muscle and ferocious expression, the
animals' coats, and convincing postures of the writh-
ing bodies. But one detail could seldom be omitted,
for some reason of mythology: a biting snake is
involved in the fight.

Realism of this order is not to be found in the con-
temporary art of civilized China. It is in place with
the semi-nomadic tribesmen of Yünnan. The pre-
occupation of the Tienian with what must be called
41, 42 *genre* subjects is however more surprising, and far
from characteristic of primitive art. On the top of
drums converted for use as containers of cowrie shells
(i.e. money) populous scenes of battle and village
festival are portrayed by lively bronze figurines and
house-models cast in the round. Both the personality
of individuals and their mutual relations are seized
with the same keen eye that observed the animals. An
engraving on another drum, showing a ceremonial
procession of villagers with a chieftainess and hunting
leopards, is a graphic version of the same style.
Mounted on weapons are beautiful miniatures of
animals, and figures of dancers and of tribesmen

coming to market are studies of human types. The
bronzes of Tien fall at the end of the second and the
beginning of the first century B.C.

Realism
in the
Han Empire

We now return to metropolitan China and a rather
earlier time, for the first evidence of realistic portrayal
in sophisticated circles of the empire belongs to the
eighties or seventies of the second century B.C. A
tomb of that date at Ch'ang-sha in Hunan containing
the artificially preserved body of the noble lady
T'ai has preserved a painting on silk in almost perfect
condition. It represents the world of the afterlife,
spirits and dragons of the air mounting to sun and
moon, and the genies of the underworld. In the midst
of this are two scenes of figures showing a lady with
attendants receiving something offered by two kneel-
ing servants; this is presumably the lady T'ai herself;
46 and the other scene shows her wake with the painted
coffin in the background. The figures are in profile,
and in order to suggest recession in space are put
merely in a row, each masking part of the one behind.

Six portrait painters of the early Han are recorded
in later writing. Their technique, if we may judge
from the tomb painting, was simple, concentrating
on the figure in profile or three-quarter face, but a
considerable space of time must be supposed for its
development. Realism of this order must therefore
extend back into the pre-Han period, from which
hardly any direct evidence of it has survived. In the
elaborate composition from Ch'ang-sha, dragons and
cloud-scrolls follow the norms of decorative art of
the Western Han period, while the ornament painted
in colours on the sides of the coffin is wholly con-
servative in taste, conforming well with the art of
the previous century. In passing we may note a con-
trast with the contents of noble tombs such as those
of Prince Liu Sheng and his wife, which were re-
cently discovered in Hopei. There no hint of *genre* or

portrait art is to be found. In courtly circles such realistic painting was probably held to be unceremonial, if not downright vulgar.

The progress of painting in a realistic idiom is not well documented again until after the end of the Western Han period; but under the Eastern Han, in the first and second centuries A.D., it can be very fully illustrated. Now a taste for realism begins to invade even the most ordinary ornament. This is seen in the lacquered cups and boxes which issued from government workshops, whose earlier work will be discussed below as one of the palace styles. Examples of these products excavated from tombs of the Chinese garrison settlement at Lolang in north Korea, which was founded in the late first century B.C., illustrate the change. Pieces with inscribed dates lying between 43 B.C. and A.D. 71 are decorated with geometric designs. But a circular tray made in the West Factory in A.D. 69 is plain save for small figures of deer and a pair of celestial beings riding through the air on a cloud. Convincingly real pictures begin to supplant the ornamental schemes of tradition. Such innovation marks an important watershed between the old world of art and the new. During the remainder of the Han period the Confucian official was destined to impose new standards in art no less than in political affairs.

Throughout the Han rule the bureaucracy had swelled its numbers. It was drawn in the main from a class whose interests largely coincided with those of the great landowners, and whose education was based upon the Analects of Confucius and the other classics. The process of unification initiated by the Ch'in emperor had entailed the destruction of the old nobility, or the drastic curtailing of its power. Such men as the prince Liu Sheng, whose tomb has been mentioned, were shorn of all real power: he was a brother of the emperor Wu Ti, but, as his only office, held the fief of territories in Hopei. This was not a politically sensitive area, and the prince seems not even to have held the post of governor.

To the taste of an official class of civil and military officers as a section of society newly risen to power and self-consciousness may be attributed the *genre* tendency which appears in Han pictorial art of various kinds during the first and second centuries A.D., and virtually ceases with the collapse of the empire in A.D. 220. Pictures painted, carved on stone, or impressed on bricks, become the normal decoration of the tomb walls of great officials. Mirroring a new intellectual life, they depict the culture heroes of an official pantheon – legendary emperors and mythical personages given similar rank – and a selection of Confucian anecdotes. In a strange contrast with these are the deities, genies and familiars of the Taoist spirit world which a gentleman could now respectably acknowledge. But the pictures include also many subjects taken from the real world. In history the dramas of attempted assassinations and noble rescues make the chief appeal, and scenes that might be witnessed on a gentleman's estate, or in factories in his care, are drawn with close attention to detail. In later times the Confucian, like the Platonic philosopher, was notoriously aloof from practical and industrial occupations, but under the Eastern Han these received unprecedented attention, and elicited new skills from the artists who were called on to portray them.

The best known examples of this work, belonging to the earlier part of the Eastern Han period, are a series of some scores of large bricks found at Yang-tzŭ-shan, near Ch'eng-tu in Szechwan, on which the pictorial decoration is pressed from moulds, so as to stand out in relief. The most striking trait running through them all is the movement imparted to the 53, 56–60 subject, whether it is a speeding carriage, galloping horseman, revels at a feast, or harvesters gathering the rice crop. One composition attempts to show the 60 derrick of a brine-well, in front of a row of stereotyped hills inhabited by wild beasts and huntsmen pursuing them. Elsewhere industry is represented by iron-founding and weaving.

In these compositions the journeyman artist work-
ing for tomb builders must to some extent reflect
standards observed in the sophisticated painting of the
time. The relations of persons standing together are
better shown than in the Ch'ang-sha silk painting, and
lifelike movement is caught with a few strokes. When
a number of figures or objects are to be understood as
occupying space in groups behind one another, they
appear in successively higher positions, on a plain
56, 57 ground, no guide-lines being deemed necessary to
suggest the desired perspective. Receding lines of
persons are placed obliquely in the field. In neither
case is there any reduction in size for the more dis-
tant elements of the picture.

The treatment of a long object which projects into
space on the line of sight is seen well in the drawings
53 of carriages: the obliquely receding parts are repre-
sented by parallel lines corresponding to the parallel
sides of the vehicle. The people are posed in profile
or three-quarter face. The legs of the horses are in an
unreal position, as if each were leaping instead of
trotting; but this is still not the 'flying gallop', with
all legs outstretched, which soon became the fixed
convention for a saddle-horse, departing yet farther
from truth.

One may deduce from other tomb pictures that
the painting style which lay behind the Szechwan
storied bricks was not the only one practised at this
time. In Shantung, where all that was traditional
Chinese culture might be found best preserved, the
celebrated stone tomb shrines of the Wu family show
another manner of rendering scenes which, in part
at least, intend to represent the real world. The tombs
extend in date between A.D. 147 and 167. Cut in very
low relief on the polished slabs of dark stone forming
the walls of the offering chapels, contiguous horizon-
tal friezes depict subjects which fall into the three
classes: Confucian, historical and Taoist.

In the first category are stories from the Analects,
such as the one about a passerby who noticed Con-
fucius in his house and said: 'He has courage, the

man who sits playing on the musical stones, but he is too stubborn – if no one will appreciate him, let him be resigned.' Models of filial piety, fidelity and chastity abound. We are offered for thought the man of Lu who, failing to recognize his wife on returning from a journey, made an improper proposal to her as she gathered mulberries, and later rejoiced at the rebuff he received. Legendary emperors, adopted as the earliest rulers in the dynastic lists first regularized under the Han, are paraded with the inventors of writing, fire, agriculture, etc., the whole constituting a pantheon of semi-divine beings proposed for veneration by officials. The Five Emperors, heading the list with the Three Sovereigns, are joined by Nü Wa and Fu Hsi. These latter, female and male, have fish-tails which intertwine, and hold respectively a set square and compasses symbolizing their rôle in preserving the world and sustaining it by instituting civilized life. They had been adopted in contemporary philosophy also as representatives of the dual forces of Yin and Yang, which were posited as the dynamic principles behind all natural phenomena.

47

The Shantung style possibly indicates painting less completely executed in line than the style implied by the Yünnan pictures. As they appear carved in stone, individual figures present massive silhouettes, on which some internal detail is shown by engraved line. Garments and head-dress are spread out with the artificiality of fashion plates, probably indicating the identity of their wearers by details which now escape us. It may be argued that the difference of medium produces a dissimilarity which did not exist in the originals. Yet in contrast with the bricks from Szechwan, the Shantung pictures look solemn and immobile in the way of religious painting. Even the most dramatic of scenes, the attempt made on the life of the Ch'in emperor by Ching K'o, who hid his poisoned dagger in a rolled map, is posed as if it depicted actors in a mime. It would not be surprising if these images were closer than others to the style of the paintings with which history tells us the palaces

47

of the time were adorned. These seem to have included portraits of past emperors, and probably great events in their reigns were similarly recorded.

The scenes on the walls of the Wu chapels show also subjects taken from a Taoist lore which apparently was not yet current in the early years of the dynasty, when the Ch'ang-sha silk was painted. A pantheon is imagined independent of the Confucian heroes, and dominated by twin deities, male and female. Hsi Wang Mu, Queen Mother of the West, and Tung Wang Kung, Royal Duke of the East, preside over paradises of immortals; but as in all Chinese mythography, west prevails over east, and it is the queen enthroned in triple crown who appears oftenest. The *Classic of Mountains and Lakes,* which supplies the earliest description of her, speaks of a 'form like a human being, with the tail of a leopard, the teeth of a tiger, good at roaring, hair dishevelled, and crowned with a *sheng*'. It was Hsi Wang Mu whom the emperor Wu of Chou had visited during his magical journey to the western mountains, and the romantic philosopher Chuang Tzŭ had credited her with knowledge of the Tao itself, the Way which was the goal of all philosophizing. The immortals who attend on these fairies fly with their own wings (they are the 'feathered men'), or ride on chariots drawn by winged quadrupeds with serpents' tails.

As in poetry, so in art, the Taoist theme releases fantasy of a kind unparalleled in any other period. Processions of dragons and banner-carrying horsemen move through clouds, immortals ride to battle astride fish. The Shantung pictures are a compendium of Chinese mythology, not all of which can be explained from the fragmentary versions of the stories which survive. Unhappily this vivid narrative painting had no sequel. Only the narrative pictures of Buddhist wall-painting flourishing in the fifth and sixth centuries can be compared with it.

The few examples of actual painting which survive from the Han dynasty corroborate the distinction made above between the styles of the Szechwan and

Shantung tomb decorators. The combination of line
with areas of solid colour which is surmised from the
reliefs of the Wu chapels corresponds to the paintings
decorating the sides of a lacquered basket found at
Lolang. Men seated on the floor and wearing court
costume (one sees the strings beneath the chins which
hold on the ceremonial caps) fill narrow panels on the
sides of the basket, painted in black, yellow and ver-
milion. Their gesticulation and expression convey
perfectly the nervous tension of the conversation they
are engaged in. One of them is labelled 'envoy' and
the rest are high officials. They are depicted with
some humour – evidently the envoy's request is de-
licate, and he waits apprehensively while a mediator ex-
plains the matter to an important personage. A screen
standing on the floor is painted with a large cloud
scroll, in the decorative style of the previous century.
Other panels portray men standing, their improbable
gestures humorously exaggerated. The detail of faces
is executed in fine line, while the garments are done
in wider bands of colour.

Here the handling of the brush contrasts with the
manner seen in some figures painted on brick, on
which the longer and tenser lines indicate a rather
later date, and a change in the artist's approach to his
work. The lines on the brick reflect natural move-
ments of the hand, and are subtly inflected. A varying
thickness of the line, answering to changing pressure
on the brush point, begins to transcribe something
more than the silhouette of the figure. The inner
curve of the sleeve is thickened and so detaches itself
a little from the background. Natural curves of
unbroken lines suggest the volume of forms, while
crisp angles at places where the line changes direction
give a pleasing tension to the contour. This is the
first sign of the manipulation of the brush in the
manner which became fundamental to the Chinese
style, a method both expressive and decorative.
Chinese theory was to claim that the correct outline
conveys all that is necessary of the third dimension,
that the soft point of the brush responds to the

55

54

painter's impressions as intimately when he paints human figures and objects as when he uses it in writing.

T'ang Realism

Between the Han and T'ang periods calligraphy was refined to an art that came to be regarded as the most direct revelation of personality and artistic sensibility. Indeed the Chinese tradition of art criticism begins with speculation on the mental process involved in visualizing a character of the script in the mind's eye before writing it with the brush. In using an ideographic script an effort of memory is often required to recall the shape of a character. If the writer is making also a conscious effort to produce a *beautiful* ideograph, what determines that beauty as distinct from the recollection of the order of strokes, etc.? Spontaneity was rated the prime virtue, and rapidity in execution a guarantee of spontaneity.

In this atmosphere of speculation and debate the art of painting was gradually moving towards the kind of visual and psychological realism which reached its apogee in the T'ang period. Everyone a little familiar with Chinese painting methods knows what happened in the sequel. Increasingly the cultivation of mental images was held to be the prime training of an artist. He might be set on his course by study under a master, but in the main it was to be a rigorously subjective process whereby the mind stored impressions from nature and no less from the works of the great masters of the past. Wu Tao-tzǔ, the whirlwind genius of linear painting, epitomizes the T'ang ideal.

But if for the T'ang critic the whole creative magic is mustered at brush tip, in T'ang times we still do not meet with the view that only the painting of the gentleman scholar, born with a writing brush between his fingers as well as a silver spoon in his mouth, is deserving of notice. It was later, particularly from the Yüan dynasty onwards, that the exact representation

aimed at by the journeyman painter, who had less
pretension to calligraphic skill, was finally and
explicitly disclaimed. Thenceforward only the gentle-
man-scholar was deemed to paint poetically and
imaginatively. Wielding his infinitely sensitive brush
he could afford to despise mere pictorial detail.
One consequence of the tradition of painting by men
of letters (*wen-jen*) thus founded was the admission
of so great a measure of calligraphic and decorative
effect into painting, that these qualities often seem
to be taken as goals in themselves. The cultivation of
the mental image and of the dexterity of the brush
both led the painter away from realism.

In the T'ang dynasty this had not yet happened.
The progress of realism can be studied in wall-
paintings preserved in cave temples at Tun-huang,
at the north-western exit from China proper into
Central Asia. The earlier of these include many illus-
trations of former lives of Gautama Buddha, and of
incidents in his last earthly existence, and these give
the occasion for delightful pictures of both imagined
events and real life. They belong to a time prior to
the mid fifth century, when Chinese values were not
yet fully asserted in Buddhist painting and sculpture,
and in them an Indo-Iranian tradition is still strong.
Masses of strong colour and figures delineated by
broad dark bands are the rule, all quite uncalli-
graphic.

In utter contrast with paintings in near-Persian
style are pictures such as the masterly brush drawing
of Vimalakírti, which could be taken to epitomize
the ideals of the early eighth century when Wu Tao-
tzǔ was the leading exponent of linear realism. This
painting, although it was executed so far from the
civilized centre of China where Wu Tao-tzǔ was
active, may even copy a famous version of the same
subject by which Wu is reported to have won great
fame. The literary context of the subject appealed to
the Chinese as much as the rationality of linear paint-
ing. Vimalakírti, an enlightened and rich merchant,
was privileged to meet the Bodhisattva Manjuśrī in

debate, and spoke of Buddhist religion with the calm reason to be expected of a Chinese scholar. Wu Tao-tzŭ's painting, a youthful work, is said to have shown the merchant 'pale, thin, with sickly mien, leaning on a low table with the air of one who has forgotten speech' – so entranced was he with the Bodhisattva's discourse.

Since we have little to show in the interim, T'ang work at Tun-huang may be compared with Han dynasty drawings in order to see the change that has come over graphic style during five centuries. Both schools are represented by professional work which we feel convinced is close to the sophisticated painting of the time, although the practitioners may have been humble men. In the Han period the canons of realism still allowed a place for distortions which are more intelligible to the present age perhaps than to any other intervening time, as when the representation of a face hesitates between the front and side views, or the movements of the arms of a dancer seem best conveyed by lengthening them almost to the ground. Particular freedom was felt allowable in relative scales, since this matter had nothing to do with giving an illusion of recession in space.

But the T'ang artist has become shy of these liberties. Even with what might be thought the temptation put in his way by the miraculous element in some of the Buddhist stories he was called on to illustrate, he remains firmly planted in a tangible world. He has a system of perspective using receding parallel lines, with some reduction of scale, which can deal with any desired presentation of space. His grasp of the proportions and the musculature of the human figure exceeds that of any of his predecessors. But if there is no gross distortion of scale, still no great need was felt to reduce the size of objects *gradually* from front to back of the picture, and they simply all keep their relative sizes as if they were represented on a small number of plane surfaces set at intervals in the receding space. In dealing with large volumes of space the painter was beginning to experiment in

methods of making great distance along the line of sight appear quite unmistakable, by such devices as zigzagging and diminishing rivers, échelons of mountains, even diagonal lines of flying geese.

More important than all of this for the quality of T'ang realism is the concentration, in figure subjects, upon psychological effect. This was no new thing among the sophisticated painters of the capital cities. At the latest by A.D. 400, and probably much earlier, theorists had declared the portrait to be the most difficult subject a painter had to tackle, and in capturing the life (as would be said, rather than the likeness) the drawing of the eye was all important.

77, 78 Hence it was to be left to the last. But it is clear from the T'ang pictures that the force of personality and emotion was understood to be equally dependent on the representation of the whole bodily posture, and on the relations between persons who are depicted together, at rest or in movement. The spontaneous linear style seemed the ideal vehicle to this end.

The linear style, with its air of ripe accomplishment and assurance, was admirably adapted to the needs of the Buddhists in their religious propaganda, and it was this connection that spread the T'ang style through Asia, from the Pamirs to Japan. One may speak of an international T'ang ecclesiastic style as one speaks of international Gothic. The Buddhas, Bodhisattvas, and paradise compositions preserved in the eighth-century caves at Tun-huang were multiplied throughout the Chinese empire. Some of the finest representative work is to be found in the contemporary Japanese capital of Nara.

As a matter of history it is difficult to separate a growing interest in psychological aspects of life, and in transcendental philosophy, from the religious speculations of the Chinese Buddhists. For example, at the beginning of the fifth century in the capital of the Eastern Chin state, the contemplation and painting of landscape was coupled with transcendentalism typical of the doctrines of the new Mahāyānist Buddhism which was coming in. On a more mundane

level we can ask what the Buddhist tradition contributed practically to the genesis of T'ang art. The impact of the image-making upon Chinese artists is discussed in greater detail below, but we should notice here that the Buddhist requirement of super-lifelike figures to represent its religious heroes, as well as the need to recount scriptural stories in easy pictures, could only reinforce the growth of an art of natural forms and readily understood moral situations.

78, 81

Such incentives towards realism were at their full towards the end of the seventh century, and another powerful one was added to them. With her hands firmly placed on the oasis cities of Central Asia once again, China drew a rich trade from the Iranian west, in return for the silk she exported along the famous routes skirting the mountains north and south of the Tarim basin. The most obvious influence from the west which followed the trade to China is seen in decorative art, and is discussed below in an appropriate place. But in expressive art also China benefited in two ways. The renewed influx of Buddhist ecclesiastics with their travelling goods of painted icons and images stimulated a revival in all the centres of Buddhist art. On the secular side, while it can hardly be claimed that the Persian styles of Central Asia made any specific contribution to T'ang painting, the colourful merchants, entertainers and menial fortune-seekers who flocked to Ch'ang-an provided exotic and challenging subjects for art at many levels. We learn much about the cultivated and decorous life of the capital from the astonishingly rich grave-goods which a wealthy class accustomed to exquisite bodily comfort crammed into its tombs.

82–5

The best known pieces are pottery figurines, painted or lead-glazed, which have been avidly collected in Europe for two generations past. As in nearly every characteristic divergence of T'ang culture, the sculptural style seen in the figurines is brought to perfection at the turn of the sixth and seventh centuries, joining the innovations in pottery, metalwork, textiles, linear painting, full-colour model-

ling in painting, etc., which crowd into the same years, as if a magic wand had waved over all the arts. The figurines were displayed on stands at the road-side as a great funeral passed by, so that there was rivalry in their manufacture. Inside the tomb they occupied special recesses along the entrance passage or were placed in the inner chamber with the sarco-phagus.

Some very elaborate figures represent genies of the tomb who have a long history, creatures of fantasy which take full advantage of the new sculptural realism. Others are guardians dressed in the parade armour of the day. But the majority portray servants, whether menials, huntsmen, entertainers, serving girls, or fine ladies who must have ranked high in households. In the tomb of the princess Yung T'ai murals of her tiring maids, dressed in the new fashion influenced by the Persians, strike the contemporary note, and show the line and colour of the international T'ang style to have reached the hands of somewhat perfunctory tomb decorators.

The majority of the tomb figurines can be seen to have been produced in moulds, and those which have more individual detail were probably moulded in the first place. Of the original work which established each type we know nothing directly, though the resemblance of the incomparable horse figurines to the paintings which survive show that the same ideal was adopted by painter and potter. It does not necessarily follow that the potter was the borrower. Unlike the impression we gain from the paintings of *genre* subjects at Tun-huang, the figurines reproduce standard designs, so that each seems to be the result of endowing one individual with the ideal points of many. No Chinese writer has given utterance to the principle expressed in the early Renaissance theory that the artist's task lay in selecting and recombining nature's best in order to improve on her handiwork. Yet Chinese practice led the artist instinctively to it, since the mental image on which he concentrated was no less an ideal abstraction.

When they are compared to schools of minor sculp-
ture elsewhere in the world, the T'ang figurines
stand out by reason of their dramatic movement and
successful portrayal of psychological types. The self-
85 satisfaction of the muscular braggart is as apparent as
the cautious and ingratiating presence of the Sogdian
merchant, while the breathing vanity of a vacuous
84 lady of the court is conveyed as easily as a huntsman's
professional concentration on the task of subduing
an unruly hunting leopard clinging to his horse's rump.
The anatomy of the figurines, like that of the Bud-
dhist monumental figures, shows appropriate detail
of muscle which yet departs from reality at many
points. The origin of the convention is uncertain, but
there can be little doubt that it derives from drawings
or models brought by Buddhists from the west.

The rebellion of 756 brought to an end the phase of
inventive realistic art which is the most characteristic
expression of T'ang genius. Before the end of the
dynasty a move towards the cooler, more intellec-
tualized aesthetic of the Sung period had begun.

Realism The use of the word realism in speaking of the image-
as Icon making required by Buddhism would be strained
were it not for the circumstances in which this took
place in China. Such Taoist personifications as the
Queen Mother of the West and her consort the Royal
Duke of the East were represented along with legend-
ary emperors and culture heroes in wall paintings,
but they were not worshipped in the ordinary sense.
As far as we know there was no widespread tradition
of image-worship in pre-Buddhist China. Certain
effigies were however made for the purpose of what
62 must be called submerged popular cults. Wooden
statues of monsters or human beings with protruding
tongue, horns, etc., made in south Honan and at
Ch'ang-sha in Hunan, in the fourth and third cen-
turies B.C., as embodiments of superstitious belief,
received no countenance in polite society or notice in

literature. The style of these images is primitive, quite unlike the hieratic and realistic traditions of civilized art that were contemporary with them. In short, when the need arose to carve statues of the Buddha and his putative successor, the Bodhisattva Maitreya, the Chinese sculptor can have had no inherited prejudice as to the style he should adopt for monumental statuary.

Important aspects of the Chinese artist's vision are revealed in the fate which befell image types introduced by Buddhist priests arriving from Central Asia, and soon from India itself. The religion was known in China in the first century A.D., when the emperor Ming Ti is said to have dreamt of a golden man flying into his palace, an event interpreted as the earliest report of a golden image of the Blessed One. In north-west India and the adjacent territory of Afghanistan a combination of east Hellenistic and Indian sculptural style flourished at this time in the work of the Gandhāran school, and we may be sure that it was statues of this kind that first penetrated to China.

Anatomically the Gandhāran figure is idealized realism of great beauty. The face, hair, hands and feet are modelled in a sweet natural style common to the classical tradition of the eastern Mediterranean and to the Indian Guptan sculptors. The custom of manipulating the folds of long garments as a means of representing the proportions and tensions of the human body convincingly, and so establishing a psychological presence, was inherited from the practice of centuries. Images made in China in the third and early fourth centuries A.D. which evidently are intended to be faithful copies of the Gandhāran style betray the sculptor's inability to use anatomy and its covering of drapery with real insight in the interest of impressing on the viewer the reality and humanity of the Buddha's person and mission. Instead, the folds of garments are exaggerated into ornamental shapes, and the proportions of the body are adjusted, in the manner of all icons, in the hope of increasing the

psychological effect through distortion. Much of the difference which appears between the Chinese images and what we must suppose to have been their models is naturally due also to incompetence, but in view of the turn which Buddhist sculpture took in China shortly afterwards, it would be mistaken to dismiss all the early aberrations of form as so many mistakes.

The purpose of the images of the earlier, Hīnayāna, stage of the religion is essentially narrative: to set forth the earthly life of a teacher who is mortal, if spiritually exceptional. Gautama Buddha appears dressed as a priest, Maitreya in the finery of an Indian prince. The latter's jewels, scarves and head-dress became the distinguishing features of Bodhisattvas in general, i.e. of the spiritual heroes who had resigned their hope of nirvāna in order to be better able to help mankind towards enlightenment and release from the fear of rebirth. At Tun-huang some of the Buddha's life stories are shown in murals full of imaginative invention. Presently, in cave temples carved in a limestone cliff by the Turkic kings of the Northern Wei state at Yün kang in Shansi, in the mid fifth century, these subjects were attempted in relief sculpture. But themes of this kind did not much catch on in China, in spite of the realistic and narrative art of the preceding Han dynasty. The creative effort was expended almost wholly on the cult figures themselves.

In looking over the sculptor's work from the fourth to the mid-sixth century, the general trend of his concept of form is clear. It arises from rational analysis of a kind approaching one of the meanings of the word realism, i.e. the real shape behind the accidental and fleeting is sought out and presented with almost geometric clarity. If folds appear as lines, then they are carved as such, or as the edges of multiple flat strips into which the rounded and swelling portions of the figure, as they appear beneath the drapery, can be most rationally divided.

The analytic style of sculpture went to its limit towards the middle of the sixth century. For example, a seated image of the Buddha may be so manifestly separable into the oblong block of the folded legs, the pillar of the torso, cylinder of the neck, squarish volume of the head, etc., that we must accept this drastic scheme as a deliberate statement by the sculptor. In incompetent hands such processes of analysis could lead to absurdity, like the musculature of an artist's lay figure. Yet they are basic in some of the most meritorious work. In detail this approach to form flattered carving style, as opposed to modelling style, and to the Chinese eye it made an appeal similar to that of the linear draughtsmanship which was being concurrently matured in secular and religious painting.

At Yün-kang, from about A.D. 460 until the end of the century, the style in practice was not yet fully transformed in the analytic fashion. Instead it attempts to keep close to the modelled forms of the Gandhāran tradition (though we should strictly speak of the offshoot of that tradition in Central Asia, of which we have little direct evidence) and the anatomy appears as continuous undulating surface, instead of surface divided by ridges and lines. Similarly the drapery still attempts, though with little success, to imitate the natural fall of cloth – or rather the skilful Gandhāran convention aimed at achieving this illusion.

64, 65

Work in the Yün-kang cave temples ceased soon after the year 500, when the king of Northern Wei moved his capital to Loyang in Honan, the better to exercise rule over the whole of north China. Even before the move the analytic treatment of form, which may be seen as a progressive sinicization, was introduced at Yün-kang, and in the new cave temples at Lung Men, near Loyang, it wholly takes command of the sculptor's work. With the analysis of surface into distinct areas, like long flat ribbons, and the bodily shapes into explicit geometric units, went also a

tendency to elongate the whole person. Long arms and torsos, slender hands, narrow high faces, achieve to our eyes an effect between pathos and inhuman detachment, with a haunting beauty.

67, 68

Since the analytic style in sculpture appears to answer so closely to the linear style in painting, it is natural to ask whether the two arts were being chiefly developed in the same part of the country. On the side of sculpture the evidence for this is slender, but it points to the same Yüeh region, around the mouth of the Yangtze (territory of the state of Eastern Chin, then of Liang), which was the centre of painting theory and practice from about the beginning of the fifth century. A bronze mirror found in the Nara prefecture of Japan, which is certainly an export from China, is decorated in the same idiom as others made in Yüeh, but instead of the Queen Mother of the West, it features the Buddha, standing and seated. The date of the mirror cannot be long after A.D. 200, and already enough of the sculptural treatment can be seen to show that the draperies are interpreted in rectilinear analytic fashion, with projecting corners at the hem. It was just such a scheme, in a much refined version, that was communicated to Loyang and north China generally about A.D. 500, when Wei moved its capital and temporarily entered into more amicable relations with its southern neighbours.

63

But more went to the designing of this first thoroughly Chinese version of the Buddha image than assimilation to a painting style, and at this point the demands of doctrine have to be reconsidered. Although to the early Buddhists the founder of the religion was an ordinary man, he rapidly got mythologized out of human existence. Great controversy arose in particular over the meaning of the nirvāna (extinction) of the Buddha. If extinguished how could worship be addressed to him, how could he be represented, how could he offer present help? Priestly answers were found, emanating from India and belatedly provoking great debate and schism in China. The view was finally established that the Buddha

continues to inhabit some transcendental world from
which he can manifest himself miraculously, in his
nirmāna-kāya, 'body of transformation'.

The problem of representing such a manifestation
in sculpture must have appealed to theorists who
were engrossed in discussing a philosophized art of
landscape painting. Tai K'uei, a sculptor who fre-
quented their circle, is said to have 'invented a way of
shadowing and echoing the dharma-form and of
giving perceptible shape to the nirmāna-kāya'. Like
an early Christian idea of the *anima*, the manifestation
body of the Buddha was evidently thought to be
shadow-like. Sculpture in the tradition thus attributed
to Tai K'uei, transmitted to north China from the
south around A.D. 500, often has high relief in the
secondary features – halo, trees spreading over a
seated Buddha – that is designed to break up the
light and enhance the impression of aerial unreality.
A desideratum in an image representing the magical
arrival of the Buddha from nirvāna is presumably that
the figure should appear as if caught in the very
instant of manifestation. That is exactly the impres-
sion we gain from the best surviving works in this
style, chiefly small gilded bronzes. Thus the doctrine
of the possibility of *sudden* enlightenment and salva-
tion, as opposed to hard-won spiritual advance, which
was being launched at this time, may have its artistic
counterpart in sculpture. Rapidity and spontaneity
were after all essential to artistic creation, as the cal-
ligraphers had proved.

Between the end of the Northern Wei period in
535 and the end of the century, Buddhist sculpture in
north China presents a confusing array of styles. First
the flat frontal effect to which the initial version of
analytic style gave rise, in what is above called the
Tai K'uei tradition, gave way to increasing roundness
in the bodies of Buddhas and their attendants. This
change still remains however within the limits of
analytic concepts, never arriving at natural plastic
form. The strangely elongated statues of the Loyang
ateliers have already been mentioned. Then in the

69

north-west, under the Northern Ch'i dynasty, appears
a new sculptural scheme, of upright, column-like
figures with broad linear drapery in the case of Bud-
dhas, and abundant jewel chains and ornaments in the
case of Bodhisattvas. From these it appears that a new
external influence is at work, whose origin can only
be India itself, although the exact manner in which it
was conveyed eludes us. In Szechwan are preserved
a number of works in which the late Guptan style of
India is aptly imitated.

Chinese work in the new Indianizing manner
breaks at last with the analytic style and makes con-
cessions to a realism closer to that of the minor
70, 71 secular figurines of the T'ang period. The most
striking image is the Bodhisattva, with bare torso and
hip bent in the three-bend pose. In this case the con-
temporaneity of the Indian model is certain, for the
finest work in the corresponding Indian style, the
torso from Sanchi preserved in the Victoria and
Albert Museum, is dated only slightly later than the
comparable Chinese pieces. Close as the adherence to
some Indian model must be, the Chinese treatment
of anatomy is more schematized. When applied to the
images of angry guardians, bare or dressed in armour,
the same rationale produced a style of heroic realism
closely matching that of the pottery figurines.

A rapid decline in the quality of Buddhist sculpture
after the fall of the T'ang dynasty is to be explained
in terms of the reduced patronage which the Buddhist
church then enjoyed, but also by a loss of purpose on
the part of sculptors. What news came now from
India, if it reached China at all, concerned the out-
landish pantheon of the late, Tantric, phase of Bud-
dhism. The Chinese sculptor seems not to have taken
kindly to such freakish anatomy, which to the stigma
of foreign, now so constantly laid on Buddhism, sug-
gested the addition of barbarian. Instead of following
in this path, Chinese Buddhist sculpture secularized
itself completely, finally producing in wood images
of a startling and rather sinister realism, with the
72 breathing but too often shallow life of wax figures.

These sleek wooden statues, dated to the twelfth and thirteenth centuries, are imbued with the decorative spirit of Sung art. Their ponderous attachment to this world seems to mock the Buddhist ethic, their message merely that well-being like theirs awaits the faithful in paradise. By now the Pure Land sect with its doctrine of rebirth in Amitābha's Western Paradise led the popular cults. These images are a Chinese invention, but their sculptural originality is inferior to that of the Meditating Bodhisattva which Chinese sculptors had developed into an independent cult figure in the sixth century. The latter concept appealed to a deeper level of the native genius.

Realism as Landscape

In the most elementary sense of realism Chinese landscape painting has little claim to be considered in this chapter. It is only exceptionally the picture of a particular place, and it certainly in theory is as much concerned with the expression of subjective sentiment and insight as with the description of appearances. Nevertheless the paintings are felt in many instances to be very like the scenes we witness. However philosophized the meaning of landscape painting became, its style never parted company completely with reality. Its realistic side, in mountain forms, light, space and vegetation, can perhaps only be properly judged by one who knows something of the reality in China. Many of its conventions are then seen to be remarkably apt. It has been said that the rôle of landscape painting in Chinese art corresponds to that of the nude in the west, as a theme unvarying in itself, but made the vehicle of infinite nuances of vision and feeling. The Chinese landscape of art is a high mountain, in a sense, always the same mountain, on which the changes of aesthetic sensibility are rung.

The status of this theme is only intelligible in the light of its history from about A.D. 400 onwards. Today unfortunately the art historian lacks enough genuine ancient paintings to allow him to judge the

practical application of the theoretical principles
which are enunciated in surviving texts. Apart from
the Han tomb scenes, and a few similar items of the
next two centuries, the earliest work is found in one
section of Ku K'ai-chih's scroll painting, preserved
in the British Museum. There a moral tag is attached
to the picture of a man, drawn grossly out of scale,
kneeling next to a mountain not unlike a slightly
elaborated version of the Han convention. It is held
to be a tolerable copy of Ku K'ai-chih's style,
although it can hardly have been painted earlier than
T'ang times.

This artist was responsible for the first theoretical
formulation that has come down to us. For him land-
scape painting was second to portraiture in difficulty
and importance, and the critical terms he introduced
were probably meant for figure painting in the first
place, although afterwards they were more widely
applied. The chief of them is a term translated literally
as 'the principle of bone', by which the proportions
and tensions of the human figure may originally have
been meant. The idea was transferred to a quality
of drawing, and to have 'bone' is soon apparently
equivalent to reaching 'the limit of excellence'.
The latter phrase might also be translated 'to
exhaust what is good' in a subject. A portrait, for
example, might be very beautiful and lifelike, but still
not fulfil that requirement. To have 'bone' was also,
as we say, to be strong in composition and style of
execution. Ku K'ai-chih's idea of landscape seems
to have been a number of peaks, with cliffs and paths,
which stood for the great spaces of nature, with a
suggestion of symbolism and mystical overtones.

Four centuries later, in the T'ang dynasty, we are
able to compare theory with practice. The care now
taken with the illusion of recession in distant space
has already been mentioned. In the Tun-huang land-
scapes of T'ang date the rocks of cliffs are painted
with strong angular brush strokes, producing out-
lines that stand for the inner crystalline structure
of the rock as much as imitate its accidental outer

appearance. Something of this kind is probably behind the term *chen*, truth, which now entered the critical vocabulary. This was a quality as much present in Wu Tao-tzǔ's rapid linear work as in the modelled and 'shaded' colour of an Indianizing style, introduced from Central Asia, which was concurrently causing such stir in the T'ang capital. Wash could be combined with line and achieve *chen*, as in Yen Li-pen's portraits of emperors and scenes of court life. In discussing landscape painting the key phrases are 'sheer mountains', 'going to the summit', 'marvellous depth', 'succession of pine and bamboo', 'clouds and rain, dark and light'. Thus two ideas regarding space were bequeathed to what now became the classical tradition. One was that the third dimension of space, suggested by the linear treatment, was essential, the other that space is partly occupied by cloud and mist and by this means becomes tangible. It might be thought, with some justification, that these two methods of persuading the viewer that he is looking into great depth of landscape are alternative, rather than complementary. But in this Chinese 'chiaroscuro of nature' they were inseparable.

It begins to grow clear that the landscape is ideal, and romantic; its chief aim is to induce mood, *Stimmungslandschaft*, as an aid to communion with nature, the Tao. Another, simpler idea, perhaps never divorced from the landscape since the time of Ku K'ai-chih himself, was that the viewer should imaginatively enter into the picture, cross that little bridge and follow that path winding up a gorge towards the majestic and unattainable peak that crowns the composition. Then came a philosophical idea entirely characteristic of Chinese thinking. A painter creates by 'establishing the idea (meaning)', and his work is the 'trace' he leaves of the idea. But painting is not to be described as a purely subjective process. It is the idea rather than the man which leaves the trace: the human mind has combined with a corresponding part of creative nature, which lies

outside the painter, or at most includes him in a greater
unit. Some spoke of the quintessence of landscape
art (naming that differently – 'spirit resonance',
'structuring spirit') as something existing objectively
in nature, which it is the artist's business to discern
and convey into his painting. Others, writing in the
Northern Sung period, would say that the 'structur-
ing spirit' is a mode of perception supplied by the
artist's mind, without objective existence apart from
the artist. These were different philosophic views
that did not necessarily affect practice much. All
theoretical propositions were by now advanced as
interpretations of the thought of earlier masters.
Chang Yen-yüan, the greatest of the T'ang critics
and art-historians, maintained paradoxically that if
the appearance of certain subjects, such as women or
horses, is different in ancient paintings from their
present appearance, that is because they really *looked*
different in the past. He would have rejected the
argument of the modern critic that 'art has a history'.

Chinese critics since the seventeenth century have
spoken of Northern and Southern Schools of land-
scape painting, dividing up the great masters of the
past between them. The distinction, which is not
geographic, separates the painters who favour clear,
emphatic structure in their compositions, with the use
of explicit perspective devices, from those who cul-
tivate a more intimate style of landscape bathed in
cloud and mist, in which pleasing calligraphic forms
tend to take the place of conventions established for
the representation of rocks, trees, etc. The painter
of the Southern School was interested in distant
effects, but his colleague of the Northern School paid
more attention to the devices of composition which
achieve the illusion of recession, and was at the same
time more attentive to close realism of detail. Since
the distinction of these fictitious schools is of style,
and not of professional or studio connection, it often
happens that one is in doubt as to which of them an
artist is to be attributed, and some artists hover
between the two.

87 Kuo Hsi, the greatest of the Northern Sung painters in the Northern School style, formulated a system of perspective which was being elaborated by his contemporaries. From the time of Kuo Hsi onwards, the technical discussions of the ancients were celebrated and developed, but the philosophic tradition they had launched atrophied. Later artists repeated earlier maxims with at most a fresh nuance, and what had appeared once to be almost a moral argument now became a predominantly stylistic one. Like other trends in Chinese art whose beginnings are instinctive, the Sung artist's sublimated feeling for spatial depth called for explicit statement. Kuo Hsi provided his Rule of the Three Distances:

> *high distance:* from the foot of the mountain the viewer looks up to the peak
>
> *deep distance:* standing in front of the mountain the viewer glimpses what lies beyond
>
> *level distance:* standing near to the mountain the viewer describes the distant mountains

The difference between the second and third of these principles of perspective is not immediately obvious. It lies in the relative scale and proximity of the farther elements which join the single main peak in the composition. Three axes of vision seem to be suggested, not connected as are the parallel or converging lines of retreat used in uniform systems of perspective. Rather the viewer is to imagine himself *inside* the picture, seeing the mountain differently as he moves forward. In practice paintings tended naturally to be constructed in terms of one or other 89 of the three distances. Compositions presenting *level distance* are rarer and individual. It was the other types of distance which came to predominate in the construction of large landscape pictures, and these tended to organize their elements in depth at three removes from the viewer, as if three theatre drops carried them.

Kuo Hsi and his greater predecessor Li Ch'eng were exponents of the landscape built of large units in strong brush-work, employing a variety of brush strokes and tree shapes which corresponded to particular rock formations and species of vegetation. In the Chinese view these are all elements of realism. It is interesting to find the more subjective mood of the Southern School changing Kuo Hsi's formulas of perspective into *vast distance*, *distance in which one is lost*, and *barely perceptible distance*, phrases coined by Han Cho to express a more sentimental and less realistic concept.

The later development of Chinese landscape painting, which space forbids us to follow here, turned first to mist-laden romanticism in the Southern Sung Academy, and then to the more evenly textured style of the Yüan masters, to whom Kuo Hsi's props to realism and the Academy's bucolic fogs were equally distasteful. In the hands of the scholar-painters of the Ming and Ch'ing dynasties a large measure of the decorative was admitted, while in the interlude of 'individualist' painting of the seventeenth century, which used strange distortion in varying degree, the artist seems no longer to consult nature, and to have moved decisively out of the realist camp.

In the seventeenth century also the brush conventions of the Sung and Ming tradition were categorized for the amateur and the connoisseur. The most famous of such works is the *Painting Manual of the Mustard Seed Garden*, written in 1679, and translated by M. Petrucci in 1918. It was issued, with all its illustrations, as *Encyclopédie de la peinture chinoise*. From it Europeans have sometimes formed an exaggerated idea of frigid discipline in Chinese painting, seeing in it only a collocation of strictly prescribed detail.

Chapter 3

Decorative Styles

Consideration of the decorative brings us to the most pervasive and least definable aspect of style. The intention of pleasing the eye, as distinct from informing or provoking it, is present in all Chinese art. The popular view that it aims *exclusively* at ornament is influenced partly by the flood of fancy goods which have been imported to the West since the sixteenth century, and partly by the impressions we take unconsciously from the *European* style of chinoiserie. The effect of the latter is the more insidious, for it suggests that Chinese art deals in saccharine sentimentality and buffoonery, two qualities which might be chosen in very antithesis to the Chinese manner. This is characteristically sophisticated, as sharply outlined in feeling as in shape, not tender or mistily fanciful.

At the outset we may recall features of decoration which tend to distinguish it from expressive art. It generally consists of a pattern with repeats, either periodic returns to a main centre of interest, or the continuous or at least regular appearances of an independent unit or motif. Decoration in our sense does not add usefully to the function of the object on which it appears (though it might sometimes be thought to hamper it) and it is not additional ornament which stands outside the functional limits of the decorated object, like a feather on a hat, or a non-bearing gable on a Victorian façade. In its general effect good decoration is as inseparable from the whole work as the skin of a body. The Chinese

artist has always been especially alive to the claims of this kind of congruence.

It can be argued that decoration plays a more fundamental, and certainly a more inescapable rôle in our lives than does expressive art, creating a reassuring environment by suggesting that we move in an ordered and fruitful world. To some extent decoration abstracts an intimate quality present in all art, on which the modern school concentrates, and which Roger Fry recognizes in his comment on Chardin: 'His pictures are among the most striking proofs that arrangements of form have direct and profound effect on the mind quite apart from what they represent.'* There is little agreement among theorists on what should be discussed under the rubric of the decorative, and the above remarks will not go undisputed, but they are at least relevant for understanding a large, even preponderant, element of the Chinese tradition.

The rhythms peculiar to traditions of decoration are distinctive, and in China one sees a general preference for curving and circular movement. The principle of repetition is naturally observed, but it is not obtrusive, for it is usually constituted by large elements connected together in so natural a manner in the terms of the nuclear motifs that a staccato effect is wholly avoided. Exceptions to this are very noticeable: for example, in knot-dyed textiles of T'ang date excavated in the territory of the Chinese commanderies in Central Asia, the decoration is often by rosettes and other small figures well separated on a plain ground. The absence of connecting elements strikes one as un-Chinese. There will be a comment below on the habit, found in the T'ang courtly style, of isolating small floral and animal motifs in continuous decoration – a manner also rather uncharacteristic of Chinese taste.

Flowers, more or less formalized, and continuous scrollery composed of them, are the most typical orna-

* Roger Fry, *Characteristics of French Art*, 1932, p. 65.

ment of all. The design is essentially organic, but the disposition of curves in petals, stems and branches is improved from nature in order to maintain the rhythm of movement and to fill the desired field in the most natural manner. Between this formality and what would be an exact representation of the flowers, Chinese taste and theory make no absolute distinction. No more is the difference expressly recognized between the exact form of rocks and the brush-strokes which are used to represent them in land-scape painting.

When the motifs used in decoration have lost every visible connection with vegetable and animal form, the movement of lines is still reminiscent of the treatment accorded originally to the organic motif, an awareness of which often still vaguely hovers around the design. Something of this kind is found in the later stages of the hieratic style. But in the decoration used in recent times, from Sung to Ch'ing, the whole decorative repertoire, archaism apart, can be designated organic. Designs and motifs of purely geometric character then play a minor part in ornament.

An exception to these principles is the occasional appearance on porcelain, textiles, lacquer, etc., of a continuous pattern resembling key-fret, or simple and symmetrical openwork in which rounded openings are connected by vertical and horizontal straight lines. Such designs date from the late Sung onwards, and their immediate origin is architectural, to be sought in ornament used on partitions filling the spaces between the bearing pillars of buildings. Since these partitions take no load themselves, it is possible to treat them freely in fretwork.

The panels closing the coffering of ceilings lent themselves to similar decoration. Sometimes the repeating motif is a formal rosette, or imitates the interlacing of basketwork, but it is still bound into a geometric system. These designs became current in the decorative arts generally through the publication in 1103 of *Methods and Styles of Architecture* (*Ying-tsao fa-shih*) by Li Chieh, a fully illustrated manual which

circulated widely and was often reprinted. As well
as geometric ornament this book supplied models
for many floral schemes, the figures of dragons,
mythical animals, beautiful women, and immortal
and legendary persons.

But architecture was far from playing the forma-
tive rôle in China which we can ascribe to it in
Europe. In the West its influence has been to confine
schemes of ornament within strict frames, to en-
courage symmetry and heraldic arrangement, and the
invention of *pendant* ornament, from the flower swags
and wreaths of Hellenistic architecture to the geo-
metries of the Gothic and the controlled exuberance
of the Baroque and Rococo. There is nothing corres-
ponding to this in China. The single feature of
Chinese architecture which develops decoration
peculiar to itself is the multiplication of brackets
below the eaves. Unlike the various details of the
Greek temple, this device did not lend itself to imita-
tion in the other arts.

The employment of allegorical figures in ornament
is another Western custom which at first sight might
seem to have its counterpart in China, for, as is
almost too well known, some of the commonest items
in the Chinese repertory have symbolic meaning. But
the case is quite different. In the archaic style the
serious symbolism which seems to be intended at the
start quickly evaporates under the irresistible decora-
tive impulse. Similarly the Buddhist lotus and the
pearl, Jewel of the Law, ubiquitous as they became,
only in the religious art itself retained any meaning
of which the viewer might be expected to be aware.

In the decorative art of the later period the motifs
which signify anything explicit are quite few. The
Three Friends are plum, pine and bamboo; the peach
stands for long life, for it was the food of the immor-
tals; a carp means success in the civil service exams;
such messages as deer for wealth and bat for hap-
piness are based on puns. All the possible graphic
changes are rung on the character *shou*, long life,
which has the distinction of producing always a sym-

metrical figure. But symbolism of this order is for the most part quite banal, utterly submerged in the unreflecting application of conventional ornament. In the late palace style symbolism seems to have been taken a little more seriously, by emperors and their servants obsessed with hopes for imperial success and longevity. Consequently symbolic ornament of this order is common in the eighteenth and nineteenth centuries, and Europeans have become specially familiar with it.

Although characteristic tendencies persist through the whole history of Chinese art, the principles underlying decorative style are not identical at all periods. The variation of space allowed around the motifs of an ornamental scheme, the proportion of reticence to statement, which is keenly felt by the Chinese artist, may reveal the taste of an epoch. Mostly the *horror vacui* is for the Chinese an *horror plenitudinis*. But the taste imposed on palace furnishings by imperial houses of un-Chinese origin could go against this canon. Most notable in this respect are the influences of the Mongol and Manchu courts, which will be mentioned in their proper place below. In other periods too it is decorative art which proves most susceptible to foreign fashion, and so it may serve to gauge an artistic atmosphere in some ways more sensitively than the major arts. This is true of European influence at the Peking court in the seventeenth and eighteenth centuries.

Early Decoration

The archaic hieratic style which was the subject of Chapter 1 had to be treated apart. As the schemes of ornament cast on bronze vessels evolved they inevitably acquired more of decorative and less of iconic character, yet the aura of the solemn sacrifice probably never quite left them. Much later, in the archaistic revival of the hieratic style which began in the twelfth century, an echo of the same special status is preserved (cf. p. 113). The conclusions we draw from

the art of the bronze age may be biased, since ritual
vessels and similar solemn objects (e.g. the bells used
in ceremonial music) account for the greater part of
tomb contents. Armourers, jade-carvers and lac-
querers worked chiefly for the ruling classes, whose
taste followed the orthodoxy reigning at the state
courts. Such things as the metal components of
chariots and ornate daggers might display different
motifs (hawk-head, wolf-in-a-ring), but the style of
execution allied them to that of the ritual pieces
rather than to any clearly discernible popular tradi-
tion.

Some wooden figures of grotesque monsters and
moderately realistic carvings of smaller animals clash
sharply with the drier art of the political and social
establishment, but they are not associated with any
work suggestive of independent and mature decora-
tive style. Even the potter throws no light on this
question, for after the neolithic age he is found either
feebly imitating the designs of the bronzes, or dis-
carding ornament altogether for his utilitarian shapes.
In sum, in a discussion of decorative style executed
in a secular spirit outside the charmed circle of the
hieratic tradition, we may look to the neolithic
period, and then leap nearly two millennia to the art
of the Han dynasty.

Painted funeral urns excavated in the Pan-shan
district of Kansu claim our attention first. The urns
themselves are well shaped by hand, but virtuosity in
this respect or creative experiment with form are not
much evident. Instead the sides are painted in black,
plum-red and scarlet with generous whorls of circles,
spirals, checkers, and occasionally a remotely anthro-
pomorphic figure. The instrument employed was a
brush with comparatively coarse hair, the lines
reflecting large movements of the hand. The checkers
look as if they were ruled, but that is exceptional.
On the other hand a ubiquitous minor feature, the
serrated edges on the inner sides of double and triple
painted bands, employ the brush point, and not a reed
stylus as might be expected; and crosses and other

devices which were felt to be necessary in the larger empty areas are roughly brushed on.

It is interesting that this ornament of circles and curving lines, not derived from geometric figures, should be so admirably adapted to the round bellies of the urns – a congruence of ornament and form by no means universal in the wide-flung painted potteries of the Asian bronze age. The Kansu urns tend to refute the view that 'geometric is the primordial element of decoration'.

96 The curves and angles on the slightly earlier painted pottery of central China (south Shensi and Honan) are more tightly drawn, with the trick of hollow-sided triangles and the sharp return of lines, reminding one of the late Celtic art of Britain seen on such pieces as the Desborough mirror. It has never been suggested that this ornament aims at anything but the pleasure of the eye. On the other hand the Kansu spirals have inspired in some writers a belief that they stand for ritual dance and maypole frolic. The serration cleverly used to lighten broad bands of dark colour was formerly named the 'death pattern', but it now appears that this motif was not after all limited to burial urns.

Han Decoration

The Han art with which we are concerned here belongs to the second and first centuries B.C., and so dates from before the rise of the *genre* and realistic style discussed in the previous chapter. Some forms of continuous ornament used in Han (especially the product of the government's lacquer ateliers – see p. 116) are quite archaistic, the legacy of the hieratic style at its fag end. The continuous dragon scrolls 30 on Han mirror backs still work in the ancient idiom, but they are now less figurative, being turned into 100 almost complete abstraction. The 'cloud scrolling' which presently derives from them passes wholly into the realm of pure decorative imagination. As the dragons which lurk in the earlier scrolls disappear

they take with them some zigzagging portions of the design (borrowed from the twill pattern mentioned below) that are incompatible with a renewed feeling for rolling movement, which seems to echo the shape of some neolithic ornament after an interval of some two thousand years. Through much of Han poetry rushes a cosmic wind on which spirits are borne aloft to a world of immortal spirits and mystery. Designs based on cloud scrolling are attuned to the same mood. This final break with the static design of earlier time, and with the principle of movement about a fixed point, is no less revolutionary in its way than the outburst of realistic *genre* drawing which occurred shortly afterwards.

A steadying influence on some pre-Han and Han decorative draughtsmanship came from the weaver. Already for many centuries twilled weave had been practised in China, and in the fourth century B.C. its designs are seen adapted to mirror ornament. Twilling produces lozenges and zigzags with great ease, as the over-and-under of the shuttle is gradually staggered from right to left. Before the Han period it was these simpler figures that were exploited for ornament in other materials. From textiles came the draughtsman's readiness to allow repeating units of design to continue in disregard of the mirror rim limiting the field, as if the ground for his main ornament had been cut out of a piece of cloth. The principal motifs were arranged within the circle of the mirror, but kept their relative positions as they would in actual weave. The influence of the rhomboid figures of twill is long seen on Han bronzes and stamped on clay bricks, while in the textiles themselves the twilling was made to yield outlines of quaint trees and animals in surprising detail. Even the elements of realistic landscape were attempted.

Bronze mirrors with ornament illustrating astronomical notions form an important group of Han designs in which the demands of decoration and representation are nicely balanced. So involved are the two principles that the literal meaning of the

29

astronomy which is incorporated eludes us, although enough is known of Han star lore to decipher an ordinary diagram. The 'star cluster' mirrors are the most intriguing, with their delicate allusion to planets moving among fixed constellations. On the so-called TLV mirrors the elements denoting earth, the heavens and the cosmic mountains (the identification of these points is much disputed) are borrowed from the twill figures, or at least become acceptable as decorative units by virtue of the currency given to woven design.

In all these schemes vegetable design, continuous ornament of an organic kind is curiously absent, even now that the tyranny of the old bronze tradition has been removed. It is curious too that the realistic school of the first century A.D. made so little of vegetable subjects, independently or as components of ornament. Instead of taking excessive pains for verisimilitude, the artist made a repertoire of simplified and regularized outlines of trees and flowers, and sometimes combined these into summary landscape. Some writers appear to believe that just through assembling such unreal units, invented separately, into summary landscape, a genuine feeling for landscape art was generated. But Han poetry refutes this odd idea. It abounds in sentiment attaching to plants, hills and animals, which also are sometimes combined in continuous, if rudimentary, landscape scenes.

A changed feeling for the decorative, as we have defined it, is certainly detectable in the succession of script styles. We can only glance at this evolution, whose import goes far outside our subject. In the Shang dynasty and earlier Chou dynasty the parts of each script character are well balanced, but no great attention is paid to the comparative sizes of neighbouring ideograms, and little effort made to ensure uniform directions for the various strokes of which each character is composed. All of these points are important in the script as it was reformed in the Han period and has continued in use ever since. Canons of

proportion are strictly observed in the Han lapidary style. Between these two extremes of the development, in the fifth century B.C., a most decorative script was invented in the southern state of Yüeh. It makes the significant part of each ideogram conform

to an equal imaginary square (in the modern manner) but adds to each a most fanciful bird. The bird perches elegantly, with the same regard for gravity as the form of every well-written character now demands. But decorative experiments with the script were sporadic. The latest examples belong to the end of the second century B.C., appearing inlaid on bronze vases from Prince Liu Sheng's tomb. Light treatment of the written word, as Pooter's friends said of his jokes on names, seemed, to the Confucian, to go a little too far.

99

Figs. D, E. Early scripts,
formal and decorated.
The inscription on the left
was cast on a
sacrificial bronze vase
about 900 B.C., and
declares that the maker's
descendants for a
myriad generations will
preserve the vessel in
use. On the right is the
fanciful script of the
ancient state of Yüeh,
as inlaid in gold on a
spearhead of the fourth
century B.C.
The inscription reads:
*King Chou Shao of Yüeh.
May he himself ever use it.*
Both pieces are in
the British Museum.

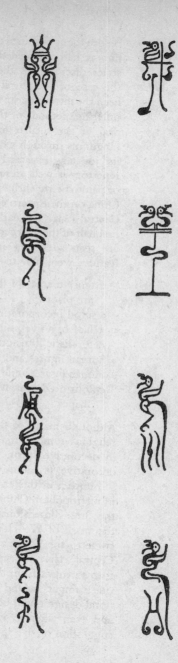

The T'ang
Courtly
Style

Before the appearance of this style much of decorative import had intervened to separate it from the Han styles discussed in the previous paragraphs. As in the case of sculptural realism, the chief event had been the introduction of Buddhism. It brought in not only the methods of the icon maker but also a good deal of the secular art of the central Asian petty kingdoms through which the religion had passed on its journey eastwards. The Buddhist ornamental repertory is well preserved on the walls and ceilings of painted cave shrines at Tun-huang, the entrance to China on the eastern end of the trade routes through Central Asia. The earliest decoration dates from the first half of the fifth century, and its principal methods are seen surviving into the eighth. Many of its features were new to China, e.g.

extensive areas of flat colour on which the motifs are placed;
a scroll incorporating a three-pointed leaf (strictly half of a five-pointed leaf, the 'half-palmette');
naturalistic lotus on long stems;
human figures and animals among vegetation;
human figures amid flowing garments and ribbons;
colour used everywhere to enhance the solidity of shapes

Although many of these motifs were fraught with religious symbolism, they nevertheless are repeated in decorative spirit, and their adjuncts are purely decorative. It is not until the seventh century that the full impact of this exuberant colourful style was felt in metropolitan China. The first recorded remark on the three-dimensional quality of painting concerns the work of Wei-ch'ih Yi-seng, a painter who had come to the T'ang capital from Khotan in western Central Asia: 'he uses colour so heavily that the forms project from the silk, but one still cannot get one's finger behind them'! After this no Chinese floral design could be content with absolute flatness, and even when it was rendered only in line, some suggestion of the upcurling of leaves and the depth

of the blooms must be given. But in Chinese orna-
ment, as in the Chinese versions of the figures of
Buddhas and Bodhisattvas, colour was used in dis-
tinct bands to set off the linear design with greater
illusion of solidity, and not in shaded washes aiming
at modelling form completely, as was the practice
which Central Asia had inherited from India.

After the fall of the Han dynasty, China had lost
control of the Central Asian city states, and did not
regain it until the opening decades of the T'ang
dynasty. It is therefore not surprising to find that
Persian influence reaches China rather suddenly, and
very intensively, after A.D. 650. The Muslim invaders
who overthrew the Sasanian dynasty of Persia seem
to have hastened these East–West contacts rather
than hampered them. The generation of the noble
and the wealthy living at the T'ang capital about
A.D. 700 was acquainted with exotic Western orna-
ment both in the authentic form, as it was brought
on the merchants' camels, and in the hybrid style
created when Chinese craftsmen imitated the foreign
designs.

Recent excavations have produced some silver
cups which, their gilding apart, might pass for Per-
sian work. The T'ang silversmith worked however
in a consistent style of his own, or rather two styles.
One of these covers the cup or box with strongly
curved stems throwing off tendrils ending in leaves
and blooms which betray a cousinship to the half-
palmette; at the centre is a multiple rosette, and the
sides of bowls may be pressed out into regular petal
shapes resembling the lotus. In the midst of the scroll
are often little flying or running birds, insects, hunts-
men at the gallop and drawing the bow.

The other silver style concentrates on large soft
flowers which are now recognizably the peonies whose
appearance in season sent the peony-fanciers of
Ch'ang-an mad, and the scrolling of stems all but
vanishes. In the short-lived heyday of exotic orna-
ment, between 700 and 756, when most of the sur-
viving silver was produced, these motifs, whether

IOI, IO2

parcel-gilded or not, were placed on a ground of minute small punched circles. The more wiry ornament with half-palmettes was the more consciously exotic, and it did not survive the cataclysm of rebellion in the middle of the century; but the broader style must be regarded as the more satisfying to Chinese eyes, for it survived to become the point of departure for the Sung development of floral design.

Another bold step which the Chinese draughtsman took at this time was the introduction of moving animals into decorative schemes. Earlier there had been *pacing* animals, but it was the foreign and Buddhist inspiration which paved the way for the entry of violent movement into something which should be reposing, whether static or rhythmic. Horses in the fictitious posture of the 'flying gallop' (i.e. with paired legs stretched back and front), outrageous little lions which had made their début as guardians at the Buddha's throne, birds, paired or single, which go back to the sacred geese of India – these are constant themes of mirror ornament. More rarely flowers and blooming sprays were similarly dispersed. All of them share in the realism of the age, for now the impact of the decorative so much depended on lifelike effect that one might wonder if the intellectual formulas of tradition would ever be able to assert themselves again. With the animals went acceptance of the hitherto unknown custom of decorating with numerous small motifs, each isolated on a plain ground. In Persian painting the placing of flowers, at regular intervals, around human figures indicated that they stood on the spring-time plain, but it also legitimized the employment of isolated elements in a continuous field of ornament.

T'ang textiles occupy a special position in the history of Chinese decoration, for it is difficult not to conclude that they were made more with an eye to foreign customers than to native taste. Persian silk weaves, whether produced in Central Asia or in Persia itself, delighted in a repeating pattern of oval medallions formed by lines of small circles – 'pearls' –

106

103, 104

and within these frames were two human figures or animals facing each other. By all precedent this heraldic arrangement should have been displeasing to the Chinese, but it seems nevertheless to have been adopted frequently in textiles made in imitation of imported Persian cloth. If the purpose was to interest Central Asians rather than the home market we should note this as one of the rare instances when Chinese craftsmen have catered for foreign taste. Even when porcelain went to Europe by the ship-load in the seventeenth and eighteenth centuries, the pieces sent, with rare exceptions, were Chinese designs known to be acceptable, and not designs adapted to the foreigner. Persian heraldic ornament did not however have a lasting effect in China, where it appears to cease after the mid eighth century. Acquaintance with Central Asia created among the Chinese a taste also for imprecise, blurred effects of colour and design, which merits separate discussion.

Imprecise Decoration

Decoration in which the edges of the motifs or sections of colour are not exactly delineated is rare in China, and each occurrence is worth examining. The earliest designs of this character are parcel-gilt bronze vessels of the first century A.D. Their ornament is engraved precisely in fine line: cloud scrolling, dragons, phoenixes, etc. Gilding is applied over most of their surface, but with margins that fail to coincide with the engraved design, overlapping it irregularly to the extent of a quarter or half an inch. The reason for this may be technical, inasmuch as it was not possible to control the spread of the amalgam which was used in the process. But this is improbable, for any use of amalgam in fire gilding presupposes that some means is found of keeping it in place. Bronze mirrors of the previous century are rather precisely gilded in parts, so if the irregular parcel-gilding of the engraved designs is not mere carelessness, which seems unlikely, we must suppose a taste for the

interesting clash of the exact drawing with the blur
of gold over it.

But the great period of imprecise ornament was the
first half of the eighth century, when it appears as
another facet of metropolitan fashion. At sites in
Central Asia many examples of the wax-resist dyeing
and the knot-dyeing of fabrics have been recovered.
Although these textiles have not been found in China
itself, it seems likely that they were imported, and
that they inspired, or helped to make acceptable, the
blurred effect of designs painted on earthenware in
coloured lead glazes. Not all the decoration of the
famous three-colour pottery of T'ang had this impre-
cision, for means were found of separating the dif-
ferently coloured glazes by grooving the surface of

108 the vessel. But some of the most striking effects of
the glaze are achieved by the splashy show of colour,
when the ornament is freely painted and the glaze is
allowed to run during the firing. In general this
resembled the designs on warp-dyed textiles, such as
are still woven in the villages of South-east Asia. On
some rare pieces of stoneware an irregular splash of
white or blue-grey suffused glaze appears over black.
Here the effect is even more fortuitous than it is with
the lead glazes.

If we argue that particular pleasure was taken in
the blurred outlines of three-colour glaze, it is under-
standable that this effect was given up, as making less
appeal, when the pottery was imitated in Japan and
the Near East. China does not share with Japan, on
the whole, the taste for fortuitous markings on
ceramics which witness to an impurity in the body or
glaze, or are an accidental result of treatment in the
kiln. Only in one sophisticated Chinese ware is
something of the kind turned into a virtue, and then
deliberately provoked. It is seen on some celadon of

110 the Lung-ch'üan kilns of the Southern Sung dynasty
(termed *tobi seiji* by the Japanese), in which dark
brown patches caused by an excess of iron mar, and
by contrast enhance, the beauty of perfect green
glaze. Other Southern Sung glazes in which a grained

effect is produced, the oil-spot and hare's-fur glazes on tea-bowls, may also have been suggested by an accidental 'kiln transformation'. All of these decorative devices are exceptional in Chinese ceramics. No Chinese product is celebrated for unpredictable marks and qualities, in the manner of certain Japanese tea-bowls which are adulated for the very perversities of their firing. In Sung ceramics the only effect approaching that of the T'ang three-colour and suffused glazes is seen on porcelain glazed black or dark brown, on which areas of lighter brown vaguely simulate leaves and flowers, or are quite irregular.

In China we do not encounter to the same degree the cult of rusticity which in Japan goes by the name of *shibui*, 'astringent', then 'tasteful, sober, quiet'. If the Japanese scholar of the old school retires to the country to use the roughest utensils with relish (especially if a famous worthy can be said to have used them before him), his Chinese equivalent will be found fondling an antique piece of bronze or porcelain, which may be corroded or cracked as befits its age, but is of the choicest quality without taint of the sophisticated-rustic.

The question of precise and imprecise, implying much that is at stake in our concept of impressionism, reaches to the springs of aesthetic feeling when we consider the methods of Chinese landscape painting.* To the Chinese of every age it has seemed most reasonable that if on looking at the massed leaves of a tree we despair of catching the shape of each, then we should not avoid the problem by putting down an area of variegated or plain colour as symbol of the total reality. Instead we should choose a single suitable formula to represent a single leaf, and multiply it without obscuring the units until the desired area is covered. Or if a leaf is unreasonably small, as in a view of distant trees, a characteristic stroke should

* cf. E. Bullough, ' "Psychical distance" as a factor in art and an aesthetic principle', *The British Journal of Psychology*, V (1912), 2, pp. 87–118.

be repeated to give the impression of branches, as far as possible suggesting the species of tree in question. But this procedure is the substitution of the precise for the imprecise.

A style of painting which served the ends of realism as the Chinese artist conceived it could also lead to cultivated imprecision of a kind that might be exploited for decorative effect in the repetitive work of the potter. This is the brief drawing, the *raccourci*, which catches just enough of reality to convey character and movement. On the celadon and *ch'ing-pai* porcelain bowls of Sung the most beautiful ornament is carved freely with the point of a knife, which generally cuts a groove with one steep and one gentler side. The character of this line itself suggests a fading into a ground of mist or water, and the ducks and water flowers which are often chosen for the design lend themselves well to rapid linear treatment. In the *ting* porcelain of north China the carved designs were made simultaneously with others impressed from a mould, and it is interesting to see how one succeeds in suggesting an infinitude of world and space, while the other, even if it is reduced to its essentials in carving the mould, remains finite.

The contrast of these two decorative styles paraphrases an eternal debate of painters, whether merit lay in the exactness and fullness of pictures produced by the 'working brush', or in work which records only the essential features of the subject, discarding all that is superflous in 'painting the idea'. Imperial taste always leant towards detailed representation. In the academy founded by Hui Tsung, the last of the Northern Sung emperors, birds and flowers were exactly delineated, but against a plain ground, for the artist was expected to seize the quintessential nature of the subject taken in isolation. Emperors, even Hui Tsung, were botanists and animal lovers before they became art critics. The tradition of scholars' painting, in which *intellectual raccourci* was the great desideratum, grew in conscious opposition to the academicism of the court.

In practice the academic style could degenerate into sterile fidelity to detail, much as European academicism tended to produce photographic accuracy at the end of the last century. The Jesuit lay brother Giuseppe Castiglione explained to his colleague Father Attiret who had arrived at the Peking court to join him in 1738:

> A good European painter would find your flower perfect; but there is not one apprentice painter here who would not tell you at a glance that your flower does not have in its outline the number of leaves it ought to have.*

Pure Form in Pottery

The idea of form, abstracted from other expressive attributes of a work of art, is so foreign to Chinese thinking that no traditional term exists for it in the language. When fine porcelain is praised in the older writings, it is for its colour and excellent quality, but not for its shape. Nevertheless in the long history of Chinese art there occur distinct phases when it is shape above all that is manipulated for the decorative pleasure it affords, without the aid of other kinds of ornament. Curiosities of shape have always elicited an aesthetic response, and since the publication of the *Ko-ku-yao-lun* ('Essential Information for Judging Antiques') in 1387, no collector's handbook has been complete without a section on strange-shaped stones.

138

A feeling for subtle change in a fixed range of shapes was seen to be specially keen in the early centuries of the evolution of hieratic style, the later Shang and the Western Chou periods. Here the appreciation of shape was allied to much else. But if we move into the preceding neolithic age a particularly telling contrast in feeling for ceramic form appears. On the whole the earlier neolithic was con-

* C. and M. Beurdeley, *Giuseppe Castiglione*, Lund Humphries, 1972, quoting from the *Lettres édifiantes et curieuses écrites des missions étrangères.*

tent with ornament painted on comparatively
simple shapes – bowls and urns which continued un-
changed for many centuries. But in the Lungshan
neolithic of the east the potentialities of the newly
adopted potter's wheel led to some experiment with
virtuoso throwing. Tall narrow beakers with wide
rims, and bowls standing high on improbably slender
stems, savour of the *tour de force*, and their black-
burnished surface offers nothing to detract from con-
templation of the shape.

Strange to relate, the Lungshan style did not stop
at natural ceramic forms, those which are readily
produced on the wheel. Some of the most numerous
vessel types have sharply angled profiles, and may
even look like two pots separately thrown and joined.
Such predilection for structural as against spon-
taneous ceramic shape has persisted in Chinese pottery
throughout its history. During the bronze age the best
pottery is that imitated from bronze vessels, and
ceramic shape is found chiefly in the plainest utili-
tarian ware. It would be mistaken to regard the
Chinese ceramic tradition as continuously exempli-
fying the virtues of the potter's wheel, through
which the individual touch of the maker is left on
every piece. From the earliest times the Chinese potter
worked to an impersonal standard, and his modelled
and structured products, in the superior wares, prob-
ably outnumbered the pieces finished on the wheel.
The studio potting now so firmly established in
Europe has arisen largely as an extension of a move-
ment launched in Japan, whose ceramic ideals have
always been sought in Korea. In the freely handled
and painted Korean stoneware which provided the
inspiration, thrown form is the rule.

The cultivation of refined form, apart from the
Lungshan experiment, began with Yüeh ware, so-
called from its rise in the region around the mouth
of the Yangtze, in south Kiangsu and north Chekiang,
where, from the third century A.D., stoneware was
gradually refined to porcelain. This is the ware des-
cribed in the *Tea Classic* as 'green and ice-like'. That

it was patronized by the nobility is shown by the old name *pi-se* (private, or reserved, colour) applied to it. But the majority of Yüeh consists of pieces imitating bronze or silver vessels; and boxes and water-droppers for the scholar's desk which take the shape of fruit or animals. It is in the white porcelains of North China that ceramic shape is made to excel by its own unadorned merit, and the cult of this pure form appropriately finds its origin in the more austere taste of the northerners.

113 The white porcelains made in Hopei in the late T'ang include a plain, rather heavily potted bowl with a thickened lip, no doubt intended for tea. Through the Northern Sung period the shape was progressively refined to a form which, by the twelfth century, in the Southern Sung, achieved the ideal of the tea-bowl. The early white bowls, like the imitations made of them at the Yüeh kilns, have a comparatively wide base, and the sides are only slightly convex. Change lay towards a narrower base and a subtly inflected side with a curve that accelerates towards the bottom. The lip was often finished with the slightest turn outwards.

There are many variations of this shape to be seen, with disproportionately small base and straight sides, grooved lips, or, rather seldom, a wider base and steeper sides. But the curve of the profile was never allowed to approach the segment of a circle, and the suggestion of an S-curve was scrupulously avoided. The virtues of these bowls are as much tactile as visible, for the tea-bowl must fit the hand. Other pieces in which form is controlled with special care, and combined with exceptional glaze, appear all to derive their shape, in the first place, from bronze vessels which they copy. But the copying is only approximate, and these porcelains are to be distinguished from others in which an effort is made to come near to the original. The tall narrow-necked vase with sides swelling in long curves is inspired perhaps by a bronze flask which owes its shape to the spinning process used in its manufacture: the thin

metal is pressed slowly over a wooden core as it rotates, and since it must be made to flow evenly without a break, no sudden change of direction is possible in the profile.

Other metal-inspired designs are an outcome of the archaistic movement discussed below. When the *ting* 123 tripod censer was produced in porcelain at Yao-chou in the twelfth century, the detail of the metal ornament is preserved as far as moulding in clay permits. But the *ting* and *kuei*, made in the later twelfth and the thirteenth centuries, omit such detail, and the motive 114 for doing so can only be the potter's sense of form which forbade such unceramic additions. Under the Southern Sung emperors, some kilns were under influence from the court. The ceramic restraint of Lung-ch'üan reflects an aesthetic whose first adherents were in the entourage of the emperor Hui Tsung, on the eve of the invasions which drove the government south to Hankow.

The Mongol Style

During the Sung dynasty, when the Persian influence present in the decorative art of T'ang had receded, native Chinese taste prevailed in the minor arts as much as in painting and sculpture. By 1271 the Mongols had completed their conquest of China and Kubilai sat on the dragon throne, and potter and metal worker inevitably adapted their designs to suit the requirements of foreign patrons. Mongol taste is difficult to define for the simple reason that the camp on the steppe knew no art of its own. When Mongol chieftains had the chance of surrounding themselves with civilized luxury, they accepted what was nearest to hand. No Chinese object of the Yüan period can be strictly ascribed to Mongol inspiration. But the *pax Mongolica* provided at least a freer passage for trade between China and the Iranian world, so that contacts which had been broken during Sung rule were to some measure restored.

Kubilai and his successors wished to assimilate themselves and their court to Chinese manners and culture as completely as possible. Painters were summoned to join a revived academy. Most of them refused, and their motives have been seen in retrospect as wholly patriotic. But in some cases they may have been influenced by fear that court promotion would belong to the newcomers rather than themselves, while on purely artistic grounds painters might well hesitate to submit to the stylistic dictates which had governed the work of academicians under the previous régime. The notorious exception to this boycott was the most gifted painter of all: Chao Meng-fu accepted the imperial summons and executed works at the court which changed the course of Chinese painting. As originator of a new style he was seconded in the following generation by Wang Meng, an artist who became involved in a conspiracy against the Mongol rulers and died in prison.

The stylistic revolution launched by Chao Meng-fu in the leading branch of the fine arts is not to be associated in any way with Mongol taste or the personal patronage of the emperors, although the archaistic and sentimental spirit which is behind it agreed very well with the Mongols' ambition to be accepted as cultivated members of Chinese society. In the minor arts something more characteristic can be detected. After the restraint of Sung ornament we are again in an age of exuberance.

In ceramics the introduction of an unprecedented technique abetted this taste. Some time after 1300, and probably near to the middle of the century, Chinese potters learned to paint designs which were covered with glaze before firing. The designs appear in blue or subdued red, depending on whether a cobalt or copper mineral was used in the pigment. The technique was probably suggested by Persian practice, but in China it was immediately raised to a level of accomplishment unknown in the Near East. It astonished the world then (for the new blue-and-

white ware soon began to be exported westwards), and it has not ceased to astonish us since. With under-glaze copper painting the potters had less success, the red proving difficult to control in mass production and too often yielding the tone called donkey's liver. The earliest dated pieces of blue-and-white porcelain have an inscription naming a year equivalent to A.D. 1351.*

The painted designs cover the sides of vessels and fill plates from side to side. Crowding is not always avoided, and the abandonment of restraint in the use of space is perhaps a sign of the nomad Mongols' delight in overflowing ornament of any kind. They had no motifs to contribute, and the part of the ornaments consisting of flowers, birds, clouds, dragons and such are taken from the Chinese repertory. Scenes of birds in gardens with strange rocks, of ducks swimming among lotus, are most pleasing, introduc-ing generous portions of comparatively realistic nature into ceramic decoration. The imperial dragon now assumes the place in palace decoration which it was destined to occupy ever afterwards. The drawing style vied with the work of professional painters in deftness of brushed line and graded tones. This early blue-and-white is painted with freshness and bold-ness which long practice has not yet tamed to the inevitable Chinese elegance. Only in the colour it is sometimes inferior, for the early pigment was apt to gather into blackish lumps, and the shining sapphire of the Ming ware still lay in the future.

The items of decoration which can be attributed specifically to the circumstances of the Yüan period 117, 118 reveal the influence of metalwork imported from the Near East. They are chiefly panels set in a circle formed by a figure which may be derived from the *lām-aliph* of Koranic inscriptions, and some small angular motifs such as the key fret. Such geometric addenda are a little incongruous amid the natural

* They are preserved in the collection of the Percival David Foundation of Chinese Art, University of London.

lines and balanced but irregular spacing of the Chinese contribution. They also encourage the artist to compose his natural motifs in distinct panels, which are arranged around the vessels in a manner reminiscent of the imported metalwork. The graded tones of the painting give it an unprecedented solidity. In white porcelain experiments were made in reproducing the high, undercut relief which is distinctive in Yüan silver.

Means were not yet available to endow porcelain with all the colour that appealed to Mongol taste. The splendour that met the eyes of Marco Polo and his party when they visited Kubilai's new palace in Peking at the end of the thirteenth century appears to outshine what one would expect of a Sung palace. In excavations at Peking was found a great deal of brightly coloured lead-glazed earthenware which seems to have fallen from architectural ornaments. The Yüan period saw a revival of lead glazing, and some vessels outrageously overloaded with ornament were executed in this medium.

Archaism A traditionalism present in all the Chinese arts ensures the survival of decorative schemes over long periods, and allows them often to be revived in the most natural manner even after they have fallen out of use for a long time. But this may be distinguished from a deliberate effort made to restore an art of the past at a time when the function of the original style was no longer generally understood. Before the Northern Sung period this had seldom been done, perhaps the most notable instance being the copying of long-obsolete types of bronze vessels in Yüeh porcelain. But at the end of the eleventh century a movement for the restoration of antiquity was launched with such enthusiasm that it has left its mark on the Chinese decorative arts ever since. It began under the stimulus of a renewed interest in Confucian studies, with the support of the emperor Hui Tsung,

and the first concern was for the ritual vessels of the ancients, which were to be reproduced exactly for use in current imperial ceremonies. The emperor gave full rein to his collector's zeal:

> As soon as the Office for Ceremonial was established a decree went forth that ancient vessels should be sought throughout the empire, in order to control the shapes of the ritual vessels *tsun*, *chüeh* and *ting* . . .

The reproduction of the antique bronzes was left in the hands of officials charged with the regulation of ceremonial, and these did not necessarily share the scientific intentions of contemporary scholars. In 1092 a compilation of ancient bronzes, the *Illustrations for a Study of Antiquity* (*K'ao-ku-t'u*), and the *Catalogue of All Antiquity* (*Po-ku t'u-lu*) which followed it about two decades later, were guides for all who wished to practise the ancient styles. There is some evidence that an initial effort was made to copy accurately the *t'ao-t'ieh* mask and dragons of the ancient hieratic style, but soon the craftsmen settled to a conventional version of the antique which established itself independently as a palace style. Its designs were somewhat influenced by the simplification and distortion peculiar to the printed illustrations which circulated. Only a privileged few could hope to see the original ancient pieces. But the *kuei* bowls and the *tsun* and *hu* vases were produced in large numbers.

Today it is difficult, if not impossible, to recognize archaistic bronzes made in the Sung period, the bulk of surviving pieces being no older than the fourteenth or fifteenth century. Judging from the accounts given in the antiquarian manuals a belief was current that the bronzes of the Hsia dynasty were inlaid with gold, an opinion particularly curious in the light of a view adopted in the second of the two works mentioned above, which differs from the earlier one in omitting the category of Hsia bronzes altogether. One may infer that a debate was in progress on the

123–9

existence of Hsia vessels, and that later opinion tended to doubt it. Modern archaeologists can add nothing to that conclusion, since no remains of Hsia date have been identified in their excavations.

The result of the antiquarian debate in the last years of the Northern Sung dynasty was to establish a system of quasi-antique ornament which thereafter proceeded to evolve with a life of its own. *T'ao-t'ieh* and dragon continued to dominate the schemes, but they gradually lost their ferocity and august associations, and could be pleasantly combined with ornament of different origin. From the palaces the archaic style invaded the minor arts generally. Its themes became as readily available to the craftsman as his flowers and animals, to be used out of context and often in versions so distorted through reproduction in inferior books that they are hardly recognizable.

On pottery the archaistic style had limited influence, for here the peculiar detail could hardly be copied. The Southern Sung porcelain in which some of the shapes are adopted was in its turn taken as a model for a large number of bronzes cast in a refurbishing of palaces undertaken in the reign of Hsüan Te (1426–35), so that we witness the curious spectacle of two continuing lines of archaistic forms, one of which was differentiated from the other by its passage through the potter's hands. In bronze work the free decorative use of the archaistic repertory, without a thought of ancient models or the prescriptions of ritualist manuals, reaches its best in the work of Kiangsu bronzesmiths of the late sixteenth century, of whom Hu Wen-ming and Shih Soù have left their signatures.

Other Palace Styles

Probably the earliest instance in which government enterprise may be said to have left its mark in decorative art is that of lacquer produced in official ateliers during the Han dynasty. These were located in Szechwan, where grew the lacquer tree, and went by

32, 33

such names as Inspection Factory, Right Hall Factory, and Eastern Garden Crafts. Lacquered wine cups and boxes for medicines, pomades and comfits were supplied to officers serving at the outposts of empire along the north-western frontier, and at the Chinese military colony of Lolang in North Korea, where many fine pieces have been excavated.

To the official connection of these early lacquers is probably to be attributed a peculiar feature. The wine cups were made chiefly (if we may judge from inscriptions appearing on them) in the last century B.C. and the first century A.D., but their ornament is derived from the last phase of the Huai style, in which the figures of the hieratic style are reduced to a rather jejune geometry. Chinese emperors were ever collectors of the art of their predecessors – its possession confirmed their pretensions as upholders of tradition and proclaimed them members of an upper class into which some of them had but recently penetrated. A classic instance is the effort made by the first emperor of Ch'in to recover the tripods of the kings of Chou, which were reported to have been lost in a river.

When art work was officially commissioned what more natural than to give an ancient piece as a model to be copied? In this way much of the official lacquered goods of the early Han period by-passed the decorative style characteristic of the second century B.C., although they later adopted the cloud-scrolls which were developed from it. But a curious and memorable tendency of the lacquer painters to indulge in dreamy linear fantasy of a Klee-esque kind is a sign of the times, for it can be paralleled in some of the distortions permitted in drawings whose purpose was otherwise realism and information. By the end of the first century A.D. this archaistic tradition of lacquer painting ceases, and is replaced by pictorial subjects allied in style to the *genre* drawing of the later Han period, which has already been described.

Courtly and official patronage of the arts has been perennial in China, and is not to be distinguished in

general from the influence of sophisticated taste in a wide sense. Its rôle in disseminating the archaistic style has already been discussed. It is appropriate therefore to single out features of palace style only when these received specific encouragement in the imperial circle. This seems to have happened in the case of porcelain during the Mongol reign, when Kubilai's enthusiasm for building at Xanadu and Peking, entailing vast furnishing, gave a constant incentive.

There was a precedent for imperial concern with potters. After the southward move of the Sung government official kilns were established on the outskirts of the new capital – the famous factory first established at the Surveyor's Office (*hsiu-nei-ssŭ*), which was later moved to a site near the Altar of Heaven (*chiao-t'an*). The first Ming emperor, Hung Wu, moved the imperial patronage to the potters' town of Ching-te-chen in Kiangsi, rather than set up official kilns at the palace, and his example was followed by his successors. An imperial commissioner with the rank of a Secretary of the Board of Works was despatched to Ching-te-chen, to the alarm of its inhabitants, 'in order that imperial wares might be in larger numbers and of finer quality'.*

Between 1726 and 1753 the supervision of the kilns was in the hands of two men well acquainted with the European painting style, Nien Hsi-yao and T'ang Ying, who had frequented the company of the Jesuit artists established at the Ch'ing court. They introduced touches of the European manner in the drawing and shading of figure subjects painted in 133, 134 overglaze enamels on *famille rose* porcelain, and even copied some European figures completely. The court had again assumed its rôle as the centre from which a foreign influence spread through the minor arts. Foreign artists had been appointed to entertain the emperor with exotic decoration for his palaces, the

* Soame Jenyns, *Later Chinese Porcelain*, Faber, 4th ed., 1971, p. 11.

counterpart of the Chinese *féeries* of the French court, but their influence was felt beyond the palace walls.

The practice of commandeering the services of artists and craftsmen for palace works began under the Ming emperors, who put it upon a regular basis, the terms of service and rewards being prescribed. The provinces of Kiangsi and Chekiang naturally provided the greater part of this 'tribute', for the arts of the weaver and the metalworker flourished in that region no less than that of the potter. We know more of the organization of the palace workshops of the Ch'ing emperors than of those of their predecessors.

The Jesuit Father Verbiest is said to have helped K'ang Hsi to arrange them. K'ang Hsi's grandson, the emperor Ch'ien Lung, had his interest in European learning and art thoroughly awakened by his grandfather, to whom he owed more in his education than to his less energetic father. For Ch'ien Lung the continuance of the workshops was a pious matter, like the classical studies into which K'ang Hsi had sternly launched him as a means of earning the respect of the Chinese official class for a Manchu prince. By 127, 128, 130–2, 136 1680 some thirty workshops were in operation, producing work in enamel, glass, bronze, gold, lacquer. Ivory and jade were carved and furniture of all kinds was made.

Among the Chinese crafts Ch'ien Lung loved jade with a devotion only second to his passion for European clocks. He designated the region of Khotan in western Central Asia as a territory for direct government from the palace, chiefly, it would seem, to secure the whole of its export of jade for his workshops. Some three thousand men were employed to quarry the stone and search for it in the river beds, and illicit trade was punishable by death – but still not suppressed. While the jade carvers inevitably spent much of their time on archaistic work (copying bronze vessels however, rather than the ancient ritual jades), this was by no means the whole of their product.

Large size was admired in everything, the jade vessels distributed through Ch'ien Lung's numerous palaces exceeding anything made in earlier times. But quality was inspected by the emperor and the work he approved is not to be mistaken among the vast

141, 142, 144 numbers of jades that survive from the eighteenth century. Excellence of the material came first, then a freshness and originality in the carving, last, amusing skill in the choice and presentation of subjects. The

137 constant theme is the imperial dragon writhing in pursuit of its fiery pearl, and the symbols of longevity, the peach and the *shou* ideogram, are ubiquitous. The emperor's writing was carved on plaques to make jade books between covers with gilded ornament. In jade Ch'ien Lung could brook no rival. When he became acquainted with Indian jade carving he felt obliged to have it copied and excelled in his own workshops. This was done so successfully that it can be uncertain whether a piece is to be ascribed to India or China. But on the whole no such doubt attaches to the exotica of the palace craftsman, and in subjects wholly European the Chinese touch is still unmistakable.

Bibliography

W. R. B. Acker
Some T'ang and pre-T'ang Texts on Chinese Painting
Leiden, 1954

J. Ayers
The Baur Collection, Geneva: Chinese Ceramics, Vols. I–III
Geneva, 1968–72

E. C. Bunker, C. B. Chatwin and A. R. Farkas
Animal Style Art from West to East
Asia House, New York, 1970

S. Bush
The Chinese Literati on Painting
Cambridge, Mass., 1971

J. Cahill
Chinese painting
Lausanne, 1960

Fantastics and Eccentrics in Chinese Painting
Asia Society, New York, 1967

V. Contag
Chinese Masters of the 17th Century
London, 1969

Sir Percival David
Chinese Connoisseurship: The Ko Kǔ Yao Lun
London, 1971

G. Debon and Chou Chün-shan
Lob der Naturtreue:
das Hsiao-shan hua-p'u des Tsou I-kuei (1686–1772)
Wiesbaden, 1969

Sir Harry Garner
Chinese and Japanese Cloisonné Enamels
London, 1970

Oriental Blue and White
London, 1970

B. Gyllensvard
Chinese Gold and Silver in the Kempe Collection
Stockholm, 1953

S. H. Hansford
Chinese Carved Jades
London, 1968
A Glossary of Chinese Art and Archaeology
China Society, 1972

S. Jenyns
A Background to Chinese Painting
London, 1935
Later Chinese Porcelain
London, 1971
Ming Pottery and Porcelain
London, 1953

S. Jenyns and W. Watson
Chinese Art: The Minor Arts, I and II
Fribourg, 1963, 1965

I. L. Legeza
The Malcolm Macdonald Collection of Chinese Ceramics
London, 1972

D. Lion-Goldschmidt and J.-C. Moreau-Gobard
Chinese Art: Bronze, Jade, Sculpture, Ceramics
Fribourg, 1960

M. Loehr
Ritual Vessels of Bronze Age China
Asia Society, New York, 1968

M. Medley
A Handbook of Chinese Art
London, 1973
Yüan Stoneware and Porcelain
London, 1974

Oriental Ceramic Society, London
The Ceramic Art of China
London, 1972

H. Osborne
Aesthetics and Art Theory
London, 1968

A. Priest
Chinese Sculpture in the Metropolitan Museum of Art
New York, 1944

B. Rowland
The Evolution of the Buddha Image
Asia Society, New York, 1963

G. Rowley
Principles of Chinese Painting
Princeton, 1959

L. Sickman and A. Soper
The Art and Architecture of China
Harmondsworth, 1968, paperback edn 1971

O. Siren
The Chinese on the Art of Painting
Peiping, 1936
Chinese Sculptures in the Von der Heydt Collection
(Museum Rietberg, Zurich), n.d.

W. Speiser, R. Goepper and J. Fribourg
Chinese Art:
Painting, Calligraphy, Stone Rubbing, Wood Engraving
Fribourg, 1964

M. Sullivan
The Birth of Chinese Painting
London, 1962

J. Tschichold
Chinese Colour Prints from The Ten Bamboo Studio
London, 1972

W. Watson
Ancient Chinese Bronzes
London, 1962

G. W. Weber
The Ornament of Late Chou Bronzes
New Brunswick, 1973

R. Whitfield
In Pursuit of Antiquity
(Ming and Ch'ing paintings in the Morse Collection)
Princeton, 1969

W. Willetts
Chinese Art
Harmondsworth, 1958

Foundations of Chinese Art
London, 1965

J. Wirgin
Sung Ceramic Design
Stockholm, 1970

Acknowledgements

I thank the following institutions and persons for allowing me to illustrate pieces from their collections, and for supplying photographs or allowing them to be made. The numbers refer to plates.

The Art Institute, Chicago: 99; The Asian Art Museum of San Francisco, The Avery Brundage collection: 8, 12, 18; The Trustees of the British Museum: 13, 19, 35, 37, 38, 100, 103, 105, 116, 125, 130, 143; The Brooklyn Museum: 106; The City Art Gallery, Bristol: 109; The Cleveland Museum of Art: 70; Lord Fairhaven: 144; The Fitzwilliam Museum, Cambridge: 124; The Fogg Art Museum, Cambridge, Mass.: 28; La Fondation Baur-Duret, Geneva: 140; The Freer Gallery of Art, Smithsonian Institution, Washington D.C.: 22, 39, 102; Sir Harry Garner: 128; The Institute of Archaeology of the Chinese Academy of Sciences: 1, 2, 7, 11, 14, 17, 20, 21, 31, 40, 45, 84, 85, 101, 104, 113, 119, 120, 123; The Carl Kempe collection, Ekolsund: 117; Kunstindustrimuseet, Copenhagen: 15, 29, 30, 61, 82; The Metropolitan Museum of Art, New York: 6, 65, 68; Le Musée Guimet: 67, 98; Das Museum für Ostasiatische Kunst, Cologne: 122; The Museum of Far Eastern Antiquities, Stockholm: 97; The Museum of Fine Arts, Boston, Mass.: 54, 88; De Museum van Aziatisk Kunst, Amsterdam: 72; The Nelson Gallery/Atkins Museum, Kansas City: 3, 89, 118; The Nezu Museum, Tokyo: 4; The Percival David Foundation of Chinese Art: 92, 107, 111, 114, 133, 134; Museum Rietberg, Zürich: 121; Die Staatliche Museen Preussischen Kulturbesitz, Museum für Ostasiatische Kunst, Berlin: 25, 27, 32, 78; Crown copyright, The Victoria and Albert Museum: 110, 126, 127, 131.

For generously providing photographs thanks are due to L'Office du Livre, Fribourg: 28, 73, 100, 102, 103,

124–9; Messrs Spink and Son: 136, 141, 142; Mr Jan Tschichold, and Messrs Lund Humphries, publishers of facsimiles of the *Ten Bamboo Studio* prints: 145, 146.

For allowing me to take the photographs used in plates 43, 44, 71, 90, 91, 132, 135, 137, 138, I am beholden to the Chinese authorities.

I thank Messrs Faber and Faber for allowing me to reuse figures D and E from their edition of my *Ancient Chinese Bronzes*.

1. White pottery jug (*k'uei*) with three hollow legs. This type of vessel is found in the eastern coastal region during the later, Lungshan, neolithic period. It marks the rise of a tradition of sculptural design which is in contrast to the hand-turned pottery of the earlier Yangshao neolithic, and which continues later in bronze vessels.
Height 29·7 cm.
3rd or 2nd millennium B.C.
Excavated at
Wei-fang, Shantung.

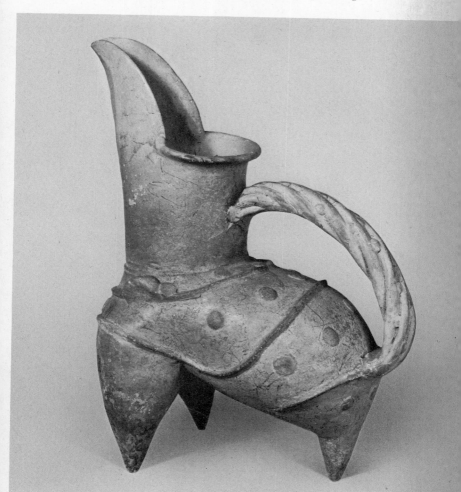

2, 3. Bronze sacrificial *lei* (left) and *hu* (right) marking two stages in the evolution of the apotropaeic monster mask. The *lei*, some three centuries older than the *hu*, shows the stylized lateral appendanges of the mask (the monster's body) still adhering to it, with an accompaniment of geometric figures. In the *hu* the half-mask has been multiplied many times as independent 'dragons' (*k'uei*) seen in side view. *Left: height 25 cm. 15th century* B.C. *Excavated at Cheng-chou, Honan. Right: height 40·5 cm. 13th-12th century* B.C. *Nelson-Atkins Gallery of Art, Kansas City.*

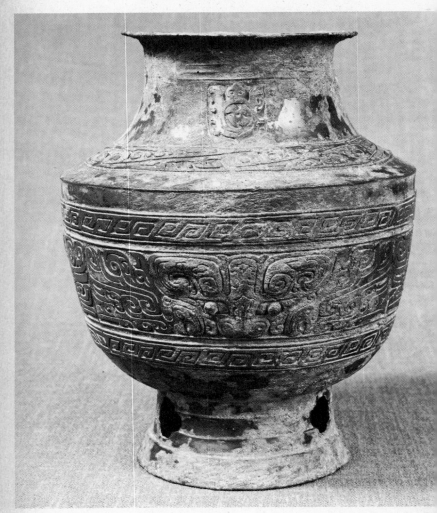

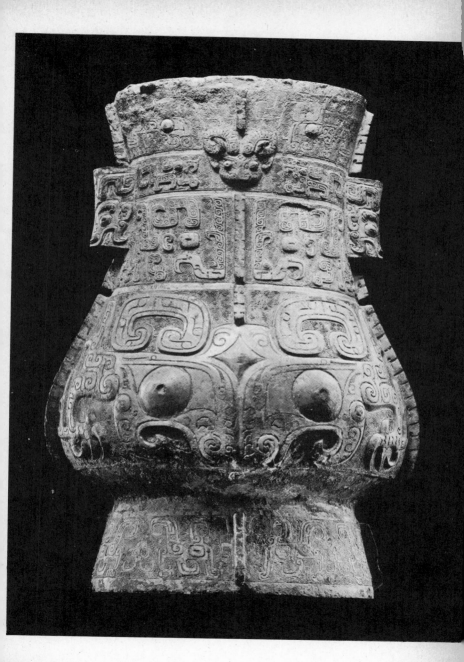

4, 5. This bronze sacrificial wine-pourer, *ho*, is one of the largest and finest pieces to have survived from the Shang dynasty. The sharp-angled, high relief of the ornament is characteristic of the latest stage of the Shang hieratic style, and of the workshops of the capital at Anyang in Honan. The monster masks over the legs are assimilated to some extent to a bull mask (in other cases the resemblance is closer) and the mask forming the cover (right-hand illustration) has the unusual suggestion of a human face, although without a hint of the realism seen on the vessel of illustration 7. The *ho* is a good example of skilled adaptation of ornament to overall shape. The notched flanges to the vertical edges acquire a prominence typical of this stage of evolution – a feature destined to be exploited to an absurd degree in some grotesque designs made at the end of the tenth century B.C.
Height 73 cm.
Late 11th century B.C.
Nezu collection.

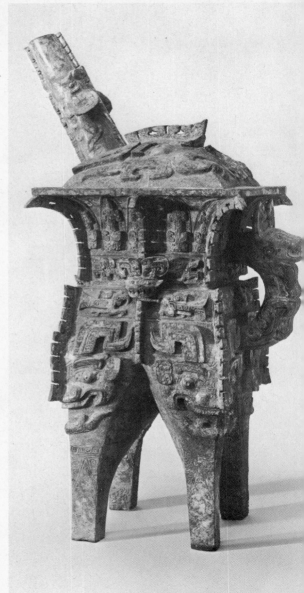

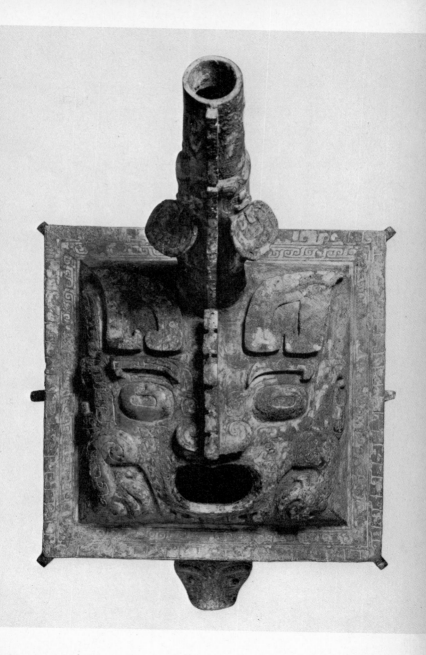

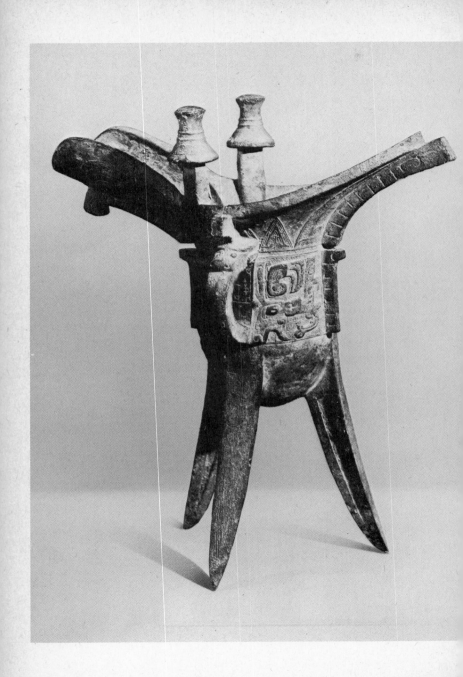

6. The bronze libation goblet *chüeh* well illustrates the balance and expressive vertical structure anticipated in some east-China neolithic designs (cf. illustration 1). The *t'ao-t'ieh* is split into two profile dragons by the handle (the single leg being particularly clear). *Height 22·5 cm. 12th–11th century* B.C. *Metropolitan Museum, New York.*

7. This ritual food vessel *ting* is the only one known with ornament of human masks. Flanking this unusual realistic theme are details taken from the normal monster mask. On the handles are *k'uei* dragons in concave line. *Height 38·7 cm. 13th–11th century* B.C. *Excavated at Ning-hsiang, Hunan.*

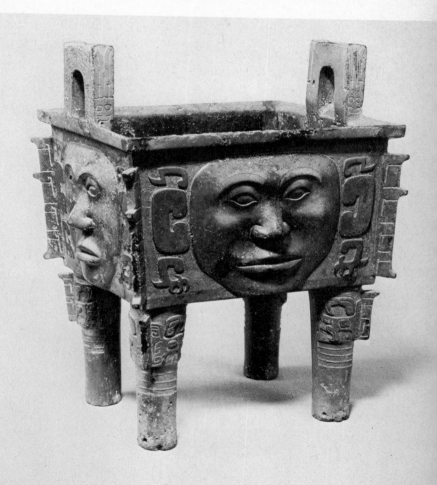

8. Ceremonial bronze wine vessel, *kuang*, displaying on its side the 'exploded' *t'ao-t'ieh* mask, its parts separated by the ground of squared spirals. Features characterizing the latest Shang phase are: high-relief of ornament, the 'humped' dragon placed near the horns, the quasi-realistic elephant and ram head. The *kuang* invited the wildest extravaganza in composing vessels with weird detail of monsters. *Height 22·8 cm. The Asian Art Museum of San Francisco. Avery Brundage collection.*

9. Bronze *ting* with coherent mask supplied with the full body on either side. The sought weightiness of the design is typical of the tripods. *Height 23·5 cm. Formerly E.K. Burnett collection. Both 12th-11th century* B.C.

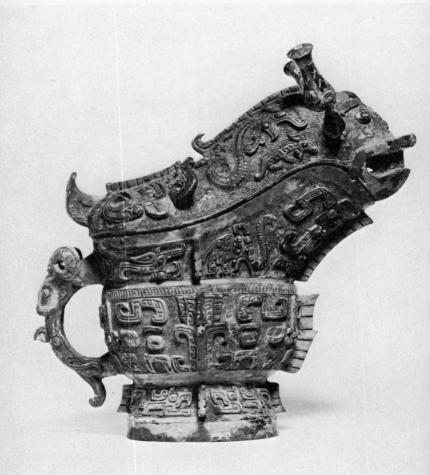

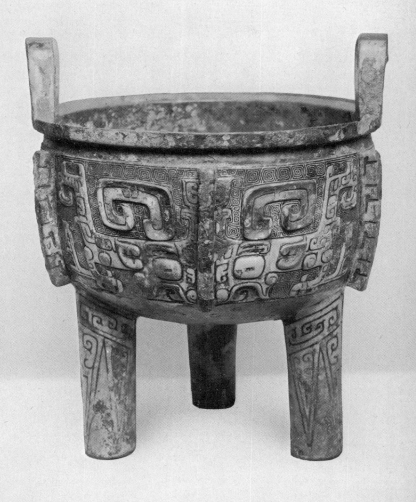

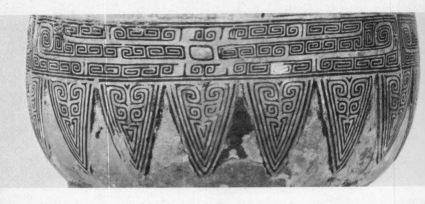

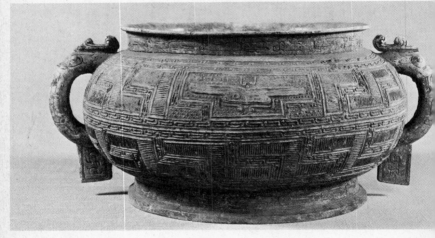

10. Detail of bronze ritual tripod showing the *k'uei* reduced to a decorative band, meaningless but for the eye surviving at the centre. Beneath are the so-called hanging blades figures derived from a more explicit design of a cicada. The interstices of the ornament are filled with black inlay to set it off. *Width 13 cm.*

12th–11th century B.C. *Cunliffe collection.*

11. Bronze food-vessel, *kuei*, from a provincial atelier, showing the final geometric reduction of mythical animal form. If the central element survives from the usual mask, it is now as unrecognizable to ancient eyes as to modern. *Height 19·7 cm.* *10th century* B.C. *Excavated* at *Tun-hsi, Anhui.*

12. *Ajouré* rolled dragon decorating the blade of a ceremonial axe. This figure stands at the origin of the animal-in-a-ring motif of the nomads of inner Asia in later times. *Height of dragon* c. *6 cm.* *11th century* B.C. *The Asian Art Museum of San Francisco.* *Avery Brundage collection.*

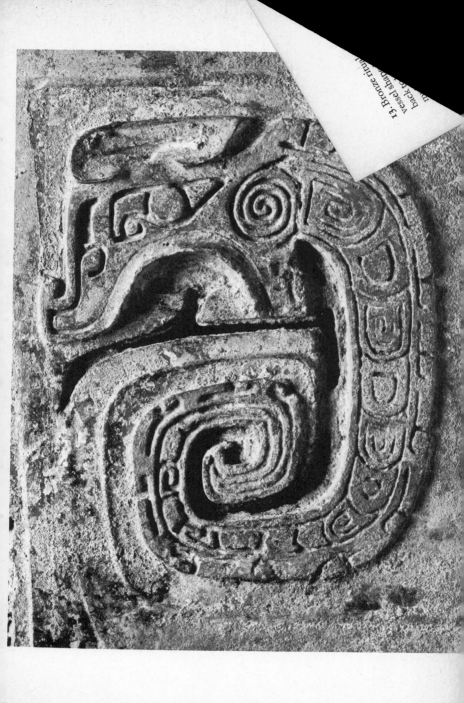

wine
like rams
back. The normal
multiplicity of animal
motifs is replaced by an
even design better suited
to revealing the noble
monumental form. The
convention of a spiral on
the shoulder (sometimes
it is a snake) persisted for
almost a thousand years.
Height 43 cm.
12th–11th century B.C.
British Museum, London.
14. Bronze wine vessel,
tsun. In an unusual
variation the relief of the
monster mask is set
obliquely, bringing the
main lines into prominence.
*Height 47 cm. 12th–11th
century* B.C. *Excavated at
Fu-nan, Anhui.*

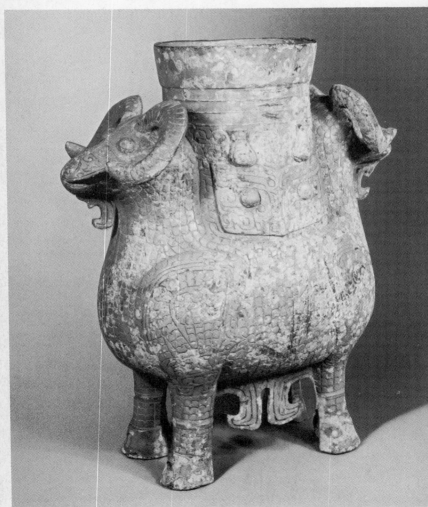

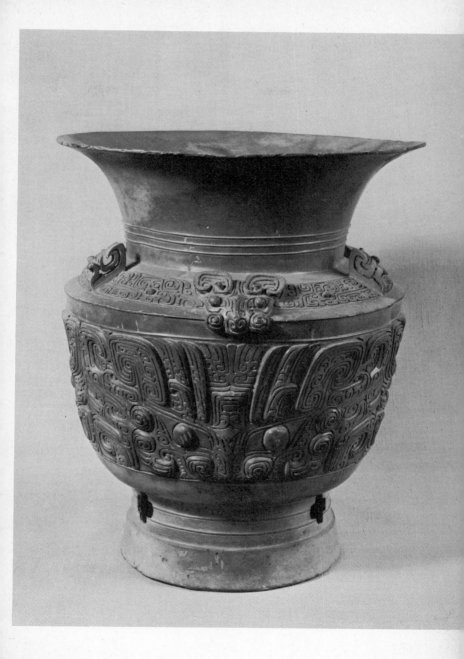

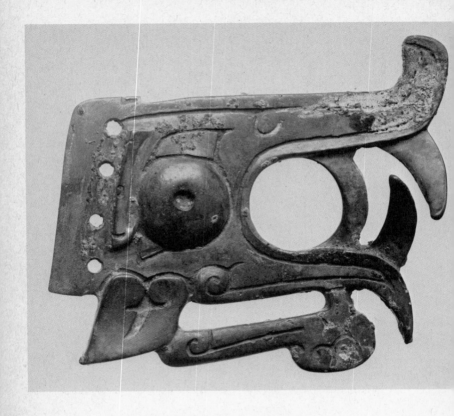

15. This bronze cheek-piece from a bridle bit shows a detail from hieratic ornament adapted to picturesque practical use. A certain disregard for the relevance of subordinate parts (here the ear shape added to what seems the joint of a leg) suggests a relaxation of traditional standards, and anticipates the regular practice of the later art of steppe nomads – the 'animal style'.

Width 10·9 cm.
8th century B.C.
Kunstindustrimuseet,
Copenhagen.

16. The handle of a food vessel (*kuei*) demonstrates a treatment of three-dimensional form as a number of intersecting planes, in the spirit of the contemporary planar design. The monster has a feline-bovine head, and bird's claws.

Height 18·5 cm. C. *1000* B.C.
Malcolm collection.

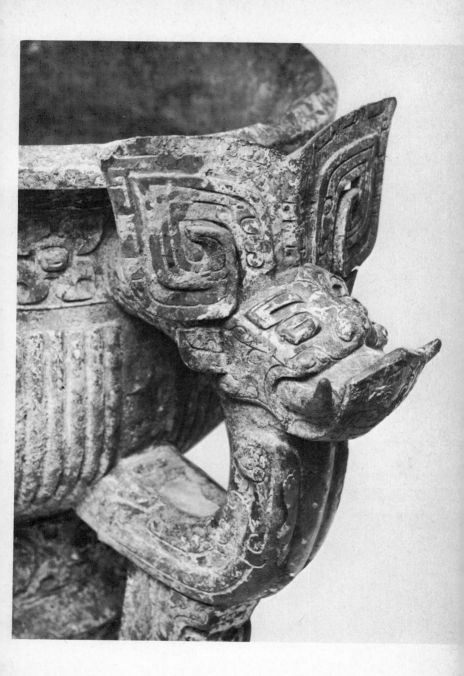

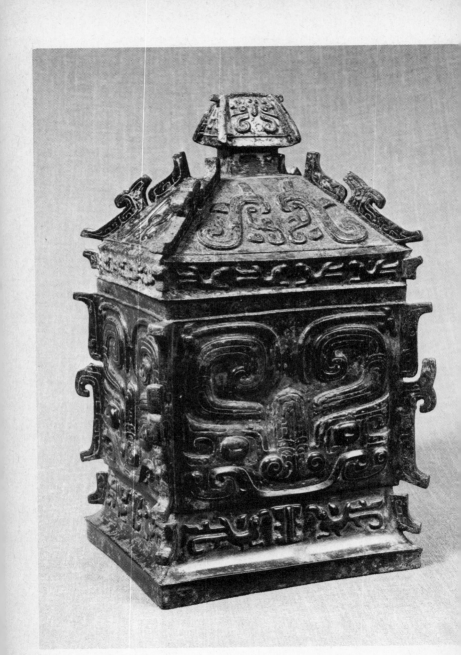

17. Bronze ritual vessel, *fang yi*, with the softened relief characteristic of the post-Shang century. In such designs of the Western Chou period the disruption of the mask into its constituent parts is rarely seen. The 'exploded' design of the mask has now yielded abstract forms like those seen on the lid of the *fang yi*. A nice sense of congruence persists in the adaptation of the lines of hooked flanges to those of small birds which now appear as the chief secondary ornament.

Height 38·5 cm. 10th century B.C. *Excavated at Fu-feng, Shensi.*

18. Bronze water pourer for ritual ablution, *yi*. For the first time the interlacing of design is experimented with. Reduced to its simplest geometry this motif yielded meaningless figures something resembling Gs couched on their sides.

Height 15·2 cm. Late 10th or early 9th century B.C. *The Asian Art Museum of San Francisco. Avery Brundage collection.*

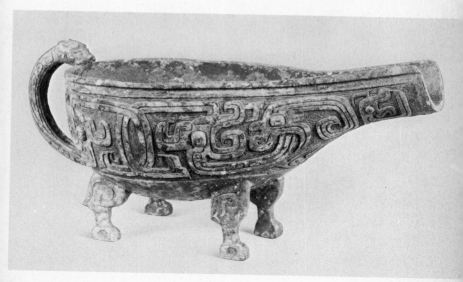

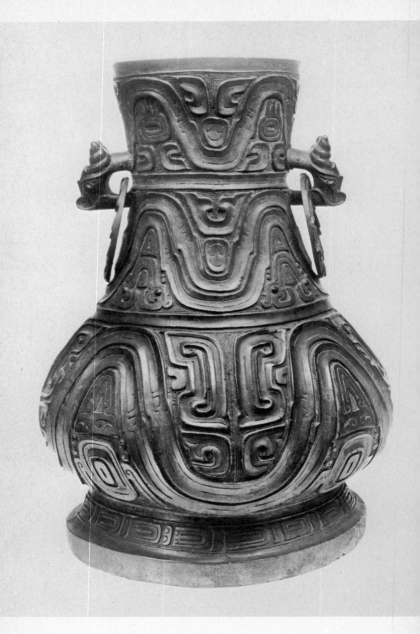

19. Bronze ritual vase, *hu*.
The geometric reduction
of animal motifs did not
necessarily conform even
approximately to the
original outlines. The
parts could be reassembled
into new schemes, and
often reflected a taste for
sweeping movement, as
appears most obviously in
this piece. The ancient
monster mask is still
hinted at, and here and
there a dragon head peeps
out.
Height 45·5 cm.
9th century B.C.
British Museum, London.
20. Ritual bronze vase, *hu*,
decorated with geometric
figures and highly stylized
tigers and dragons. In this
piece are combined the
earlier geometricized
ornament, giving the quite
abstract designs used on
the neck, and a newer
convention in which
smaller elements are built
compactly into the bodies
of imaginary animals. The
interlacing snakes of the
belly of the vase interpret
on a larger scale the
movement and counter-
movement of the new
schemes of ornament, in
which restless animation
replaces static designs,
introducing effects more
perplexing to the eye than
the undulations of the
previous piece.
Height 86·6 cm. 6th or early
5th century B.C. *Excavated at*
Hou-ma, Shansi.

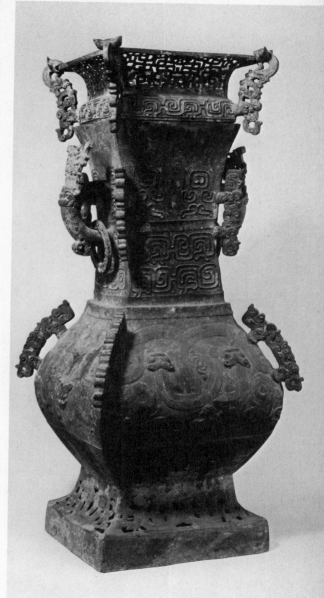

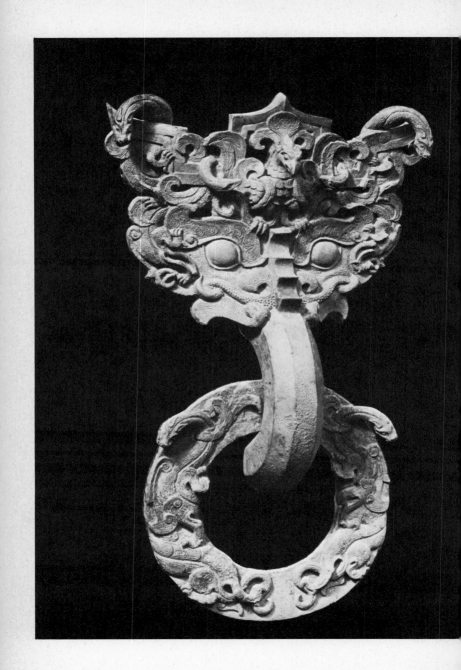

21. Bronze gate ornament consisting of a ring entwined with dragons hanging below a monster mask composed largely of a bird of prey, dragons and snakes. The need felt for vital movement is satisfied by the inclusion of bodies treated with as much realism as the unreality of the animals allows. The scales covering the bodies of the lower dragons are taken from an abstract design of an earlier period. *Length of mask and retaining bar 45·5 cm. 5th century* B.C. *Excavated at Yi-hsien, Hopei.*

22. Detail of the side of a bronze bowl, *chien,* showing traditional geometric ornament revived as raised interlacing bands. The spiral relief which punctuates the bands, with its spiral-and-wing additions, and the spiral-and-triangle of the linear filling, provided the main themes for subsequent development. Animal masks are still Simulated. *Height of the detail 18 cm. 5th century* B.C. *Courtesy of the Freer Gallery, Washington,* D.C.

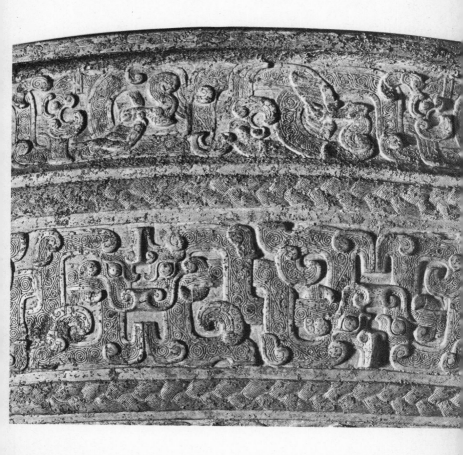

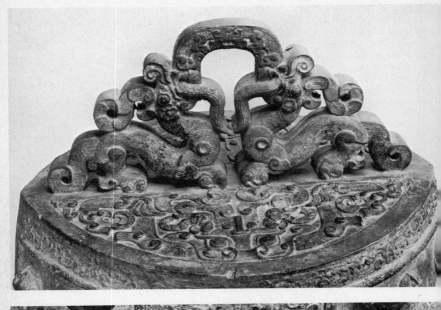

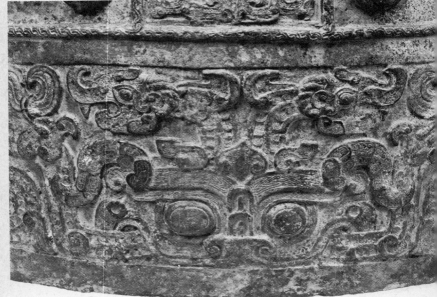

23a, b; 24a, b. These details of a bronze bell (left) and bowl (right) represent two stages in the evolution of ornament descending from the scheme shown on the previous plate. Dragons' bodies and the monster mask are built of units closely resembling those used in continuous fields of decoration. On a further reduction of scale and content the 'Huai style' ground reached the state seen in the lower figure of the right-hand plate, and such things as monster heads might be spiralled almost out of existence. Left: *height 55 cm. British Museum, London.* Right: *height of the monster head c. 8 cm. Former Oeder collection. Both 5th c.* B.C.

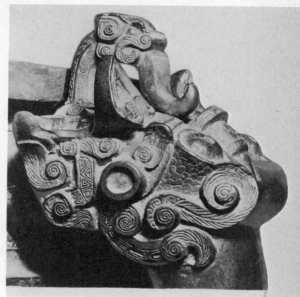

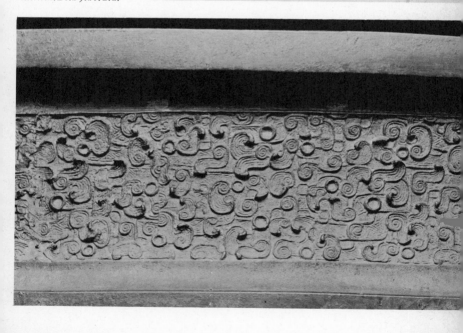

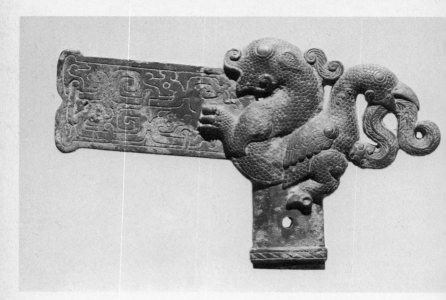

25, 26. These two bronzes exemplify two treatments of animal form found in the middle and late periods of the tradition of hieratic style. The earlier custom (lower picture) was often to combine a considerable measure of realism with an unreal feature: here the horns of the ram head of a linch-pin become the two bodies of a stylized snake.

In the decoration of the axe (upper picture) the spiralling unreality of the design pervades the whole composition, and concern for the geometric balance of parts is uppermost.
25. *Length 12·8 cm.*
4th century B.C.
Museum für Ostasiatische Kunst, Berlin.
26. *Length 12 cm.*
8th century B.C.
Malcolm collection.

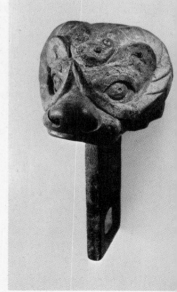

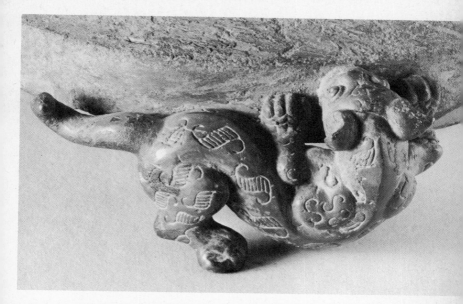

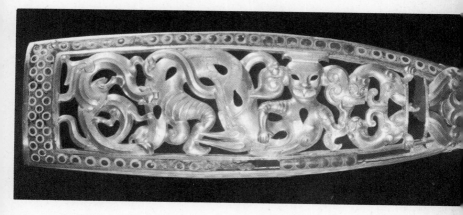

27. The tiger used as the foot of a bronze vessel has the body twisted through a half-circle, in the manner of the nomad artists of the inner Asian steppes. This unreal contortion, and the figures marking its coat, are a legacy of the hieratic tradition. *Length* c. *8 cm.* *4th–3rd century* B.C. *Museum für Ostasiatische Kunst, Berlin.*

28. Openwork gold belt-hook depicting the Taoist goddess Hsi-wang-mu. It preserves elements of ancient hieratic style in its design both in outline and in detail. *Length 8·2 cm.* *2nd century* B.C. *Fogg Art Museum, Cambridge, Mass.*

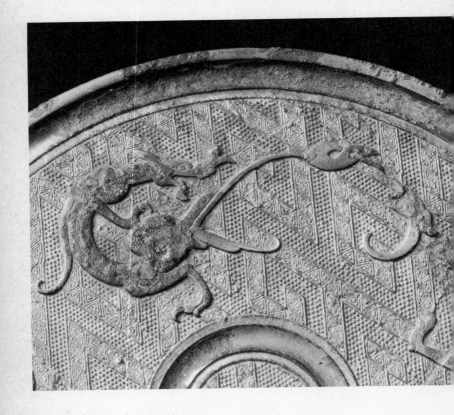

29. Leaping dragon, part of the ornament on the back of a bronze mirror. In combining into a vital design elements mostly drawn from traditional convention the artist has worked wholly in the spirit of the ancient hieratic art. The background of granulation and triangular spirals, in general inspired by twilled design in textiles, repeats a corresponding feature of Shang dynasty bronzes. *Length 8·5 cm. 4th century* B.C. *Kunstindustrimuseet, Copenhagen.*

30. In a final blossoming of hieratic design, bronze mirrors of the early Han dynasty display ornament combining interlacing and scrolling lines with stylized birds and the zig-zags of twill. The graphic conventions bequeathed by the hieratic style were falling into disuse. Their life was prolonged under palace patronage at a time when more realistic standards were gradually establishing themselves in art. *Diameter 13·2 cm. 2nd century* B.C. *Kunstindustrimuseet, Copenhagen.*

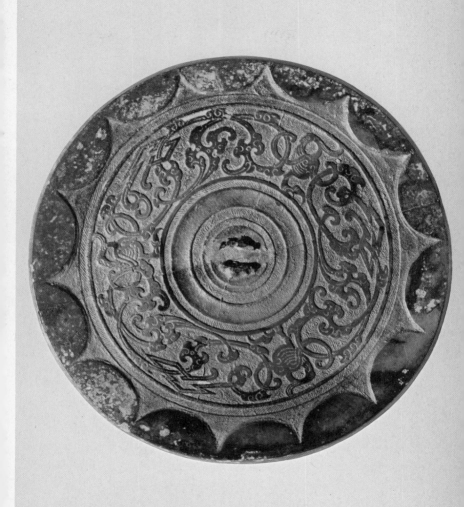

31. Silver-inlaid bronze
mount from a chariot.
The strongly geometrical
design executed at the
end of the Period of the
Warring States abstracts
the vigour and decision of
the hieratic style while
finally discarding every
hint of animal shape or
symbol with which it is
associated in earlier phases
of the evolution. *Length
21·3m. 4th or 3rd century* B.C.
*Excavated at
Yung-ching, Shansi.*

32, 33. The painted lacquer
cups made in official
factories under the Han
dynasty adapt the inherited
geometric designs in both
symmetrical and
asymmetrical schemes.
Painted lightly with the
brush, they avoid any
calligraphic effect, just as
they eschew floral or
vegetable shapes. This is
the last gasp of the
hieratic art in its natural
descent.

Top: *length* c. *20 cm.
Excavated at Ch'ang-sha,
Hunan.*
Bottom: *length 23·4 cm.
Museum für Ostasiatische
Kunst, Berlin.
Both 1st century* B.C.

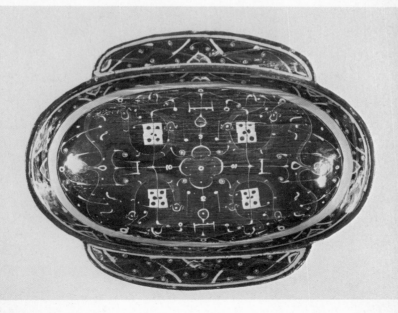

34. Limestone figure of a seated man. The linear decoration of the surface has been of greater concern to the artist than accuracy of anatomy, which remains rudimentary. The figure denotes a status – servant or prisoner – rather than an individual, and approaches the abstract standards of hieratic style.
Height 14·5 cm.
13th–11th century B.C.
Ch'en J. T. collection

35. Bronze figures of acrobats about to perform. This is the earliest known piece which attempts to portray a secular event, and to suggest actual or anticipated movement.
Height 15·2 cm.
5th–3rd century B.C.
British Museum, London.

36. Bronze chariot orna-
ment. Since the model
for the head can only have
been Przewalsky's steppe
horse, which has a blunt
muzzle and thick neck, a
degree of distortion is
evident. The artist's
intention comes nearer to
reality than in his
mythological motifs. The
added ornament spirals on
the jaw belong to the
secondary ornament of the
hieratic style.
Length 17 cm.
11th–10th century B.C.
Formerly in the
possession of J.H.Hewitt.

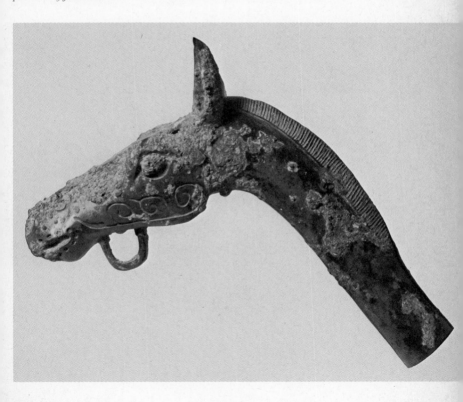

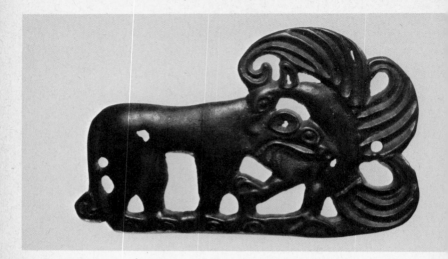

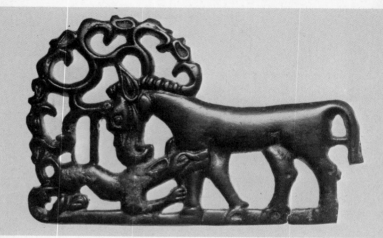

37, 38. Openwork bronze plaques from the Ordos district of north-west China. The occupation of this region by Hsiung-nu tribes introduced into Chinese territory a variety of the steppe nomad's art.

The rather placid portrayal of the animal combat (a predatory animal attacking a docile species), and the concern for a smooth silhouette are characteristic of the Hsiung-nu designs.

The elk head on a horse and antlers composed of birds' heads are the usual incongruities of the style.
Length both 12 cm.
2nd or 1st century B.C.
British Museum, London.

39. A cheerful bronze monster, of good omen. Although it is two-horned, it is probably the ancestor of the single-horned *ch'i-lin* depicted later as a symbol of prosperity and success. While much of the detail is conventional the overall shape is not one found in the usual hieratic repertory and appears to be an original essay in vital form.
Length 36·6 cm.
1st or 2nd century A.D.
Courtesy of the Freer Gallery, Washington, D.C.

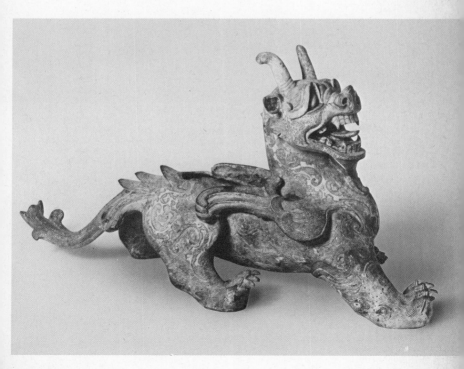

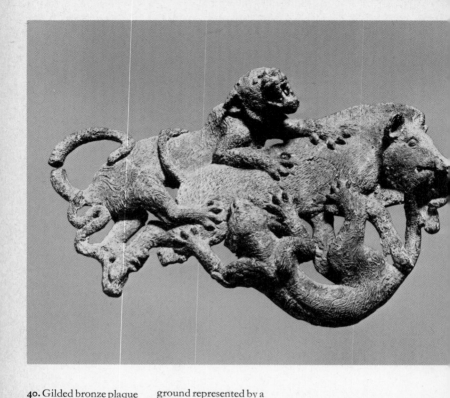

40. Gilded bronze plaque
of two hunting leopards
bringing down a wild boar.
The realism of the relief
and the expression of the
upper leopard (a snake is
biting the root of his tail)
are typical of the king-
dom of Tien. The theme
of the animal combat may
be copied from the art of
the steppe belonging far to
the north, but Tien
realism is unaffected by the
nomads' conventions.
*Length 17·1 cm. 2nd or early
1st century* B.C. *Excavated at
Shih-chai-shan, Yünnan.*
41. Two dancers in bronze,
treading a measure on

ground represented by a
snake. The Tienians'
ability to capture
movement in their
compositions is as evident
in persons as in animals.
Width c. *18 cm. 2nd or early
1st century* B.C. *Excavated at
Shih-chai-shan, Yünnan.*
42. The ceremonial
procession of a
chieftainess, with a retinue
including hunting
leopards, part of a larger
design cast in negative
relief on the side of a drum.
*Length of the section shown
c. 40 cm. 2nd or early 1st
century* B.C. *Excavated at
Shih-chai-shan, Yünnan.*

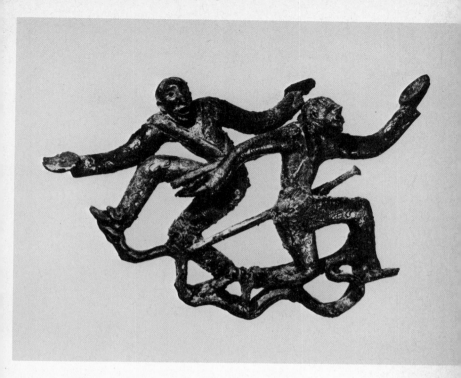

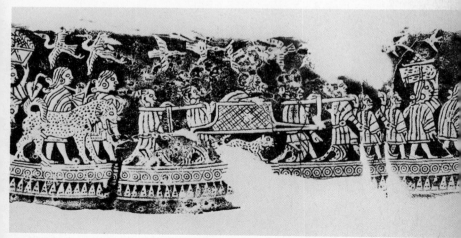

43. Head of a stone lion. While the form is strongly stylized its realistic purpose is clear, a natural model lying behind it and not mythical convention. The accentuation of ridges where planes of the surface meet is a constant characteristic of Chinese sculpture.
Height of the head c. *35 cm.*
3rd or 4th century A.D.
Loyang Museum.

44. Stone sculpture of a horse from the tomb of general Ho Ch'ü-ping. It is a naïve representation of the steppe horse (possibly leaping) where set formulas do not intervene to attenuate or support the realism.
Height c. *160 cm.* *118* B.C.
Loyang Museum.

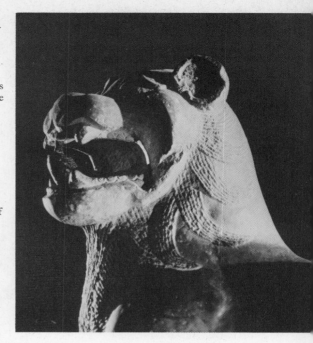

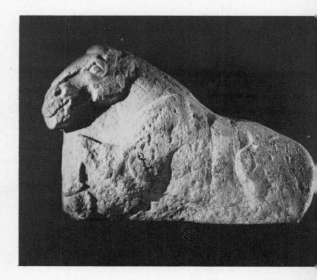

45. Bronze horse with a hoof touching a swallow, on which it balances. This is the most striking of a group of horses with similarly modelled heads which were found in the tomb of an official in Kansu. It represents an idealization of the western, 'celestial', horse which the Chinese obtained from Ferghana/Sogdia in about 100 B.C. 'Flying Swallow' was a name previously used for a dancing queen and for an emperor's charger. The movements of the legs and head, rather than anatomical accuracy, are the main motif of the work. The haggard head with open mouth interprets the animal's celebrated nervous vigour. *Height 34·5 cm.*
2nd century A.D. *Excavated at Wu-wei, Kansu.*

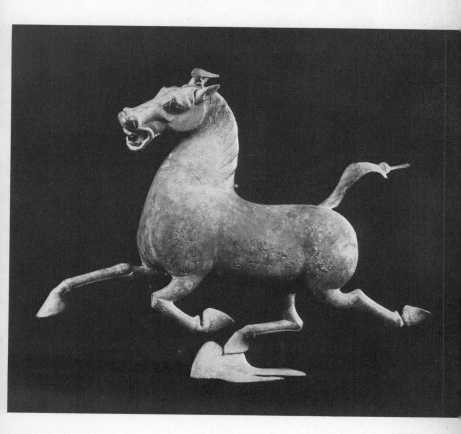

46. Detail of a silk funeral banner placed in the tomb of the Marquess T'ai, showing, between the fabulous monsters and spirits of the upper and lower worlds, the scene of the marquess's wake, with mourners, funeral vessels and the painted coffin in the background.
The attempted three-dimensional scene is to be contrasted with the planar silhouettes of 47, 48.
Height of the detail c. *78 cm.*
Mid-2nd century B.C.

47. Stone-carved scenes in low relief: a man felled by an arrow in an unidentified incident; the attempt of Ching K'o to murder the First Ch'in Emperor; the culture heroes Fu-hsi (right) and Nü-wa (left), male and female genies with tails entwined. The other winged figures are their attendants.
Height 80 cm. Second quarter of the 2nd century A.D.
Offering chapel of the Wu Liang tomb, Shantung.

48. Stone-carved scene in
low relief of the divine
archer Yi shooting down
the eight supernumerary
suns which had appeared
in the heavens and
threatened to burn up the
world. The suns are shown
as crows scattering from a
tree. The man entering a
building belongs to
another scene, and the
carriages are the customary
emblems of office.

Height of the detail 69 cm.
Second quarter
of the 2nd century A.D.
Offering chapel
of the Wu Liang tomb,
Shantung.
49, 50. Stone reliefs
showing weaving and
ploughing. Whereas the
reliefs of 47 and 48 are
plausibly explained as
copies of mural painting
executed in an archaistic
style, the present scenes

taken from real activities
reflect a more considered
sculptural method. The
simplification of the lines
of the loom suggests long
practice in dealing with
such subjects. The
exaggeration and
distortion of the ox are a
play upon reality and not
determined by traditional
formula.
2nd century A.D.
Yang-tzŭ-shan, Szechwan.

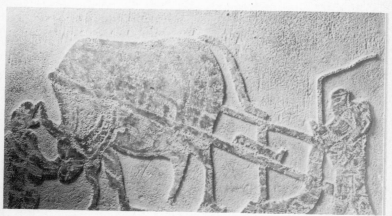

51. Brick relief of a dancer and an archer on hilltops. The treatment of the latter, with its suggestion of simultaneous full face and profile, is characteristic of the free experiment in perspective found in the Han art of Szechwan. The dance is the usual performance of whirling sleeves. This manner of symbolizing hilly landscape survives in the earliest Buddhist painting. No explanation has been given of the scene. *Height c. 35 cm. 2nd century* A.D. *Yang-tzŭ-shan, Szechwan.*

52. Brick with designs impressed from stamps. The scene of a man controlling or defying a tiger is frequent, probably representing courage and loyalty (see also 61). The stiffening convention of such themes as treated in Honan contrasts with the Szechwan effort towards truer representation of space and movement. *Height c. 30 cm. 1st–2nd century* A.D. *Loyang, Honan.*

53. Brick relief of a carriage at speed. *Height c. 40 cm. 2nd century* A.D. *Yang-tzŭ-shan, Szechwan.*

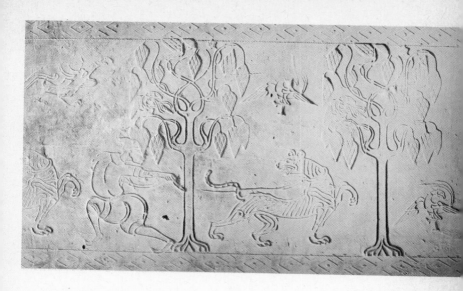

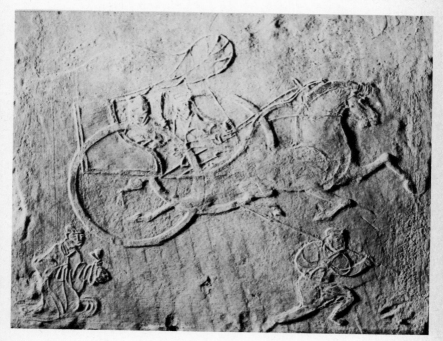

54. Figures painted on a brick in black, red and green. Two officials are shown in conversation, giving and receiving instructions. The animation of the one is as evident as the expectant stillness of the other. This is the earliest surviving example of painting in which the artist exploits the possibility of using the Chinese brush for subtle inflexion of line and for varying the thickness to suggest weight and volume of the outlined form.
Height 19·5 cm.
2nd century A.D.
Courtesy Museum of Fine Arts, Boston.

55. Two of a series of standing and seated figures of courtiers and officials painted in red, yellow and black lacquer pigment on the sides of a basket. All the men are shown in earnest talk: visitors perhaps, being advised on their deportment for the audience, and there is evident humour. All wear the hard court caps attached by strings beneath the chin.
Height 18 cm. 1st century B.C. *National Museum, Seoul (excavated from the Tomb of the Painted Basket at the commandery of Lolang in North Korea).*

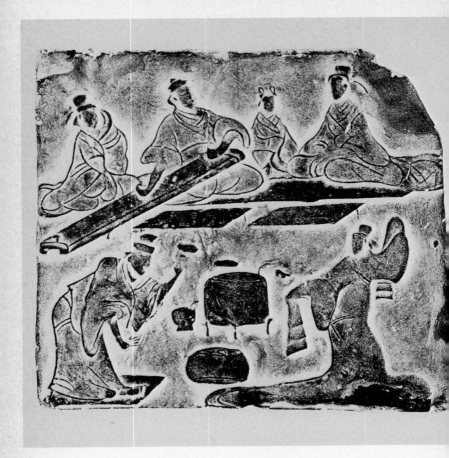

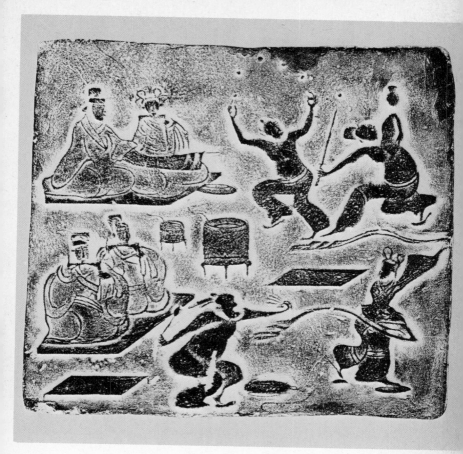

56, 57. Bricks from tomb structures impressed with scenes of entertainment. Their chief interest regarding composition is the assured convention for conveying an illusion of space. The viewer's point of view is taken to be on a level with each item of the pictures, but the gradual lifting of the subjects within the frame, and the diagonal placing of a few of them, give sufficient hint of the third dimension. All are drawn to the same scale. The brush-painted originals which lie behind the engraved versions probably resembled the figures of 54. Players of the *ch'in* and pan-pipes, singers, jugglers and performers of the whirling dance (see 51) compose the groups.
Height 42 cm.
2nd century B.C.
Yang-tzŭ-shan, Szechwan.

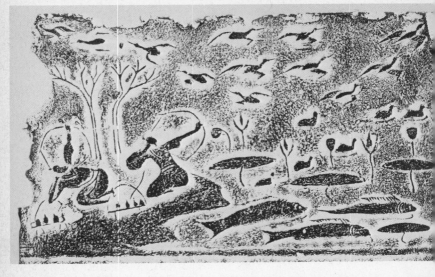

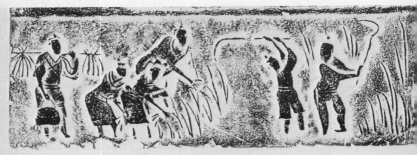

58–60. Impressed bricks
from tombs, illustrating
country life and industrial
activity. In 58 archers,
with decoys under a cover
beside them, shoot at duck,
probably with string-
attached arrows. The lazy
carp sleep under lily leaves;
the ducks scatter in
formation. Flights of birds
were used as an indication
of free space in painting as
late as the T'ang period.
The picture of rice-reapers
is a nice study of attitudes.
In the diagram of salt
mining the practical part
of the picture – derrick and
possibly evaporation pans
– is combined with the
fantastic mountain hunt
which stood for untamed
nature.
Height 42 cm.
2nd century A.D.
Yang-tzǔ-shan, Szechwan.

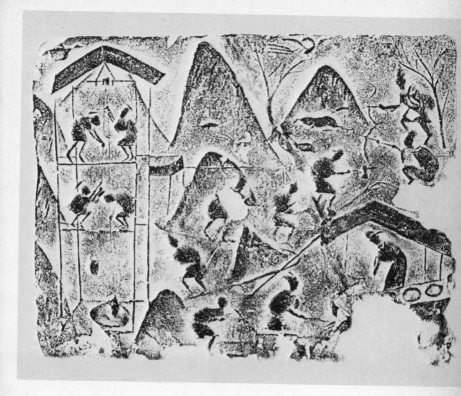

61 (*below*). The humorous scene of man defying tiger has taken on new energy compared with the version of 52. Retainers defending their masters from wild beasts became a stock subject, referring to exalted status. *Height 11·8 cm. 2nd century* A.D. *Kunstindustrimuseet, Copenhagen.*

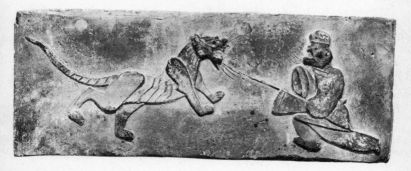

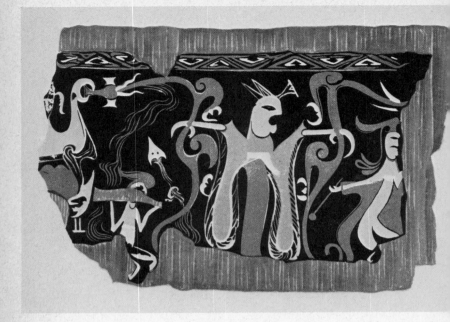

62 (*above*). A leading spirit
of the underworld, to be
encountered by the souls of
the departed. Such
inventions as these seem to
have furnished the totally
unreal iconography of
popular superstition, but
few examples of them have
survived. When an ordered
iconography of Taoism
emerges, the deities are
shown in comparatively
realistic forms, retaining
from the old designs
only such details as the
crowns and wings. The
scene is painted on wood
in coloured lacquer
pigments.
4th century B.C.
Hsin-yang, Honan.

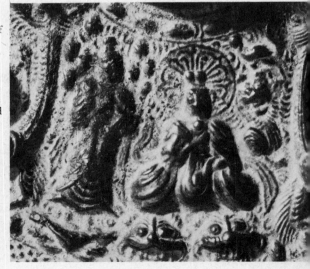

63 (*lower left*). An early
representation of the
seated figure of Šākyamuni
Buddha, cast on the back
of a bronze mirror. With
the advent of Buddhism a
motive was provided for
more or less realistic icons,
based on models whose
ancestry goes back to the
Hellenistic naturalism of
Western Asia. Here the
Buddha appears between
dragons of a Chinese kind.
The mirror was imported
from China or cast in Japan
after a Chinese specimen.
Height 3·5 cm.
3rd century A.D.
Excavated in
Naganoken, Japan.
64 (*right*). The later
Mahāyānist Buddhism
introduced into China
images designed in the
naturalistic Indian style,
real in form apart from
multiple heads and arms.
For a time their rounded
anatomy was imitated by
Chinese sculptors,
particularly at Yün-kang
during the second half of
the fifth century. This deity
is the Maheśvara form of
Vishnu, lord of the present
universe of worlds.
Height of the
seated figure c. *150 cm.*
470–85 A.D.
Yün-kang cave temples,
Shansi.

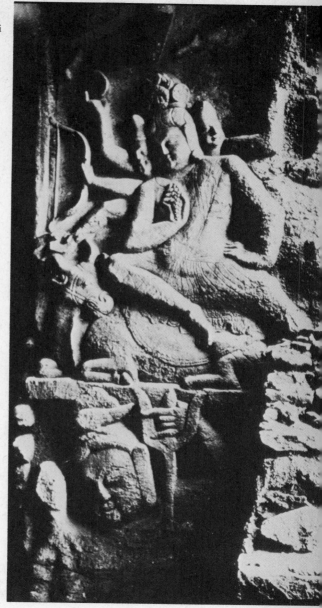

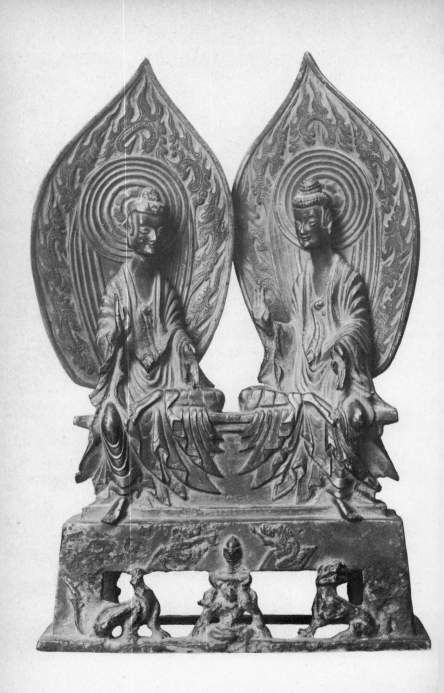

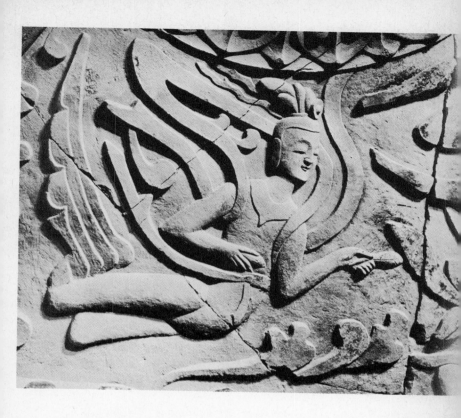

67 see next page

65. Stone statue of the
Bodhisattva Maitreya,
carved with the full,
rounded relief of the
middle Northern Wei
period. For a short time
the Chinese sculptor
showed great interest in
the manipulation of real
form with the aim of
maximum psychological
impact and monumental
effect. Maitreya, the
Bodhisattva destined
according to Hinayāna
doctrine to be next in the
succession of Buddhas,
was conceived in human
terms, and to this demand
the sculptor responded
with a benign and affable
image.
*Height 146 cm. 470–85 A.D.
Yün-kang, Shansi.*
66. Flying *apsaras* carved
on the cave wall as an
accessory to the principal
images. Compared with
the style of the preceding
work, the Chinese taste for
rationally divided form,
instead of organic form,
has asserted itself, with
reduction of relief and
greater emphasis on the
junction of different
planes, producing an
overall linear effect. Such
designs do not necessarily
follow painted models
closely, but from this time
the influence of linear
painted form became
gradually stronger.
Height c. *30 cm.
Early 6th century A.D.
Kung-hsien cave temples,
Honan.*

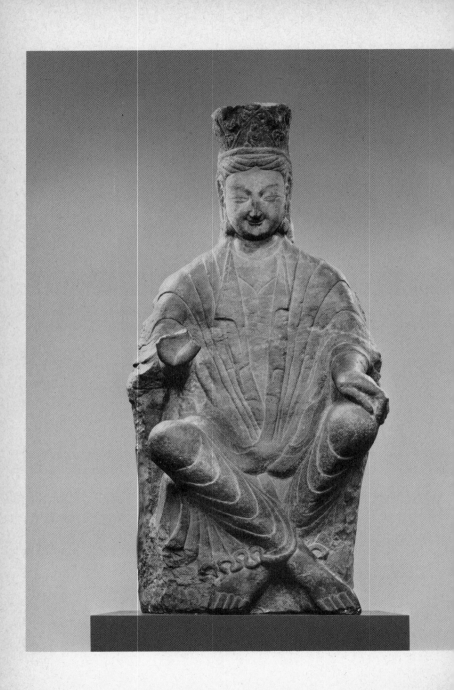

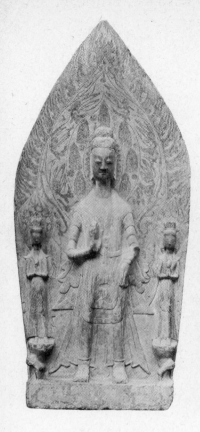

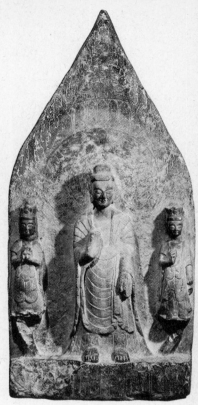

65 turn back a page

67. Gilded bronze image of the Buddha Šākyamuni in conversation with his predecessor Prabhūtaratna. This piece ideally shows the complete subjection of organic form to a rational scheme which reduces it to multiple linear and planar detail. The elongation of the larger units of form reflects indirectly the tendency of brush-painting, with its predilection for long and inflected but unbroken line. *Height 26 cm. Dated to A.D. 518. Musée Guimet, Paris.*

68, 69. Two stone steles of the Buddha with Bodhisattvas, carved in Honan, showing on the left the acceptance of distorted proportion which invaded sculpture as one result of the application of the analytic and linear method. Elongation lends an ethereal dignity to the figure. The trinity on the right marks the return of more natural form, represented more fully in the round, but still subjected to an almost geometric analysis of parts. *Second quarter of the 6th century A.D. Metropolitan Museum, New York. Deposited with Messrs C. T. Loo, Paris.*

70. Gilded bronze figure of a praying priest. Much of T'ang sculpture, particularly that of secondary figures subjected less to iconic tradition, reveals the influence of linear painting style. The long sweeps of the lines of this statuette copy the like trend of brushwork in figure drawing.
Height 15 cm.
8th century A.D.
The Cleveland Museum of Art: Gift of Mrs John Lyon Collyer in memory of her mother Mrs G. M. G. Forman.

71. The Indianizing style seen in T'ang sculpture of the eighth century introduces a new measure of anatomical realism, in which Indian formulas are simplified and hardened. The drapery however follows Chinese tradition more closely, with brittle lines and a certain weight, as contrasted with the diaphanous 'wet' garment characteristic of the Gupta sculpture of India.
Height c. *160 cm. First half of the 8th century* A.D.
Loyang Museum.

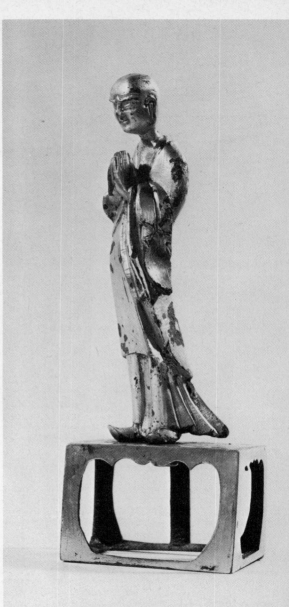

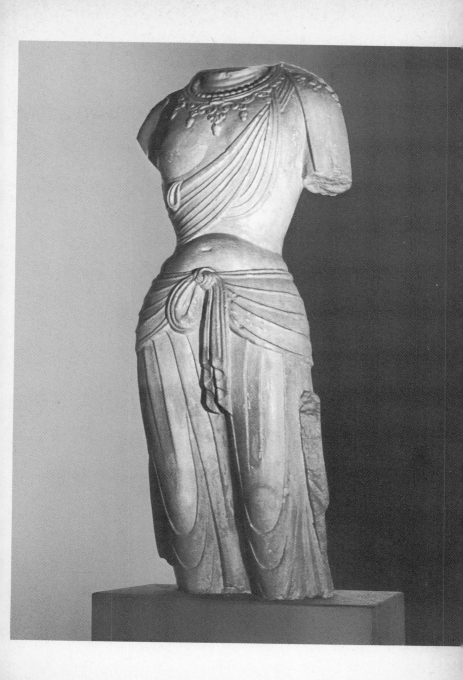

72. Wooden statue of the Bodhisattva Avalokiteśvara (Kuan-yin), polished and polychromed. At the end of the Sung period some Buddhist statuary adopts a form of idealized realism which breaks completely with the partial realism of past traditional styles. The new manner was the invention of sculptors, perhaps enlarged from the realistic forms of minor glyptic, and gave models to the painter rather than borrowed them from him. *About life-size.* *12th or 13th century* A.D. *Rijksmuseum, Amsterdam.*

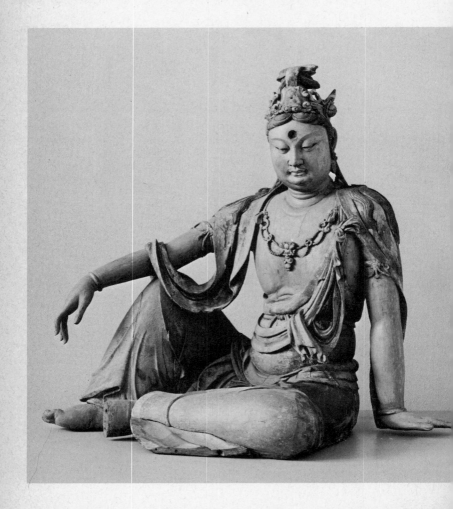

73. Gilded bronze figure of a Lohan, a recluse who has achieved Enlightenment without recourse to the Buddha's teaching of the Law. This subject invited life-like portraiture from the first formal introduction of the Lohan cult into China in the seventh century. In the manner of the early portrait painters, the character of the Lohan is concentrated in his facial expression, but supported by the whole posture of the body. *Height 15·2 cm. 14th or 15th century* A.D. *Sedgwick collection.*

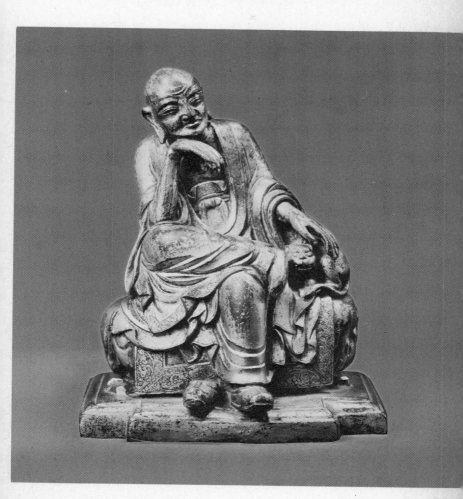

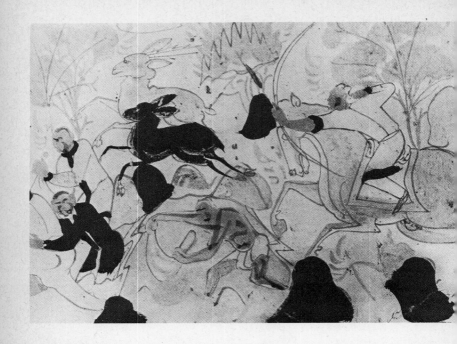

74. Mural of a mounted huntsman chasing deer, painted in black outline with light colour. This composition repeats with greater realism the fantastic mountain with animals and men which is a frequent theme in Han art. The sketchy line-and-wash style is evidence of ready application of practised conventions. In general the style represents a compromise between Chinese brushwork with its long unbroken lines, and Iranian custom of imagining a picture at the first step in segments of colour. c. *400* A.D.
Cave 290 at Tun-huang, Kansu.

75. Head of a Bodhisattva painted in heavy colours. The method of dividing the anatomy into segments of colour derives from Central Asian practice inspired by Indian rather than Iranian painting. Realism pursued by such means made little appeal to the Chinese painter, however much the sculptor's habit might be to segment his forms in a manner comparable to this treatment.
About life-size.
Late 6th century A.D.
Cave 420 at Tun-huang, Kansu.

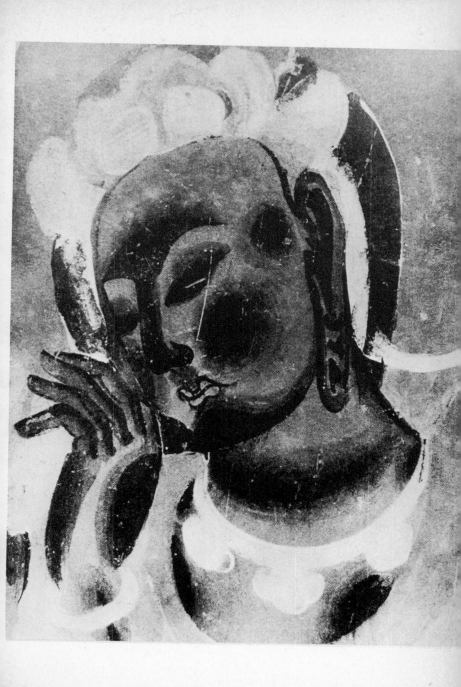

76. A butcher's shop, symbolizing the evil of killing animals.
The Tun-huang murals of the middle T'ang period take full advantage of the system of parallel-line perspective which was now established practice among Chinese painters. The method further elaborates a principle already present in later Han painting. Larger and more carefully organized compositions would not necessarily repeat the naïveté seen here in the false relation of the table to the front of the pillared shop-front.
Late 8th or 9th century A.D.
Cave 85 at Tun-huang, Kansu.

77. Mural of a priest reading a scroll. The concentration on expression, poise of head and the fall of the garment reflect at journeyman level the more sophisticated portrait style of contemporary artists in the T'ang capital and the eastern cities of China.
About life-size.
7th century A.D.
Cave 201 at Tun-huang, Kansu.

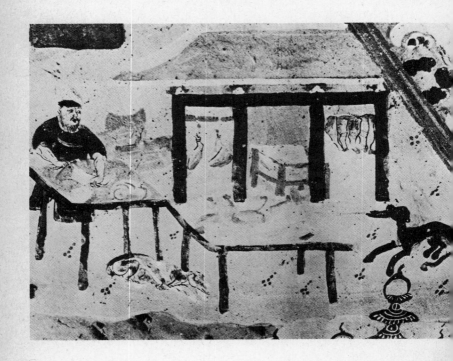

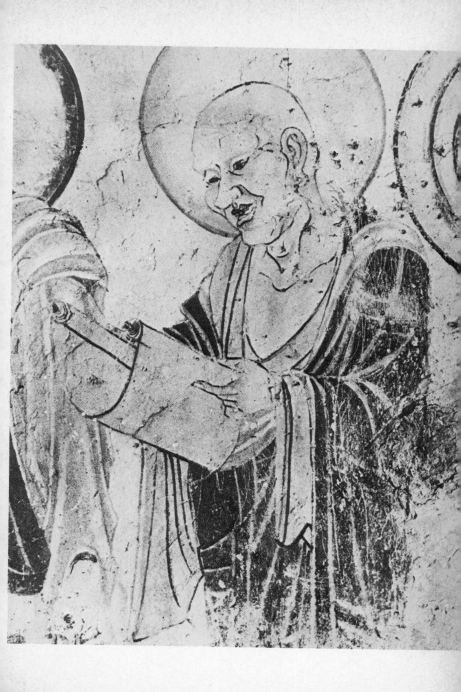

78. A gentleman seized by soldiers, fragment of a mural from Central Asia. The hardness of the line suggests that the Chinese brush is here replaced by the reed pen or some similar hard point. As the T'ang realistic linear style spread to the oasis cities along the Silk Route leading westwards, it was used to illustrate subjects of local religion and story. *Height 36 cm. 8th century* A.D. *Excavated at Qumtura, near Turfan, Central Asia. Museum für Ostasiatische Kunst, Berlin.*

79. Mural of the rich and virtuous citizen Vīmalakīrti in conversation with the Bodhisattva Mañjuśrī. This theme, in which a layman discourses philosophically with a Bodhisattva, appealed specially to the Chinese, and figures prominently in sculpture after 500 A.D. It could exemplify all the qualities of Chinese brushwork and psychological realism. Vīmalakīrti is curious to discover Buddhist truth, but confident of his own worthiness to engage his divine visitor in debate. *About half life-size. Early 8th century* A.D. *Cave 103 at Tun-huang, Kansu.*

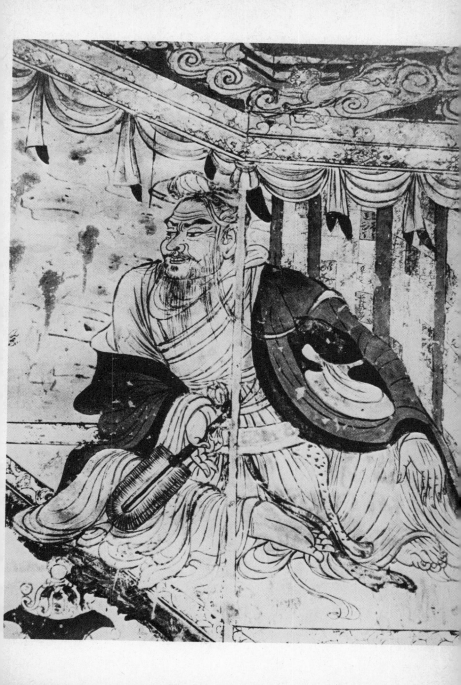

80. The Tibetan ambassador coming to the imperial audience, painted by Yen Pi-pen. Much of the ingenuity of T'ang painters went to curious and realistic pictures of foreigners. Differences of ethnic physiognomy and dress were minutely observed. The meticulous style of this work resembles that used for flower and animal painting rather than the abbreviated manner of the psychological portrait (in which spiritual qualities were not supposed to be captured merely by exact rendering of the features). *Height of the right-hand figure 19 cm. Early 8th century A.D. National Museum, Peking.*

81. Detail of a mural depicting the mourners at Sākyamuni Buddha's death. The Mahāpari-nirvāna was unique among Buddhist subjects in giving occasion for extravagant grimaces of affliction and a variety of exotic and savage facial types. *8th century A.D. Cave 158 at Tun-huang, Kansu.*

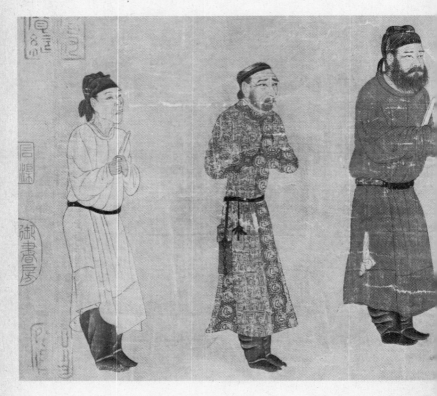

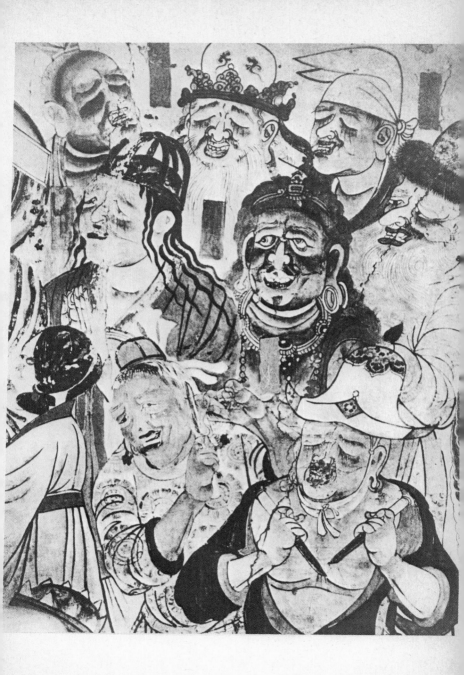

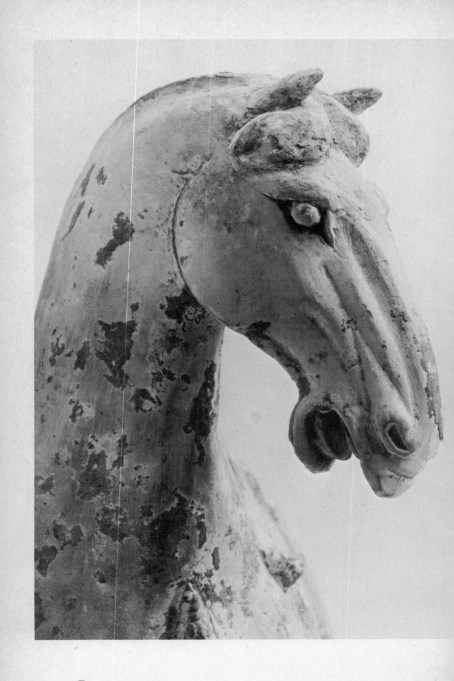

82. Pottery horse's head, detail of a statuette of the standing animal pawing the ground impatiently. Conventions for equine form had been developed since the Han period. The special contribution of the T'ang potter-sculptor was the introduction of real movement into the design. Studied naturalism in detail, combined with idealized proportions in the whole are characteristic. As in other branches of art, this objectivity had come to replace the freer fantasy of Han invention. *Height of the whole statuette 49·7 cm. 8th century* A.D. *Kunstindustrimuseet, Copenhagen.*

83. Pottery figure of an angry bull. *Height 16 cm. 8th century* A.D. *Cleveland Museum of Art, Purchase from the J. H. Wade Fund.*

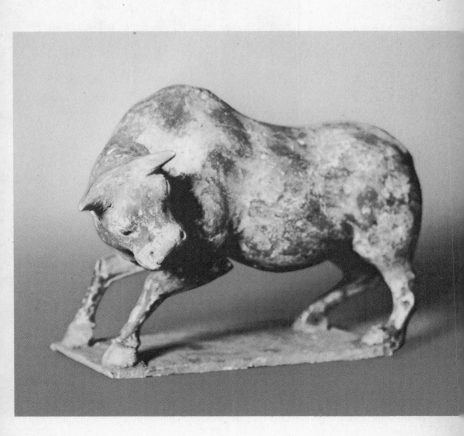

84. Pottery figure of a lady with yellow, blue and red glaze. The costume is the fashionable one of the T'ang capital, Ch'ang-an, at the beginning of the eighth century, with low-cut neck and loose sleeves. The better figures of this kind were finished by free modelling after shaping in a mould, and always portray character or active situation in the stance and expression. This figure represents a senior female officer of the palace or household, and her *hauteur* is very evident.
Height 45 cm.
First half of
the 8th century A.D.
Excavated at Ch'ung-p'u
near Sian, Shensi.
85. Painted figure of a mounted huntsman, by his beard and cap shown as a Central Asian.
Height 30·5 cm. A.D. *706.*
Excavated from the tomb of
the princess Yung T'ai at
Ch'ien-hsien, near Sian,
Shensi.

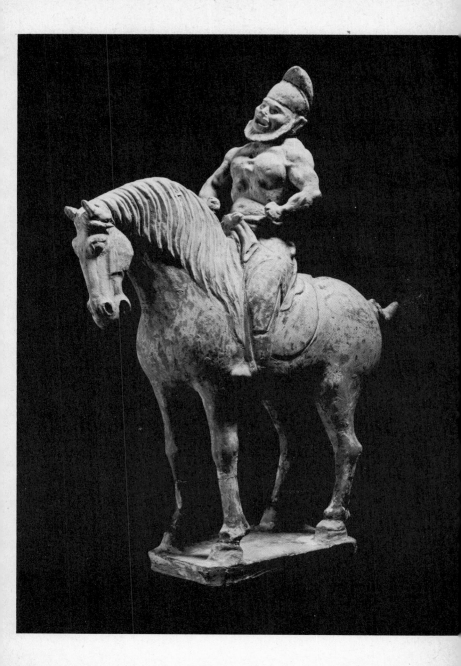

86. Travellers among the Mountains, by Fan K'uan (*fl.* 990–1030). The imaginary landscape is built of realistic components reassembled to capture essential qualities: unattainable, awe-inspiring height and distance, approachable rocks and trees promising refreshing tranquillity. Concern with illusion of recession arises partly from the wish to separate these two spheres, partly from the need to give visible form to the space in which the imagination is invited to soar.
Height 206 cm.
Palace Museum, Taiwan.
87. Early Spring, by Kuo Hsi (*c.* 1020–1090). The movement from nearer to farther elements is more gradual than in the preceding landscape, and there is less insistence on deep perspective. The reality sought is that of spiky burgeoning of trees set against worn, unchanging rocks.
Height 158 cm.
Palace Museum, Taiwan.

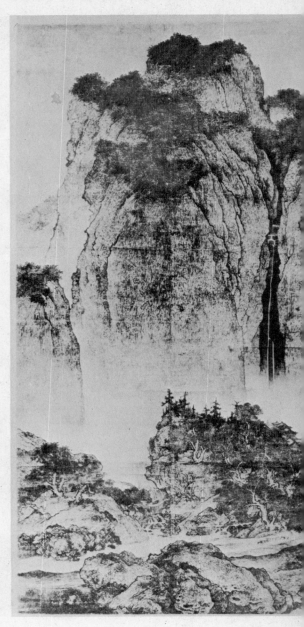

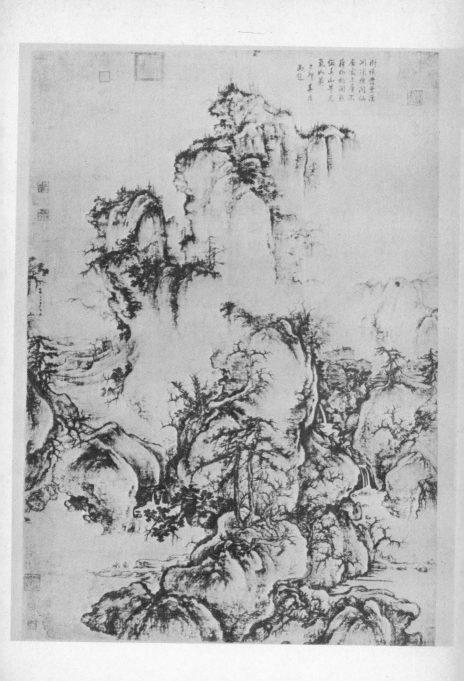

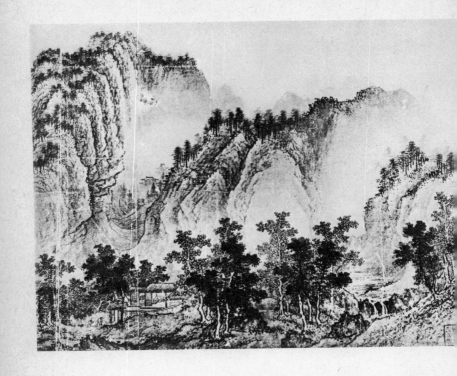

88. River Landscape, part
of a scroll attributed to
Tung Yüan (*fl.* late 10th
century). The landscape
style associated with the
so-called Southern School
was reputed more intimate
and beguiling than that of
the sterner Northern
School. Here the treatment
of foliage illustrates the
principle that, when near
leaves should be broadly
distinguished by genera,
while in the distance they
blend until a distinction
between conifer and
deciduous is barely made.
*Height 37 cm. Courtesy
Museum of Fine Arts,
Boston.*

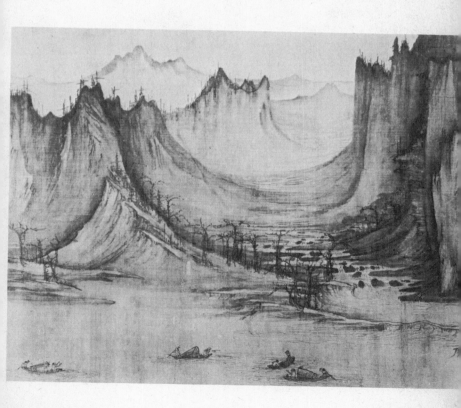

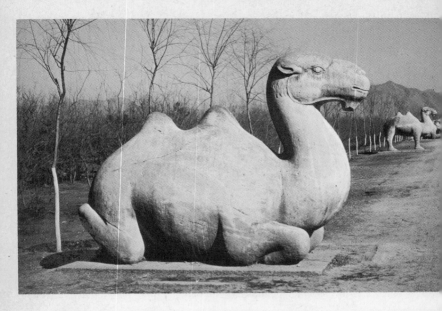

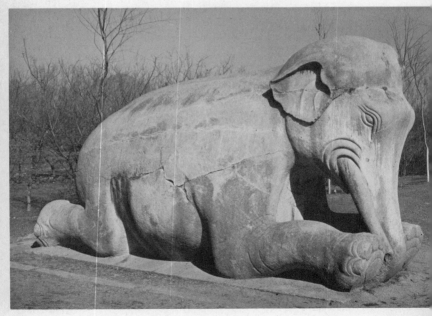

90, 91. Stone camel and elephant at the side of the approach to the Ming tombs. These full-size sculptures executed for the imperial mausolea are in a class apart. The handling of the forms shows an unusual understanding of the anatomy and posture of the animals, but there is no sign of effort to transcribe the details exactly from nature. Other animals placed along the road are the more usual fantastic monsters, some of them of more compelling appearance than the camel and elephant.
Height c. 250 cm.
15–16th century A.D.

92. Blue porcelain duck made as a table ornament. In the hands of the potter animal form was necessarily simplified. The impression given here of moulded shape contrasts with contemporary Chinese ceramic models carved to more exact representations, using a variety of tools.
Height 11·4 cm.
Percival David Foundation of Chinese Art, London.

93. Book woodcut illustration of a rose. Conventions are adopted for the botanical diagram which do not appear in ordinary painting, such as the dotted outlines of leaves and the use of dots to represent the deeper colour of the inner petals. The rather natural crowding of the blooms is unlike decorative flower-painting, in which the parts would be more widely separated. But accuracy does not go beyond the point at which the character of the flower is denoted, in leaf and petal shape, bud, thorns, etc. *Height 23 cm. From the* Chi-ya-chai hua-p'u, *by Huang Feng-ch'ih, 1620.*

94. The Repeater Cross-bow. The treatment of trees, rocks, the birds and the human figure represents a summary and standardized version of traditional methods of painting: thus also the conventional leaf shapes, the blank paper left to represent the receding space. For the purposes of technical illustration these resources were felt to be totally adequate. *Height c. 15 cm. From the* T'ien-kung K'ai-wu, *by Sung Ying-hsing, 16th century.*

95 (*overleaf*). A Derrick for Lowering Bamboo Pipes into a Drilling. This design, typical of technical illustration, attempts to represent the mechanics of the device with great exactness. The drilling derrick stands in the middle. Not all the functions of the ropes are clear, however. *Height 19·5 cm. From the* Tien-kung K'ai-wu, *by Sung Ying-hsing, 16th century.*

竹木下

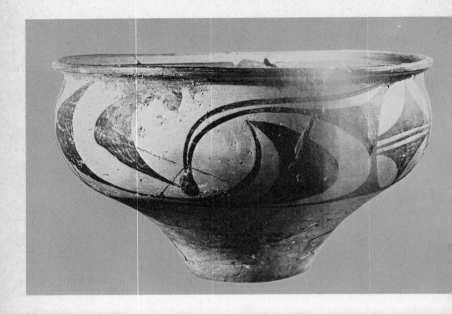

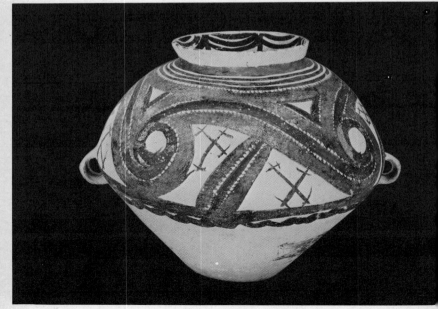

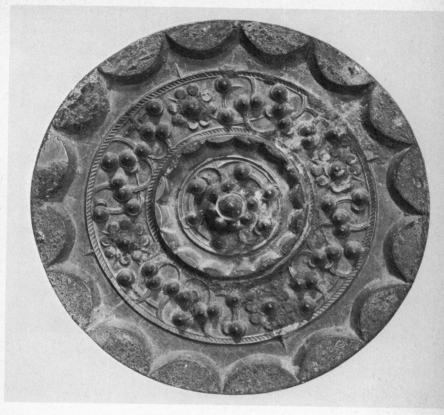

96 (*opposite above*). Bowl of reddish pottery with black-painted ornament. The style is that of the central and earlier Yangshao neolithic tradition, as found in Honan, in which curving lines are balanced against solid areas formed at their intersections. The main lines echo the profile. *Height 17·2 cm. 4th–early 3rd millennium B.C. Excavated at Miao-ti-kou, Honan.*

97. Pottery funeral urn of buff clay, painted in dark red and black, belonging to the Kansu variety of the Yangshao neolithic tradition. All the parts of the design are freely drawn with brushes of various widths, particular care being given to the serrations of the inner red band which break the weight of the main motif. *Height 35·1 cm. 3rd or 2nd millennium B.C. From the cemetery at Pan-*

shan, Kansu. Museum of Far Eastern Antiquities, Stockholm.

98 (*above*). Bronze mirror decorated on the back with a design suggesting constellations. The varying arrangement of the clusters of points and the curving triple lines joining them is contrived to suggest the movement appropriate to the theme. *Diameter 10·1 cm. 1st century B.C. Musée Guimet, Paris.*

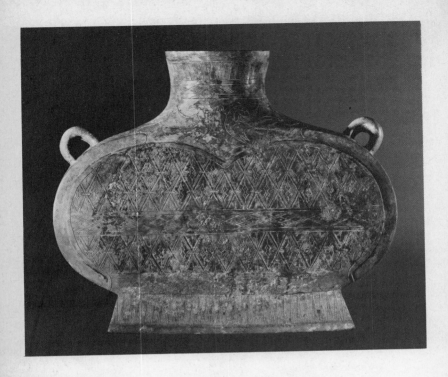

99. Bronze flask with rectilinear design. On the model which must have preceded the manufacture of the casting mould the ornament was engraved, mostly against a straight edge. Static and mechanical ornament of this kind is found on a short-lived family of bronze vessels, and, in a coarser version, on hardfired pottery made contemporaneously in south China.
Height 22·2 cm. 1st c. B.C.
The Art Institute of Chicago.
100 a, b. Lacquered toilet box, painted red on black, with some silver inlay. The design represents the latest and freest version of the cloud-scrolls of early Han date, which are a legacy of hieratic style. The insertion of animals among the scrolls associates the ornament with the common Han theme of the mountain joining heaven and earth, among whose crags and caves magical monsters lurk. The Feathered Man of the Taoists, and the tiger, dragon and tortoise of West, East and North are among them.
Height 9·5 cm.
1st century B.C.
British Museum, London.

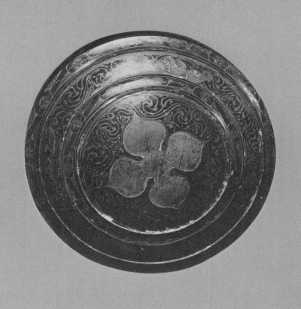

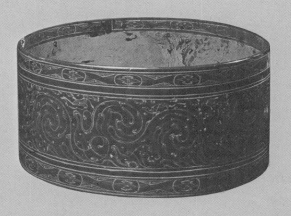

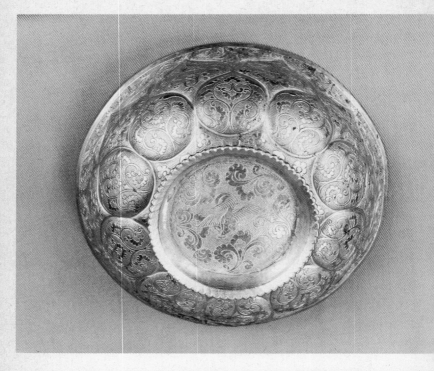

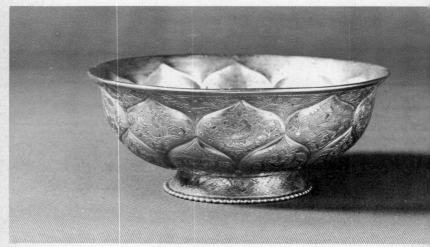

101 a, b. Gold bowl with the sides pressed out as lotus petals. The traced ornament shows deer and birds among flower scrolls. The animals are of Chinese tradition, but their scattered position reflects an influence of Iranian style. On the lower petals are leaf scrolls which continue the manner of decoration known in the previous two centuries, but here somewhat relaxed from the earlier stiffness. The beaded rim of the foot copies the similar feature of Iranian (Sassanian) silver. Tracing on T'ang gold and silver is executed by a blunt point which does not remove any of the metal (strictly, 'chasing'), although a minority of pieces have sharp engraving executed with a burin. *Height 5·5 cm.*

Mid 8th century A.D. *Excavated at Ho-chia, Sian, Shensi.*

102. Bronze mirror backed with repoussé gold foil displaying a scroll with leaves approximating to the palmette and half-palmette. The ground is chased with an even cover of minute rings. *Diameter 15 cm. 1st half of the 8th century* A.D. *Courtesy of the Freer Gallery, Washington,* D.C.

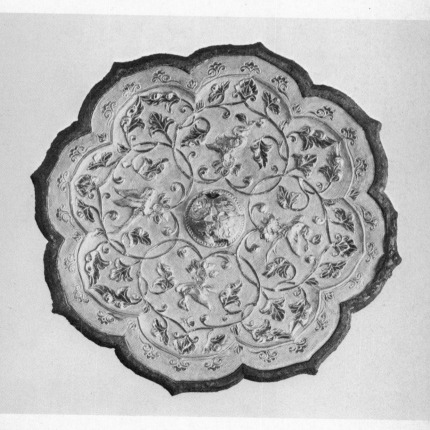

103. Embroidered silk bag with leafed scrolls and fanciful multicoloured flowers. Among them appear mandarin ducks. All these motifs are in satin stitch. The outlines of the petals and leaves were originally formed of silver thread, and the ducks were worked in gold thread and couched. Design of this kind is the origin of decoration on silver, in which the forms appear stiffer and the position of leaves and flowers more regulated. *Height 44 cm. Late 7th or early 8th century A.D. From the Caves of the Thousand Buddhas, Tun-huang, Kansu. British Museum, London.*

104. Fragment of yellow textile with lighter coloured ornament of birds and a floral spray. The heraldic arrangement is characteristic of the Persianizing designs introduced at the beginning of the 8th century. The weave is a gauze and the design is dyed by wax resist. *Length 57 cm. A.D. 721. Excavated at Astana, near Turfan, Sinkiang.*

105. Porcelain ewer,
phoenix-headed, carved
with an elaborate and
formal paeony scroll and
overlapping lotus petals.
The off-white clear-glazed
surface is jade-like. This
scroll is a potter's version
of the ubiquitous 8th-
century design. It was
imitated in slightly
simpler forms on a variety
of Northern Sung
porcelains. Here it owes
its spring to the free
carving in which a knife
point has set the angles of
the incisions at varying
slants. The phoenix head
is in the tradition of the
bird-headed, lead-glazed
ewers of the earlier 8th
century, but here the
harder medium has
allowed its features to be
sharpened up a good deal.
Height 39·4 cm.
10th century A.D.
British Museum, London.

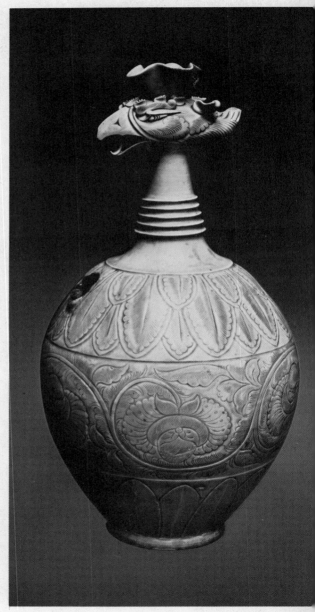

106. Bronze mirror with a high-tin, silvery surface, showing lions and phoenixes in alternate procession among formal blooms. In the insects and sprays in the margin the designer avails himself of the accepted Persian-Izing pattern of small isolated motifs. *Diameter 19·4 cm. 8th century* A.D. *Brooklyn Museum, New York.*

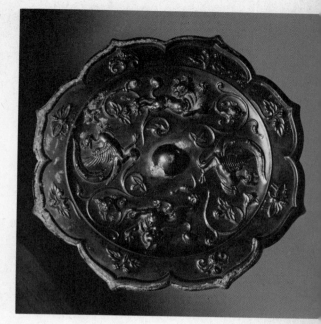

107. Box of northern celadon porcelain, grey-white clay covered with translucent olive-green glaze. The design is wholly carved with the knife point, assuming no more than fixed guide points. *Diameter 17·7 cm. Late 11th or 12th century* A.D. *Percival David Foundation, London.*

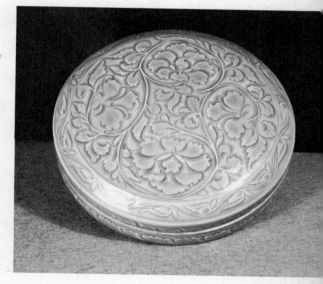

108. T'ang vase with lid, earthenware with lead glaze dappled green, blue and white. The nature of this low-fired glaze did not permit exact drawing, however closely its viscosity came to be controlled. One method for defining its designs was that of separating areas of colour by grooves. From the beginning of the 8th century the fortuitous dappling produced in broad schemes of ornament in the course of firing was exploited for picturesque effect. The colouring of the glaze has been brushed on at approximately regular intervals. The result is not unlike that produced in decorating textiles by knot dyeing the warps, the imitation being possibly intended. *1st half of the 8th–9th century* A.D.

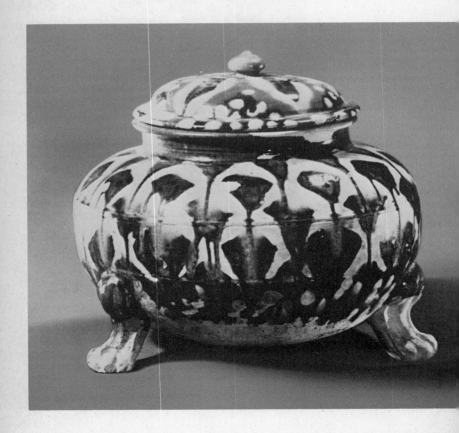

109. Stoneware jar covered with a black high-fired glaze. The suffused passages of white in the glaze are deliberately contrived although it is clear that hardly any control could be exercised over their extent, as the colorant fell down the sides of the vase during the firing. The viscosity of the black glaze has been adjusted to prevent its reaching the foot of the vase and so possibly adhering to the kiln floor. The simple shape is a favourite one of T'ang potters who threw their ware, their enterprise in this technique falling short of their experiment in the moulded shapes of the lead-glazed pieces. This kind of imprecise decoration was not imitated in the Sung period.
Height 12·7 cm.
8th-9th century A.D.
City Art Museum, Bristol.

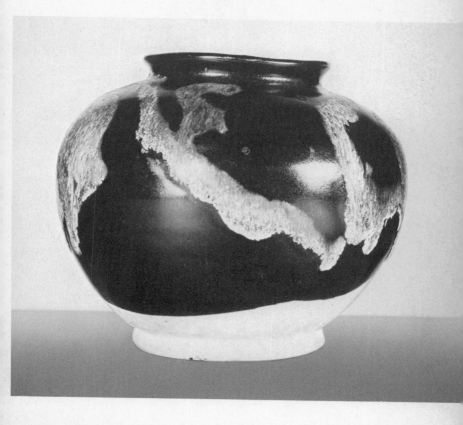

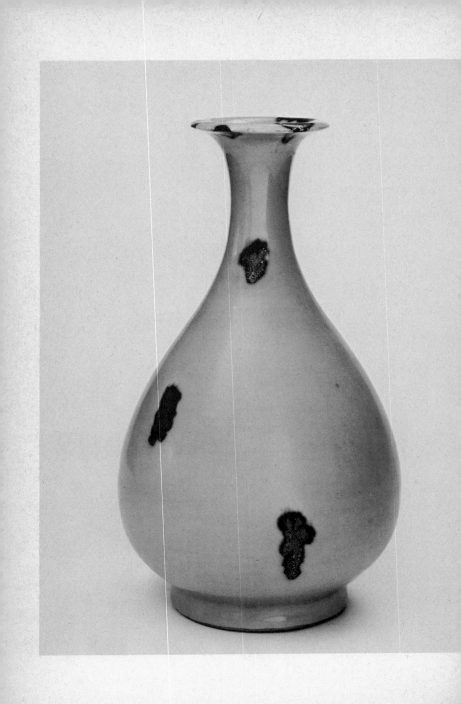

110. Celadon porcelain vase, shaped like a bottle spun in metal. The pea-green glaze has rust-brown marks which develop a silvery iridescence on the surface. The position of each patch of brown was fixed by adding further iron colorant to the glaze at these places, but the shape of each mark was unpredictable. *Height 27·4 cm. 13th-14th century* A.D. *Crown copyright. Victoria and Albert Museum, London.*

111. White porcelain bowl with a carved design of ducks and water plants. The economy of the free-drawn scenes on such pieces contrasts with the much fuller explicit detail impressed on other bowls from a carved pottery mould. The clear glaze shows the body of white porcelain beneath. This *ting* ware of Hopei province continues the tradition of earlier white porcelain of T'ang. *Diameter 22 cm. 11th-12th century* A.D. *Percival David Foundation, London.*

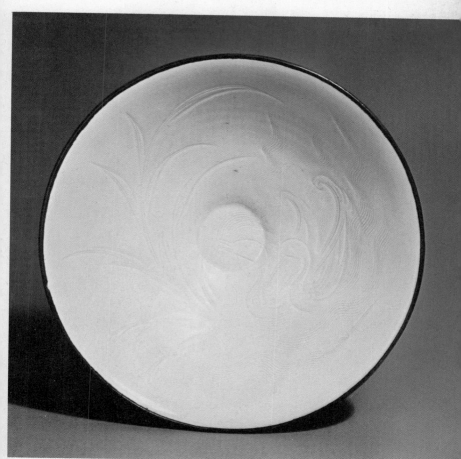

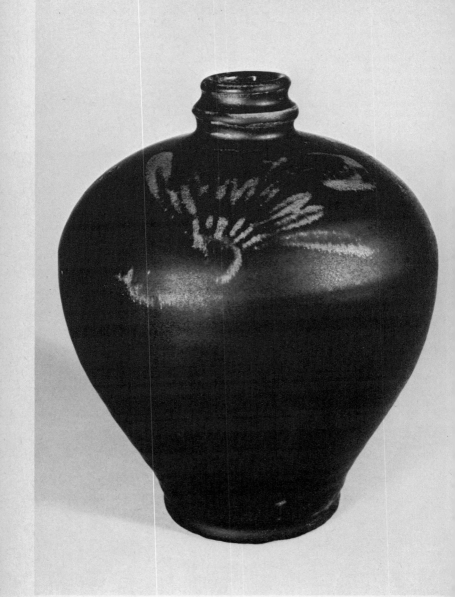

112. Stoneware vase covered with a thick black glaze, on which rust-brown marks suggest a spray of leaves. Such designs were reserved in the glaze by coating the surface with a substance such as wax which would vary the density of the glaze, protecting the area covered until the coating burnt off in the kiln. This northern black ware was made in large quantities during the 12th and 13th centuries. The lighter markings occasionally define a floral spray more completely, though the edges of the design are generally diffused into the ground. *Height 20 cm. 12th or 13th century* A.D. *Author's collection.*

113. White porcellaneous spittoon covered with a translucent feldspathic glaze. During the T'ang dynasty high-fired pottery made in the north implanted there a tradition of stoneware imitated from the technique of Kiang-su potters. In the simple shapes of the T'ang white ware of Hopei one detects the first signs of experiment in delicate profiling and calculated proportions of work thrown on the wheel. *Height 10·5 cm. 2nd half of the 9th century* A.D. *Excavated at Sian, Shensi.*

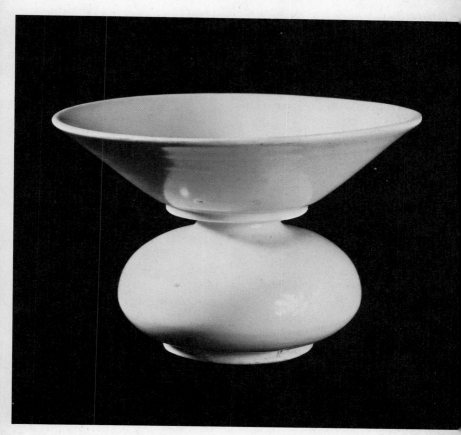

114. Bowl of Lung-ch'üan celadon porcelain, approximately imitating the shape of a bronze sacrificial *kuei*. In responding to the archaizing taste of the mid-Sung period the potter adapted the forms of cast bronze to the possibilities of thrown and moulded porcelain. *Diameter 18·5 cm. 12th–13th century A.D. Percival David Foundation, London.*

115. Tripod of Lung-ch'üan celadon copying the sacrificial *ting. Height 12·4 cm. 12th or 13th century A.D. Excavated at Jui-an, Chekiang.*

116 (*opposite*). Porcelain vase with pale bluish glaze, decorated with a scrolling peony in relief. The curves of the stem are nicely adapted to the profile, which presents an unusually strong inflexion. *Height 22·3 cm. Probably 14th century A.D. made at the Lung-ch'üan kilns. British Museum.*

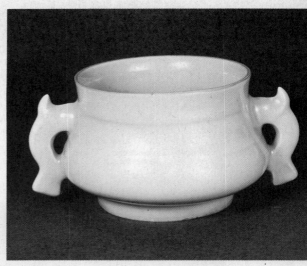

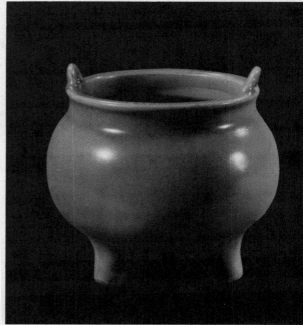

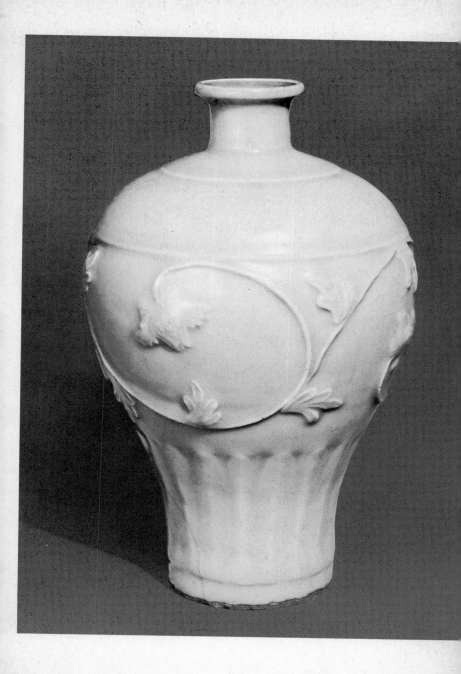

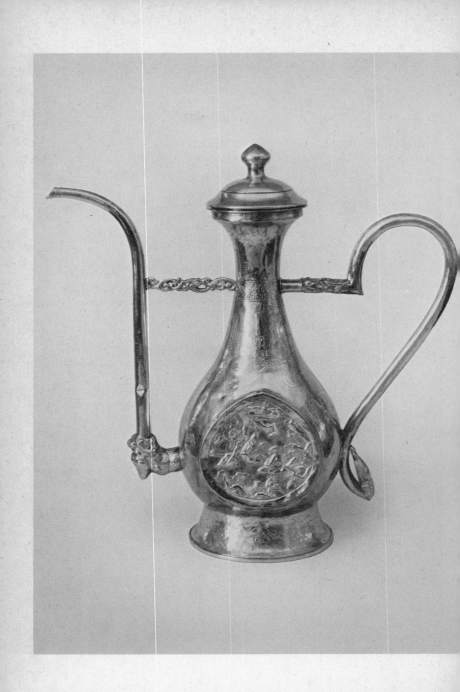

117. Silver ewer of exotic shape. The form is an adaptation of one current in the Near East. The delicacy and balance of parts is perhaps characteristically Chinese, while the combination of detailed relief and openwork with large areas of smooth metal is typical of the court taste of the Mongol period in China. *Height 27 cm.* *Late 13th or early 14th century* A.D. *Carl Kempe collection.*

118. Silver cup with lobed body and foliated rim, in Islamic style. The shape has no precedent in the Chinese tradition, even considering the Persianizing silver of the T'ang period. The ornament, in contrast to the T'ang technique, is engraved. *Height 5·7 cm.* *Late 13th or early 14th century* A.D. *Nelson-Atkins Gallery, Kansas City.*

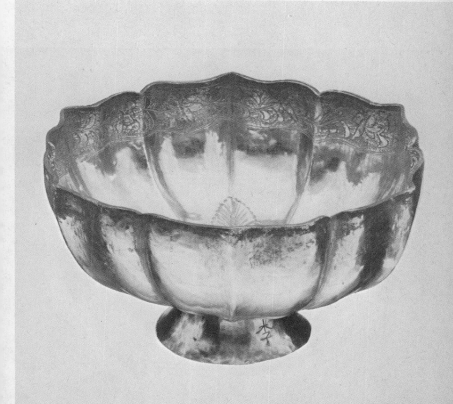

119. Stoneware jar decorated with two phoenixes. The main design is painted in dark brown slip over the white-slipped body. The detail is scratched through the brown to the white. Crowded floral ornament at the neck of the vase is characteristic of Yüan work.
Height 36 cm. Late 13th or early 14th century A.D. Excavated at Liang-hsiang, near Peking.

120. Eight-faceted porcelain vase of the *Mei-p'ing* (plum-bottle) shape. The decoration is painted in cobalt blue under the glaze. Large dragons, their scaley bodies in low relief, sport among water and clouds. Both theme and technique of this ornament are innovations of the Yüan period.
Height 51·5 cm. 14th century A.D. Excavated at Pao-ting, Hopei.

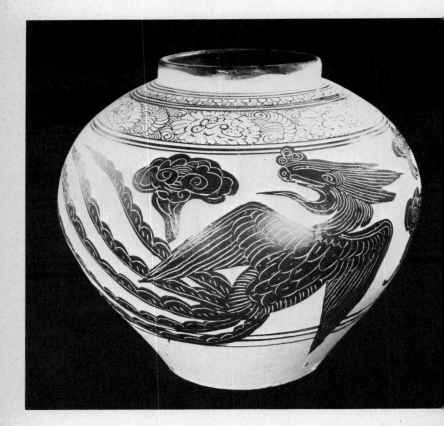

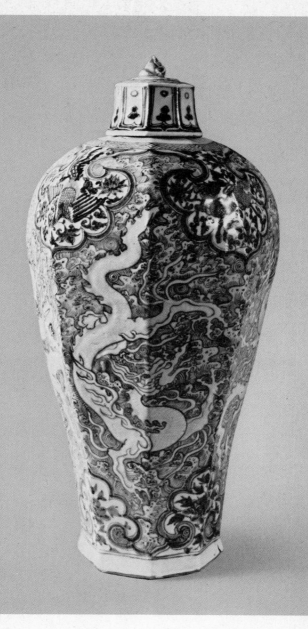

121. A Homestead in the Mountains, by Kung Hsien (active 1660–1700). The repeated vertical and oblique lines into which the fantastic landscape is moulded ally the design to the pattern of ornament. The painting appears all surface, without adjustment of receding scale or other device to suggest depth. Though not characteristic of all the work of the individualist artists of the seventeenth century, surfaces of comparatively even texture with repeating rhythms are one means they adopted to mark alienation from real form.
Height 62 cm.
Drenowatz collection, Zürich.

122. Mother-of-Clouds Peak, an album leaf by Shih-t'ao (*fl. c.* 1660). One means employed to unify the design is the uniformity of brush-work and weight of ink throughout the picture. The artist habitually gives much thought to maintaining the delicate beauty of the surface without too obvious resort to the leaf and tree conventions of tradition. The concern for pervasive decorative effect, the hall-mark of scholars' painting, is served both by calligraphic skill and by close study of rhythmical but credible rock forms. The black ink is lightened by the addition of pink, purplish and yellowish colour.
Height 24·5 cm. Museum für Ostasiatische Kunst, Cologne.

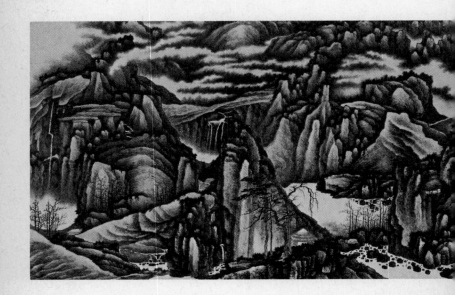

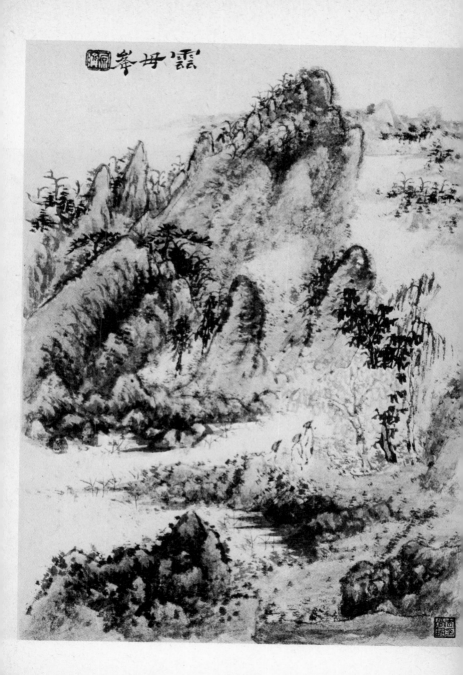

123. Sacrificial tripod, *ting*, in celadon porcelain. This piece imitates a contemporary design based on that of the ancient bronze vessel, but departing from it considerably in proportions and ornament. The last is influenced by the distortion of the ornament in book illustration. *Height 27 cm. 12th century* A.D. *Excavated at Lan-t'ien, Shensi.*

124. Bronze censer shaped like the ancient *ting*, inlaid with gold and silver. The monster mask follows the 'exploded' version of ancient times, but the outlines of the components are softened in the manner characteristic of Sung and Ming archaistic work. Not even the squared spirals of the ground conform closely to the ancient model. *Height 12 cm. Late 16th century* A.D. *Garner collection, Beckenham.*

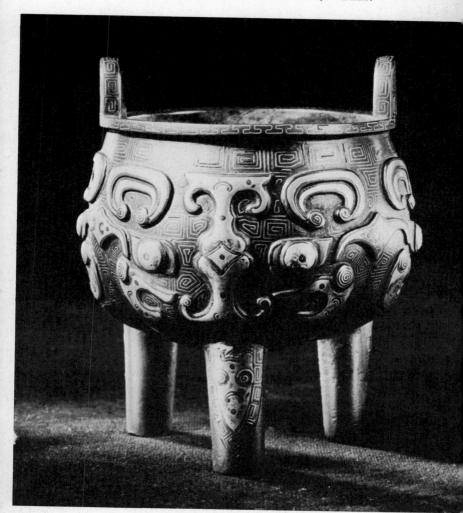

125. Winged lion in
bronze, inlaid with gold
and silver. The figure was
probably the support of a
vessel. In this case the
inlaid ornament follows
very closely the style of
work executed in the
4th–3rd centuries B.C.,
that is in the later Hui
phase of the hieratic
tradition. Both the general
design of the lion and the
treatment and finish of
detail mark it off sharply,
however, from
ancient bronze.
Height 21·5 cm.
11th–12th century A.D.
British Museum, London.
126. Bronze vessel in the
form of a phoenix carrying
a second vessel on its
back. Here the archaistic
imagination runs riot,
producing a shape
unknown in antiquity.
There is further
anachronism in the combi-
nation of details,
e.g. the mask at the front
and the style of geometric
inlay. The ancient concept
of the zoomorphic wine-
holder *tsun* allowed of
many fantastic animals.
Height 32 cm. 12th–13th
century A.D. Crown copyright.
Victoria and Albert
Museum, London.

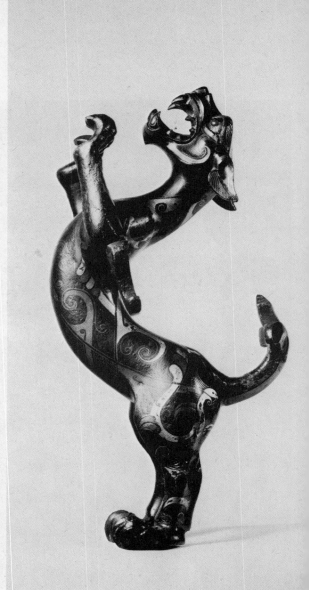

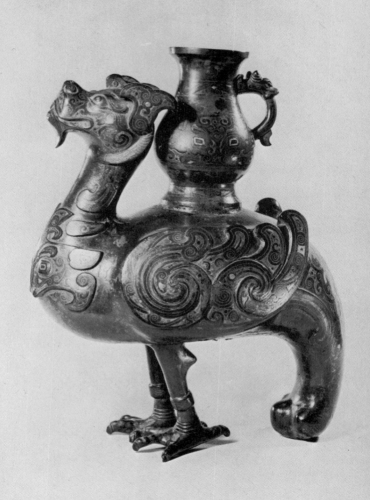

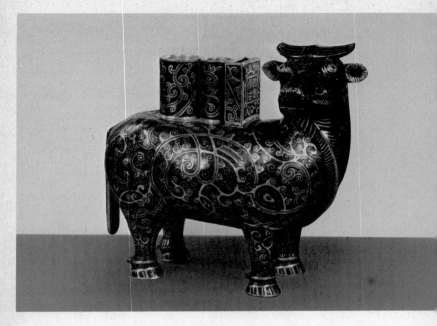

127. Bull-shaped vessel in champlevé enamel. The form and decoration are vaguely authorized by ancient design. It is marked Ch'ien Lung Period, (1736–95) in imitation of the antique! *Height 19·2 cm. Mid 18th century* A.D. *Crown copyright. Victoria and Albert Museum, London.*

128. Incense burner, *ting*, in cloisonné enamel, yellow, red, white, light blue, dark blue and gilded. The floral ornament revives a T'ang motif. *Width 14 cm. First half of the 15th century* A.D. *Garner collection, Beckenham.*

129. Bronze vase in summary imitation of the ancient libation goblet *ku*. The inlay of silver wire follows designs influenced by wood-block printing. Inscribed with the maker's name Shih Sou. *Height 15·6 cm. Late 16th century* A.D. *Author's collection.*

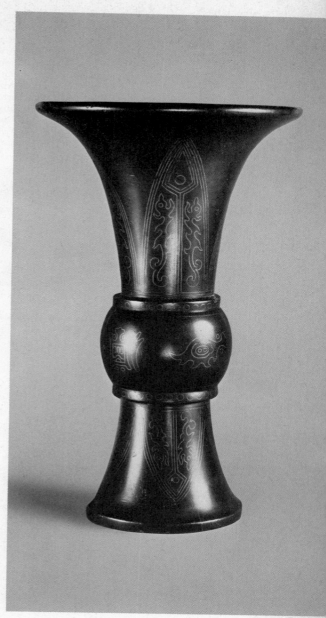

130. Jade water holder for the scholar's ink, carved like a lotus flower and leaves. Such near-realistic work is typical of the products of the palace jade workshops established at the end of the 17th century. *Length 24 cm. Late 17th or 18th century* A.D. *British Museum, London.*
131. Table top of carved red jade in the Ming palace style, showing imperial dragon and phoenix. *Length 119·1 cm. 16th century* A.D. *Crown copyright. Victoria and Albert Museum, London.*
132. Lion of gilt bronze at a stairway of the Imperial Palace, Peking. This elaborate fiction, originating as a pair of such animals flanking the throne of a Buddha, is everywhere interpreted as a guardian of the Buddha's law, but appears here in the rôle of palace ornament as favoured by its sponsor, the Emperor Ch'ien Lung. *Height* c. *150 cm. 18th century* A.D. *Imperial Palace, Peking.*

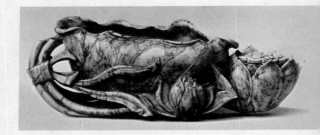

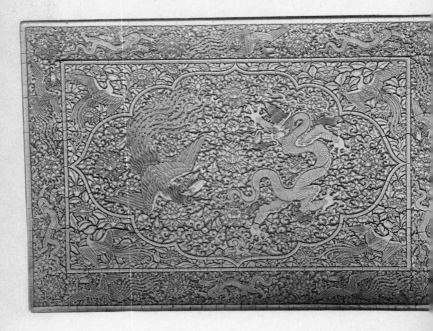

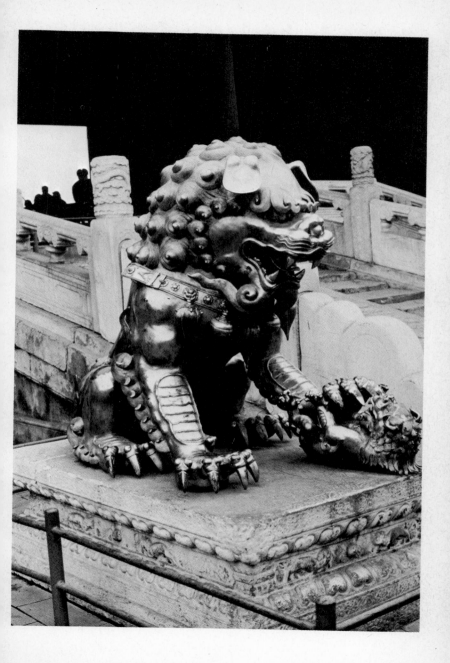

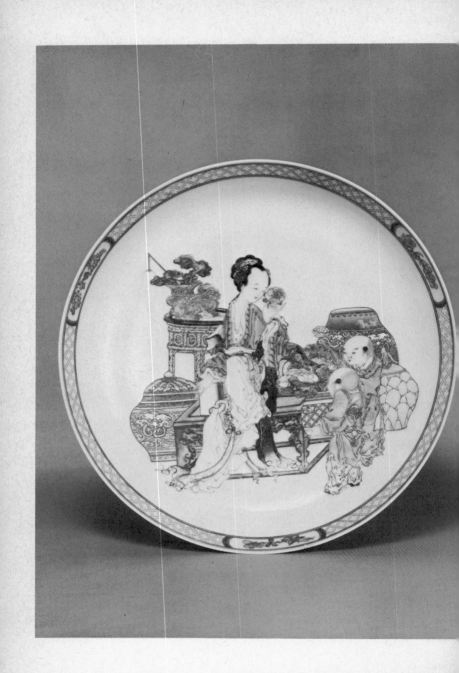

133. Dish of ruby-backed
enamelled porcelain.
Famille rose enamels are
used to depict a scene of
conventional palace
elegance: a court beauty
with children, in the style
of earlier painters. The
high table holds a bronze
goblet *ku* with branches of
the mythical *ling-chih*
fungus. The pottery jars
are more normal
paraphernalia of a
cultured interior.
Diameter 19·8 cm.
18th century A.D.
Percival David Foundation,
London.

134. Porcelain vase painted
in *famille rose* enamels in
the manner of European
portraiture in oils. The
affectation of European
bergeries was a common
resource of the palace
decorator under the
Emperor Ch'ien Lung. In
particular this style
imitated the colour
modelling of European
painting, which indeed
began also to invade the
art of palace painters.
Height 20·3 cm.
Mid 18th century A.D.
Percival David Foundation,
London.

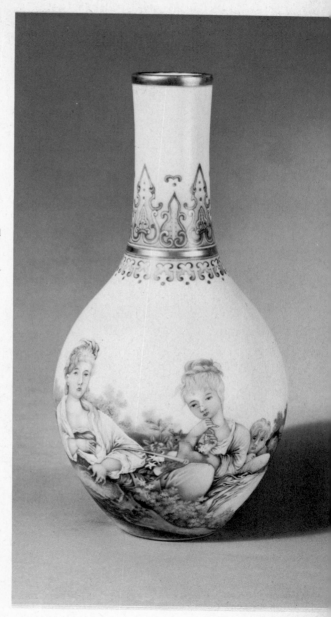

135. Wall ornament in polychrome ceramic, as ordered by the Emperor Ch'ien Lung in his refurbishing of the Inner Palace. The compact confusion of the design is characteristic of much of the overladen ornament of the 18th-century palace style.
Width c. 165 cm.
18th century A.D.
Imperial Palace, Peking.

136. Tripod censer *ting* in polychrome cloisonné enamel. Such a piece gathers together most of the fanciful ornament ever devised in the archaistic imitation of the antique. The malapropism of the floral detail is writ larger in the clumsy animals clinging to the lip. *The* ting *was obtained in 1860 from the Yüan-Ming-Yüan Palace. Height 54·6 cm. 18th century* A.D. *In the possession of Messrs Spink.*

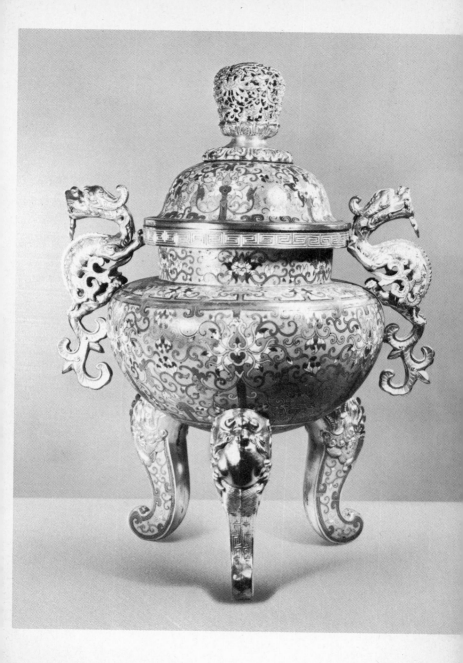

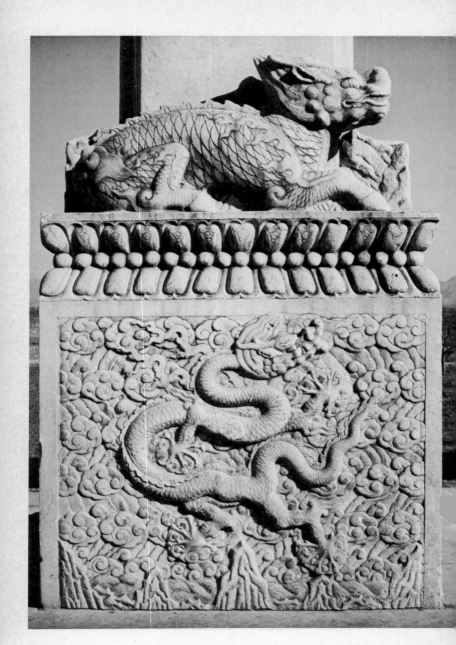

137. Decoration of a memorial pillar at the ceremonial gateway before the Ming tombs. White marble was much used in the Ming rebuilding of the Imperial Palace, its treatment setting a style for much palace work done subsequently in lacquer, jade and enamel. The monster is designed afresh. The dragon squirms among clouds on mountain tops.
16th century A.D.
At the Ming Tombs
near Peking.

138. Fantastic rock in the Emperor's private garden. The collecting of such things in the spirit of *objets trouvés* provided the elegant and conventional amateur with visual relief from the ordered repetition of palace ornament, so uniform inside and outside the buildings.
Height c. *250 cm.*
18th century A.D.
Imperial Palace, Peking.

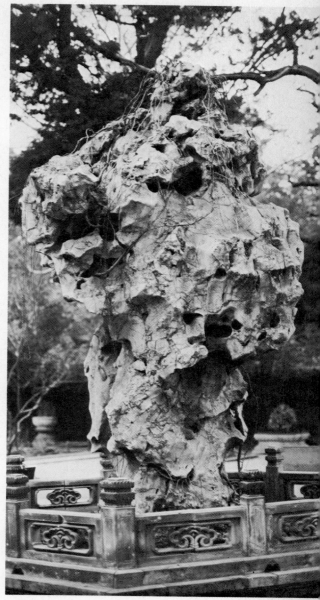

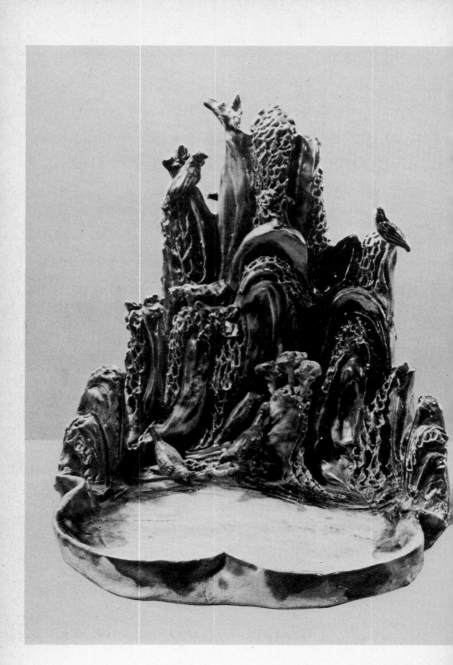

139. Green-glazed pottery inkstone decorated with an inhabited mountain. The theme of a sacred mountain inhabited by strange and normal beasts was a traditional one from Han times. It is always represented in miniature, inviting a curious examination of interesting detail.

Height c. 20 cm.
8th century A.D.
Found at Sian, Shensi.

140 a, b. Porcelain bowl decorated in *famille rose* enamels with three panels of landscape. The miniaturist style so often found in other palace craft was adopted by the potter in wares supplied for imperial use. Painting of the same scale and quality appears on wares widely traded, including those supplied for the European market.

Diameter 16 cm.
18th century A.D.
Fondation Baur-Duret, Geneva.

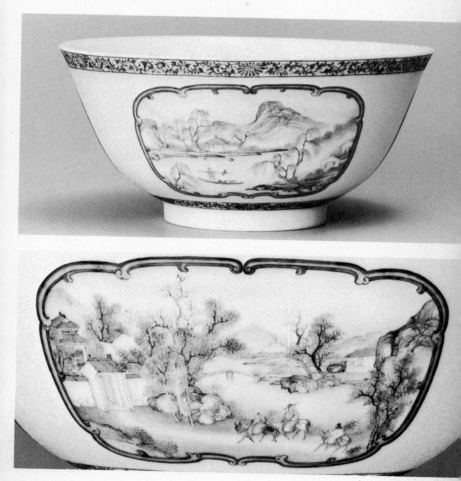

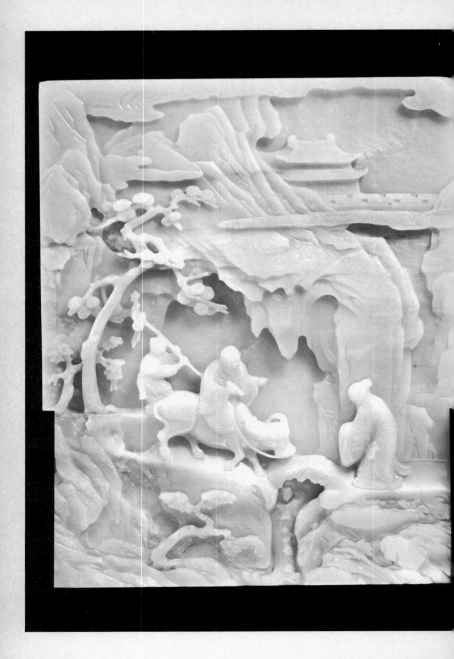

141, 142. Ornaments for the table, and especially for the scholar's desk, include small jade screens in which the romance of the miniature landscape is the theme. The palace workshops excelled in this carving, imaginatively adapting the scene to markings present in the jade slab and achieving an illusion of height and depth scarcely inferior to the painters. The screen on the left shows the philosopher Lao-tzŭ in his mountains; that below, a mountain pavilion in spring. The style was peculiar to the subject, which portrays a detail of the classical mountain theme of the painter more often than the total subject of the rearing peak with its foreground. Only the finest quality of jade lent itself to this work, but much of it was executed also in the slightly softer jadeite.

Height of the jade tablets 30 and 17 cm. respectively. 18th century A.D. In the possession of Messrs Spink.

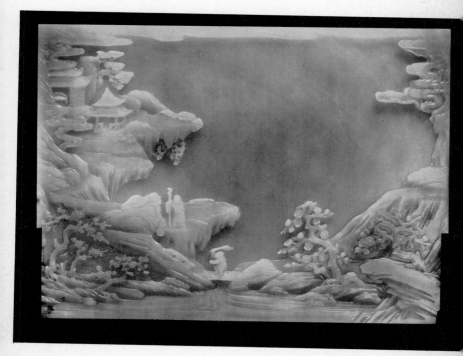

143. Jade dragon bent in a ring. The bibelot made, as is usually said, for the scholar's table appears in infinite variety of form and material and often alludes to the Confucian past. Apart from its imperial connection as an earnest of official promotion, the dragon links with the hieratic ornament of the ancient ritual vessels, the tail-devourer *ouroboros* first appearing on them in the 9th–8th centuries B.C. The comparatively simple outline of this piece suggests the palace style of Ming rather than the later period. *Diameter 13 cm. 12th–14th century* A.D. *British Museum, London.*

144. Chalcedony goblet of the ancient ritual form *ku*. The decoration of a dragon at the centre in openwork departs from the ancient model, adding the kind of complication favoured in the imperial style of the Ch'ing period. The chalcedony is transparent and of a smokey bluish-grey rather resembling agate. *Height 21·3 cm. 18th century* A.D. *Lord Fairhaven collection, Cambridgeshire.*

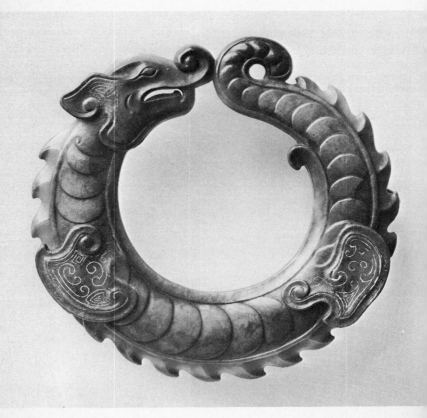

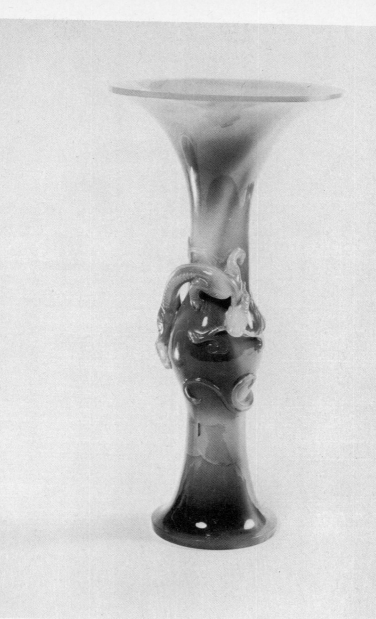

145, 146. Wood-block prints of a branch of chestnuts, in black, brownish and purplish red, and sage green, and of three yellow oranges on a bark-wood dish in black, reddish brown, yellow and sage green. The prints of the Ten Bamboo Studio epitomize the sensitive composition of a long tradition of flower painting. In each case the subject is placed on a blank ground with an unerring eye for the natural balance of the parts and the imaginative suggestion of their ambience, whether this is wide space, or the continuation of the subject beyond the margin. The colours in every case are exquisitely toned together, mere brilliance of hue being avoided. The registration of the printing is correct without pedantry, the effect aimed at being that of painting in which colours in contact may even overlap a little. The purpose is wholly decorative, and in a sense the prints were designed in conscious defiance of exact botanical painting.
Width 28·2 and 28·7 cm.
c. *1633.*
Painting Manual of the Ten Bamboo Studio, *VII, 17 and 18. British Museum, London, and Museum für Ostasiatische Kunst, Berlin-Dahlem.*